STREET ★ ART

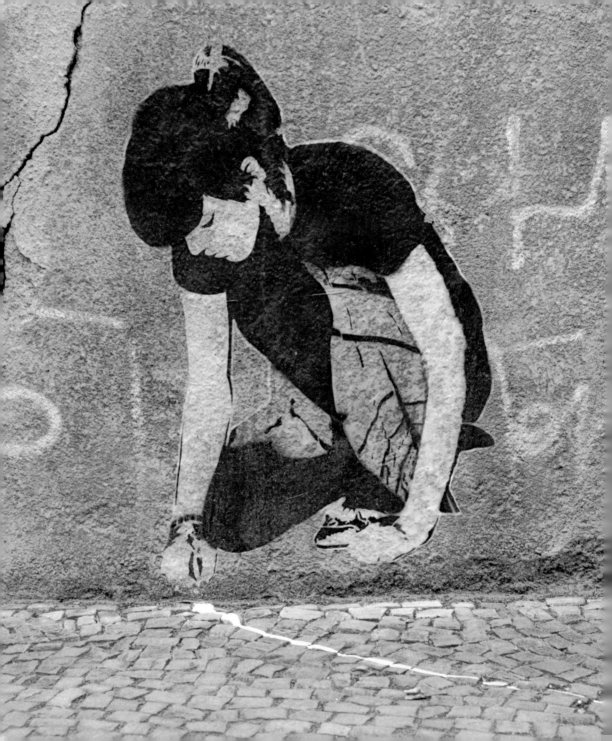

Johannes Stahl

STREET★ART

h.f.ullmann

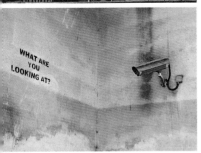

Contents

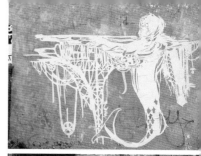

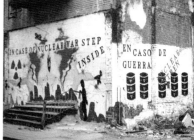

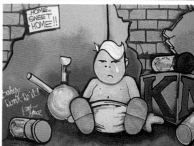

p. 2: Girl drawing, Stencil, paint trace on ground
Photographed in 2008, Halle (Saale), (see also p.197)

Prelude: An Idea without an Era

Unofficial and non-commissioned signs and images on the walls have always existed. They bear significance not only for their makers but also set strong signals for the viewers – bones of contention and impulse for discussion since the Stone Age.

We have long since got accustomed to understanding art history as a succession of epochs. It is the epochs which, besides the counting in years and centuries, beat out the rhythm of time. Generations succeed one another and from the maintenance or rejection of their traditions, a complex structure of values emerges. But at the same time, there has always existed something outside of official art history: a unruly, recalcitrant art, which takes place not in the sheltered environs of churches, collections or galleries, but out on the street. More often than not, this art is the work of those whose prime aim is not really to create art. But like many artists (and unlike advertising), they focus on images and messages that are first and foremost about themselves.

"Street art" is a comparatively new term for this ancient culture: that of placing one's mark on a wall and so making it public. Another term, employed time and again to define those unofficial texts and wall paintings, is "graffiti." It is derived from the Italian word "sgraffire". "Sgraffitio" is a technique for decorating façades in which layers of contrasting plaster are superimposed onto one another and a design of lines and patterns is then scored into the wet top layer. This creates a highly durable façade decoration which can still be seen in many places. The term "graffiti" was first used in the mid-19th century, parallel to the discovery of scribbling and inscriptions on walls in Pompeii. Right from the start, the unofficial aspect

became a major feature of the phenomenon. Archeologists such as Raffaele Garucci used the term graffiti to distinguish it from established art.

This point of view has served to create a bias toward street art and graffiti which often dominates its reception to this day: anything that comes from the street will seldom be considered "respectable". Next to the illustrious pedigree of high art and its epochs, street art looks like a kind of mongrel. It may at times display nobler elements or objectives but it never denies its humble origins. At the same time, it is characterized by the sturdiness characteristic of mongrels. It can be found at almost all times and in virtually all places and is practically impossible to eradicate. Its formative and most fascinating element has always been its close connection to everyday street life – as well as the fact that it far transcends these origins.

In his seminal essay of 1933, the French photographer and essayist Brassai calls graffiti "l'art batard des rues mal famées" – "the bastard art of ill-famed streets". He expounds the necessity and honesty of graffiti as a benchmark for the contemporary art of the time in no lesser a place than the magazine *Minotaure,* the central organ of the Surrealist movement. And along the way, the close confidant of Pablo Picasso manages to create an early example for the use of the modern term "street art." "The bastard art of the ill-famed streets, which ordinarily hardly ever incites our curiosity, so ephemeral that some weather,

Spiritual line drawing
Photographed in 2005
Ladakh, India
Photograph: Andrea Zaumseil

Boxi
Cutout
2007
Berlin-Kreuzberg

a coat of paint, can wipe out its traces – it becomes a measure of value. Its law is binding; it turns all those painstakingly established esthetic systems upside down. Beauty is not the object of creation; it is the reward (…) what will remain of contemporary works in the face of such a confrontation"?

But the signs on the walls and on the streets certainly do not exist independently of a close frame of reference to the period in which they wre created. Political ideas, esthetic perceptions and objectives of the moment – the signs on the wall often reflect trends which will only later become part of official culture. Thus the creative phenomena of the street do not simply serve as benchmarks for artistic creation, but above and beyond that, as an important historical indicator. The graffiti in Pompeii reflect the advent of Christianity; and the street proletariat scribbled caricatures of Louis-Philippe, Citizen King, all over the walls of 19th-century Paris. You can find Nazi graffiti as well as that of their opponents. "The words of the prophets are written on the subway walls," sang Simon and Garfunkel in the 1964 hit "The Sounds of Silence". During the student revolts of the 1960s, under the slogan "the walls will have their say", not only political opinions but also poetry appeared all over the walls of the metropolises. And last but not least, the current controversy surrounding the invasive billboard advertising in the cities is constantly provoking creative acts of street art.

Even if not every epoch is as enamored of its street art as the above-mentioned Brassai – graffiti has been taken into account by the artists of all epochs. And with good reason: after all, it is often the following generations who first try out on the streets what later may well turn out to be fit for the salons. And these youngsters take their cues not only from ancient and

established art – thus entering into a creative dialogue with it – but they develop their own, sometimes new and good ideas and images.

Since the 1970s, paying attention to street art has made particularly good sense. Through increasingly sophisticated techniques, graffiti culture, which had long since turned into a juvenile mass movement, managed to render the pieces on the New York subway fit for the select circles of the art establishment. Many galleries showed graffiti art and sought to cleanse the phenomenon of its disreputable provenance by using labels like "post-graffiti". Collectors and museums alike bought the images, now respectably tamed on canvas. But what at times was being presented as an inde-

Piece
2003
Leverkusen-Küppersteg

Seak
2007
Hürth

pendent little epoch within the turbulent unfolding of 20th-century art has since turned out to be a short-lived hype. And yet on the streets, the irrepressible phenomenon is alive and kicking and, unless we are very mistaken, is experiencing another renaissance as the focus of attention of "orthodox" art, this time under the label of "street art". One does not have to be a prophet to guess that this will not be the last one.

All the same, street art is not really dependent on the art scene and its progression through the epochs. On the contrary: it has its own networks. It has always been a very youthful art, and very much a part of the manifold structures of youth sub-culture. The specific characteristics of the period in question – music, appearance, clothing, hairstyle, lifestyle and language – often count for far more in this context than participation in the formal rituals of the art scene such as salons, art fairs, Documentas and Biennales. One aspect of the scene which is by now almost traditional is its excellent internal network. Street art its external

appearance serve as a mutual platform. The complicated alphabet of a piece is often hard to decipher for outsiders, the language of the writers not always easy to understand. And it is hardly surprising to realize that the scene wants to remain underground. After all, the fine art scene is by no means an attribute of society at large; it, too, likes to educate its own circles.

There is one aspect of street art which it may prove particularly interesting to consider: it is very public. The appearance of a wall, a street, a city is as relevant as it is controversial. "The house must please everyone. As opposed to the work of art, which does not need to please anyone. The artwork is the private business of the artist. The house is not," as the Vienna architect and essayist Adolf Loos wrote in 1908 in his famous essay "Ornament and Crime" Street art exists within a sector where the purveyors and contractors of architecture have taken on a creative responsibility. Therefore, just like architecture and advertising, or like any form of public creation or design, it is obviously no private matter. Loos has consciously exaggerated this fact with the stipulation that a house needs to please everyone. At the same time, however, he has put his finger on the heart of the controversy in which street art is also involved. Of course, the consensus of esthetic pleasure is a fallacy. The simple assumption that the house owner or the financier of public advertising or public planning will have enough good taste to achieve an esthetically pleasing result has been proven to be a pipe dream many times over.

In short: the setting where street art takes place has always been a controversial one. Reason enough to cast a sweeping glance over its history, its idiosyncrasies and the rich store of arguments, humor, beauty, and provocation it has to offer to this discussion.

Nowadays, the strong colors and imagery of sprayed graffiti have found an enthusiastic audience – no matter whether they have appeared illegally or as a private commission.

The Mother of All Pictures

HAL!!! Come home! Mother's voice sounded annoyed. But Hal had only been over to the rock to try something out. There, right next to the old animal pictures, you could now see the negative image of his small hand. Hal had laid it on the rock, fingers apart. In his left, he had held a blowtube filled with a mixture of water, chewed up ripe cranberries and saliva. You could only achieve such a mist of color if the tube was really narrow in front. Now you could see the small hand really well, with red color all around it.

In the evening, there was trouble. On the way back from their hunt, the men, as usual, had passed the rock with the old animal pictures in order to thank the hunting gods. There they had been surprised by the color and the small hand, for they had to pay close attention to signs from the hunting gods. In the cave, they had of course noticed the color on Hal's hand. But at least he did not get beaten, and the Elder even asked him how he had done it.

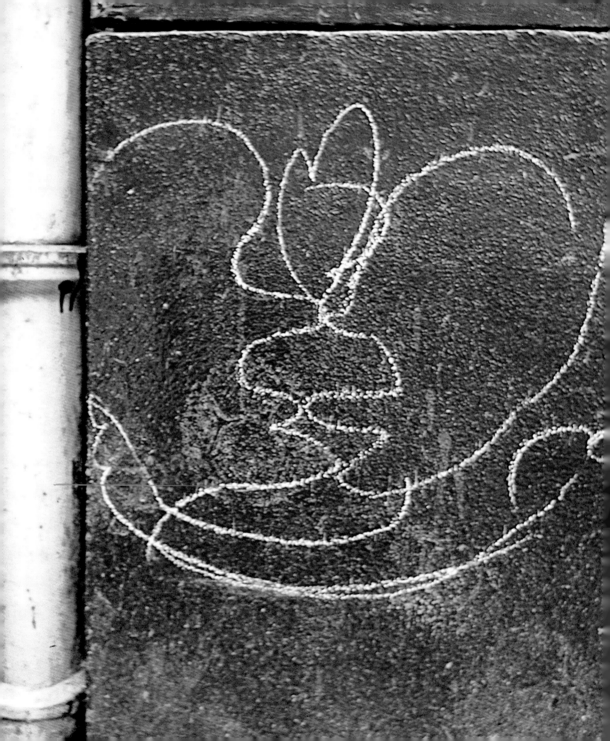

Signs and Art on Walls

What came first – the writing on the wall or art? This discussion is as old and as impossible to resolve as the famous question about the chicken and the egg. The fact remains, however, that there have always been drawings and images on the walls of human civilization. From the modern perspective of a world full of paper, telephones and screens, it is sometimes hard to imagine just how essential walls of every kind have been as a means of communication.

Kissing couple
Chalk drawing
1985
Paris

Trees and cacti full of inscriptions, chalk drawings on the pavement on the way to school and the walls of nursery schools talk volumes about the essential human need to communicate in words and images. There has always been an abundance of graffiti in important places. But even enclosed spaces like toilets and prisons have at all times reflected the private and political thoughts of their inmates, thoughts which might equally have been expressed in much the same way on more public walls. These inscriptions have been left behind not only as a sort of legacy on behalf of the person who wrote them but also in

Keith Haring et al.
1986
Berlin, Wall

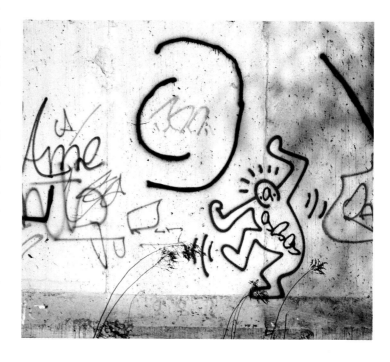

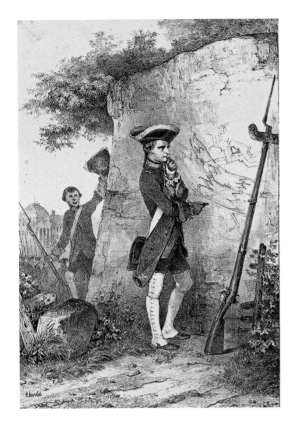

Charlet, Nicolas-Toussaint (1792–1845)
Napoleon as a student at the Military Academy, drawing on a rock wall
Lithography taken from "L'Empereur et la Garde Imperiale", 1845

general for posterity, to be seen by others.

"The wall is the street urchin's natural medium of exchange," observed a French magazine which established itself as an *"Intermédiaire"* for public discussion as early as 1866. Today, this need for private and public exchange knows many outlets: the small ads boards in the supermarkets or the blogs, dating pages or auction sites on the internet are only a few examples of the evolution of this ancient idea.

The Wall of the Artist's Studio, the Walls of the City

In this respect, a glance into the artist's studio might prove to be worthwhile. Sketches can be found here in their original function: as the direct expression on a creative idea on the wall. Several factors come into play in this context. This is where the idea first takes shape: as yet, nothing is definite but shape, material, size and effect are examined in the first instance. Then the artist gradually grows more confident in the treatment of his subject matter. He will then often arrive at a valid draft or a finished work of art with miraculous speed. That is why the public is often awe-struck at the knowledge and proficiency of the artist – whether he be portrait painter or graffiti artist.

For street art, the place of action is, as the name already says, a crucial factor. Unlike the artwork on the private walls of the artist's studio, street art takes place in the public eye and is accessible to all. Quite apart

from their artwork, the artists also convey first and foremost the mere fact that they exist. At the same time, they shape their environment and imbue it with their own, idiosyncratic interpretation. Naturally, this gives rise to several conflicts. One of them is the question of legality. Whether or not an individual should have the right to change the public appearance of a place and if or where this should be allowed is a basic question that is seldom addressed in any depth. The broad social consensus is based on established legal, commercial or political factors – and on the curious fact that everyone loves to get annoyed about individual

TOOF et al.
2007
London, Hackney Wick

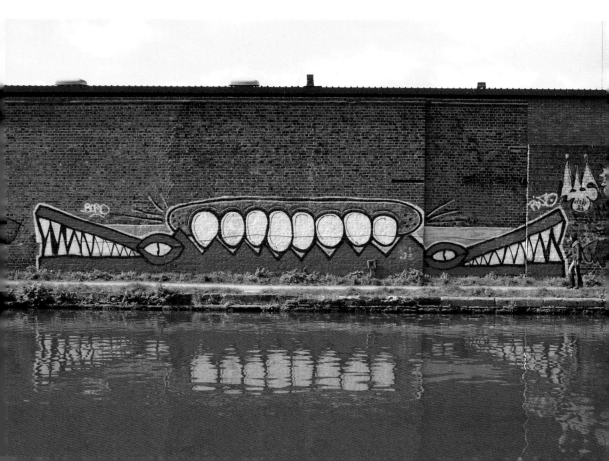

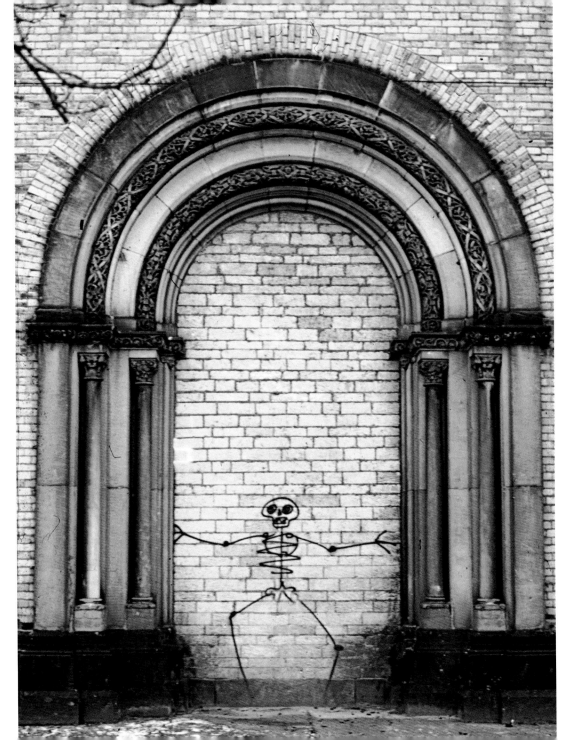

cases but, almost traditionally, hardly ever discusses the basic problem. The question as to what pleases the eye, in how far the appearance of the public space has changed in the course of time and how humanity really expresses itself at this point in time, is seldom asked. Street art does not crave the acceptance of the general public. On the contrary, it adds – mostly without being asked – its own contributions to the whole. In this context, a mural such as Lee Quinone's tag of the "Allen Boys" in New York's Allen Street, ultimately establishes a territorial claim. The architecture, after all, has usually been produced without much public involvement. Advertising spaces have grown progressively larger and larger, while the pedestrians have become more and more adept at looking the other way. Street art serves as an irritant; it begs the questions about individual expression, public perception and, time and again, also poses the question as to how much "user interface" the passer-by is really presented with.

Questions like these cannot be answered quickly and easily because they depend on many variable factors. In the best-case scenario, we will arrive at a clearer perception of our everyday environment. Harald Naegeli, the "Sprayer of Zürich", is an encouraging example: the few tags that have survived in Zürich after all these years are now widely accepted. Some of his graffiti are now even regarded with affection; they have become advertising vehicles and attempts are made to conserve or even restore them. The development and long-term persistence of a public discussion that has already been going on for decades is an interesting result of this visual occupation of public space. It is quite obviously possible for someone to set the right impulses, uncalled for and illegally, and in a format perfectly suited to this discussion.

Previous double spread:
Lee Quiñones
Allen Boys
1985
Allen Street, New York City

Death himself opens the bricked-up Romanesque church portal – or is it just his bouncer? The poetic imagery of the "Sprayer of Zurich" appears in the most bizarre locations.

Harald Naegeli
Cologne Dance of the Dead
1981
Köln, Schnütgenmuseum

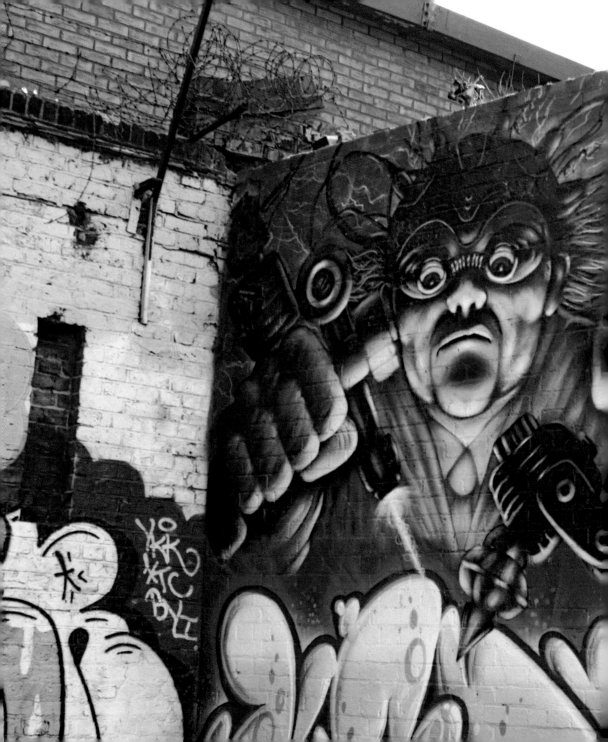

Public walls have always been a kind of laboratory for images of all kinds. Their development receives the same amount of care and attention as if it had taken place in an atelier – especially in the case of capital letters.

Laboratory scene
c. 2007
London, Hackney Wick

Graffiti as a Research Subject

Graffiti as a research subject has a long tradition. The first person to collect it systematically was a certain Hurlo-Thrumbo, who published a collection of toilet graffiti in 1731. He had to use a pseudonym, because the introduction alone

Thomas Rowlandson (1756–1827)
Dr. Syntax copying the wit of the window
Colored etching taken from "Tour of Dr. Syntax in search of the pittoresque"
London 1812, plate 6

was a potentially explosive political issue: "Original Manuscripts written in Diamond by Persons of the first Rank and Figure in Great Britain". His collector's enthusiasm aimed at one of the classic concerns of political research: "handing" his findings "to Posterity." It is quite possible that such inscrip-

tions on windowpanes were not even that rare. Even Thomas Rowlandson allows the protagonist to assume the role of the eccentric investigator of graffiti in his popular Dr. Syntax series launched in 1812. He is so naive that he does not notice what is going on around him.

After Raffaele Garrucci's account of the graffiti of Pompeii in 1853, the term was adopted to refer to unofficial inscriptions and the importance of such expressions for historical research was established. Today, there are numerous bodies that collect and evaluate graffiti; the number of publications is legion. Especially noteworthy amongst them are the Graffiti Archive in Kassel, established by Axel Thiel, as well as Norbert Siegl's collection in Vienna. In Henry Chalfant's studio – the epicenter of New York Graffiti – another type of collection has been established: a photo archive as the starting point for the discussion and development of street art.

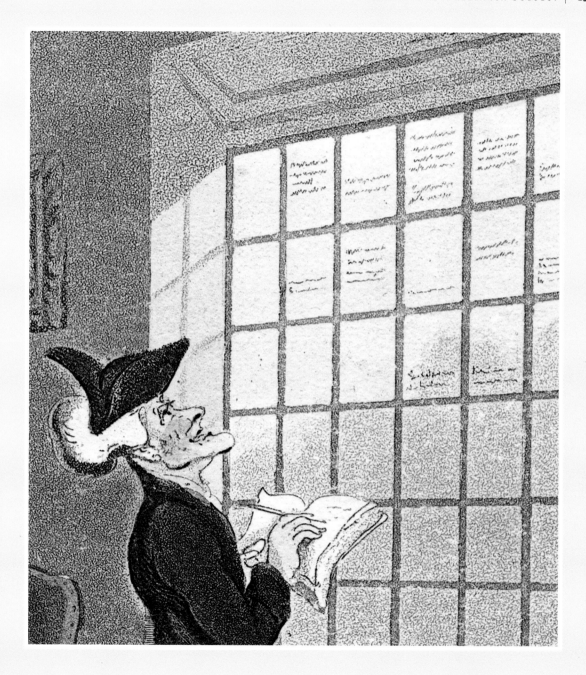

"Hello, here is my Name"

It could have turned out well. After all, Quintus was the son of a slave who taught the two sons of a senator. Even if those two rarely felt like attending school, this meant that he was highly respected. Quintus did not receive any teaching from his father – at least not officially. But what he picked up unofficially was enough to allow him to read and write. Of course, nobody was supposed to see Quintus practicing with the stylus. But as a slave boy, he was often in town and he practiced on the walls, which were covered in writing anyway.

Since the slave revolts, the secret police had their eyes everywhere. Therefore, he never wrote his own name. "Quis" or just "Q": you could see it everywhere in those days. His writing had gradually taken on an increasingly formal appearance and Rome was puzzling over who this person or "somebody" was. By the time they caught him, he no longer carried just a stylus but also a small chisel under his toga. After that, he was never heard of again.

People, Names, Signatures

"The Name is the faith of Graffiti": this is how none other than Norman Mailer paraphrased the statement of a New York graffiti artist as early as 1973. At this time, the very first attempts were under way to domesticate the activities of the New York graffiti writers by putting their work into galleries. But indeed, leaving one's name on a wall is one of the most ubiquitous and oldest types of graffiti. There are signatures on the walls of Pompeii. You can even see how these names engage in a sort of communication – comparable to the modern exchange of calling cards or homepage addresses. This sort of presence, however, very public and engraved in stone, is much more noticeable and durable. Official inscriptions, which can be seen to this day on palaces and public monuments, are a typical example for this. For the mere mortal, the name on the door, the doorbell panel or the sticker on the car may suffice, or at least the inscription on the gravestone. But people did not always want to wait that long.

But the statement can consist of much more than just a name. Like many other creative processes, graffiti can be driven by the challenge of the pristine canvas,

Quik
Hello, my name is…
Quik working on the piece; left:
Detail of finished piece
1991
Schweinfurt

Memorial Graffiti

Parallel to the proverbial Kilroy in the Anglo-Saxon region, there was a certain filing clerk at the time of the Danube Monarchy named Josef Kyselak who left his name on walls all along the Danube region. To this day, the ubiquitous nature of the name is astonishing. It encourages us to conclude that there must have been imitators at work who wished to partake of the fame of the widely traveled clerk and who thus served to augment it.

The shapes and aims of such inscriptions cover a broad spectrum. They are even sanctioned in some circles of society: academics, for example, leave their signatures at their place of learning after passing their exams and royal visitors inscribe the walls of a mine during a visit. To this day, mountaineers leave their initials on the summit cross but in the 19th century, a hiking guide suggested taking paint and brush in order to immortalize one's presence on the rocks. Given the fleeting nature of fame, it is very important for athletes or film stars to have their name set down in a Hall or Walk of Fame. But whether a name was signed personally or put down by recommendation, it signifies first and foremost that this person exists, that he or she has a real or assumed name and that the public had better remember this name.

J. Kyselak
Inscription, 19th century
Krems, Cycle path along the Danube

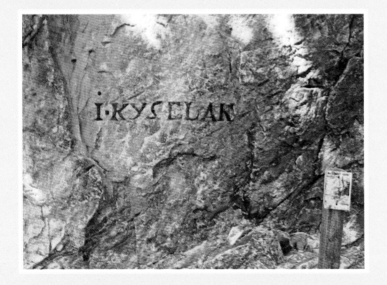

the primeval urge to fill an empty space. At the same time, it leaves a trace, proof of someone's presence at a certain time in a certain place. It is not for nothing that many name tags come with dates, sometimes to the day: the "I was here" signature serves like an entry in a guest book and documents the date and place of a presence.

But the ultimate goal of such a relic far surpasses the mere statement; it documents a very specific aspiration: to sets the event in stone very publicly and for all time. Halls of fame such as Valhalla have not become the eternal resting place of heroes and gods for nothing. But this interpretation also has a flip side: if you read "Strictly Kings or better" in the New York Hall of Fame, you know that you had better not write here.

Signatures

For creative artists, the name has a much greater significance. In the form of a signature, it serves as a trademark and, at the same time, as proof of authenticity. Therefore it was painters in the first instance who noticed the ubiquitousness of graffiti. Throughout art history, you can discern the playful experimentation with unofficial signatures as a constant and underlying theme. Quite frequently, the signature on the picture can be found right next to a reproduction of children's drawings. In Hendrik Avercamp's winter scene of 1608 in the Rijksmuseum in Amsterdam, his signature is placed right next to a graffito at the margin of the painting. Surprisingly, however, he does not repeat this motif in other paintings. Almost 50 years later, a trompe-l'oeil by the Netherlandish painter Melchior d'Hondecoeter takes it a step further. The bagged fowl on a wooden surface seem even more real because right next to them, some awkward graffiti

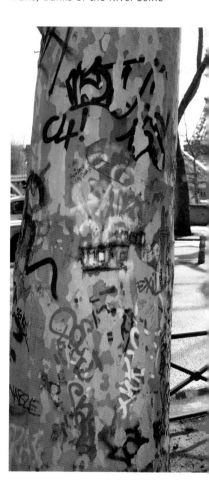

Sprayed tags and carved inscriptions
Photographed in 2008
Paris, Banks of the River Seine

figures have been drawn, apparently with the same piece of chalk as the signature of the master. Here, the signature has not just been artfully incorporated into the painting – a frequent phenomenon – but has become an indispensable component of it.

A small illustration by Grandville shows another facet of this relationship between graffiti and signature.

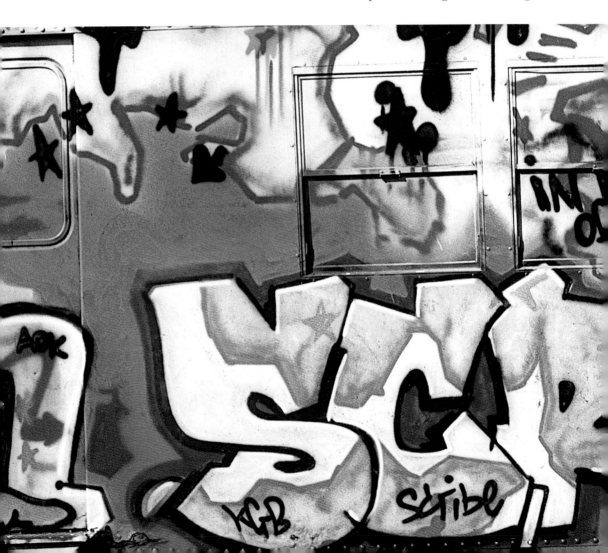

In his series "Cent Proverbes" of 1844, the artist portrays himself writing his signature on a wall in a sweeping gesture. It is the act itself that is significant: after all, it takes place in a publication that the artist aims at the general public. The title of this drawing ironically undercuts the subject matter: the proverb depicted is "Muraille blanche, papier des fous" – "A

Mesh/Age/Reas
Epitaph for Scribe
1986
New York City, Subway
Detail of p. 275

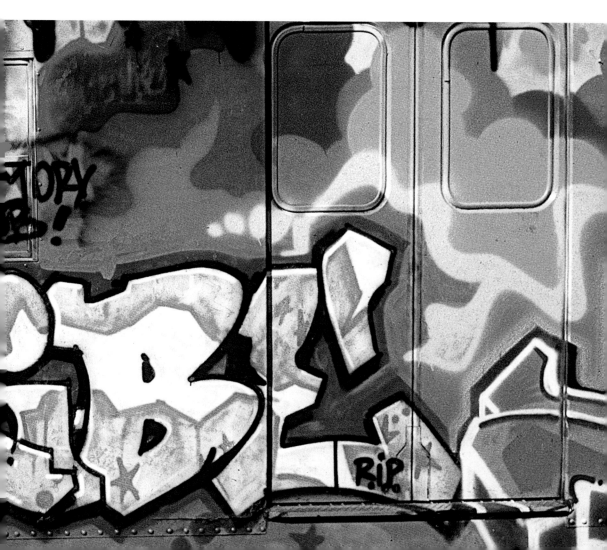

white wall is a fool's paper". Next to the master, who is wearing a fool's cap and casting a guilty glance over his shoulder, stands a boy who writes the name "Salomo" on the wall. In view of the fact that the Paris intellectuals of Grandville's day strongly sympathized with the street proletariat and that in their drawings they let them write their own opinions on the walls, the artist really seems to ask which of the two is the fool and which the sage.

In 1945, Jean Dubuffet revived the discussion with his painting "Mur aux Inscriptions". Here, the signature of the painter can be found twice: once as a monogram apparently written on the wall in chalk, and again, almost disappearing in the complex graffiti next to the central figure, as a full signature in black cursive script. A good twenty years later, Ben Vautier integrated his own signature into his graffiti as a matter of course. His messages to the public were conceptual statements of an artist who considered public walls as one of many media, like performance, painting or the typical merchandise of museum gift shops.

If the name, as in the New York pieces, could become the central or, indeed, the only motive of public images, the term graffiti art is historically valid but, at the same time, remains ambivalent. After all, the name now occupies the entire space of the image as a central statement, fully styled, leaving its graphical nature far behind. By comparison, throw-ups or tags maintain the character of a signature placed on a public space in the city in a much more pronounced way.

Graffiti are a medium of communication but they do not always result in a dialog. Keith Haring seems to put Martina on a pedestal, which probably accounts for her surprised expression.
In the 1980s, the Berlin Wall was a prime location for inscriptions, dedications and opinions.

Keith Haring et al.
1986
Berlin, Wall

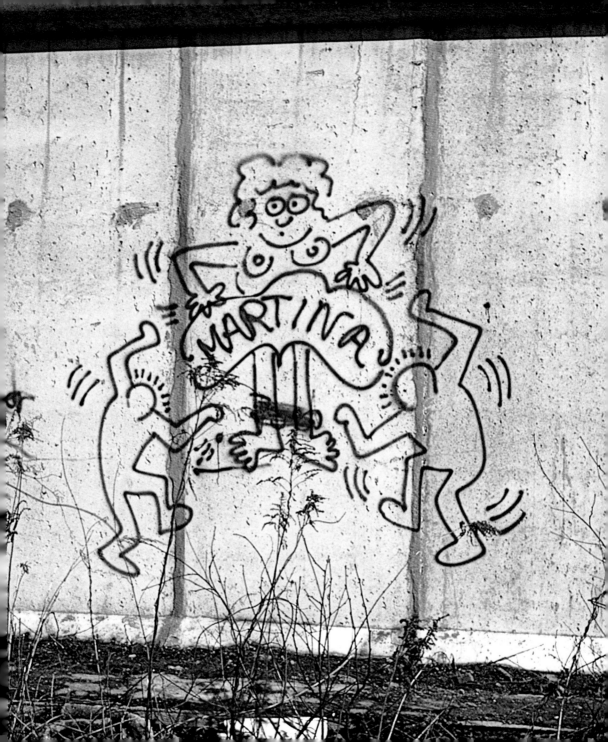

AERO AH AIDA AKIO AKT ALDOUS AR ASEK BA
BI NA B NX BI SM BZK BLAZE BLOPS BON
DE EMON DS OS ER
JA Q E JOE KA S KATJ A KIC K KLOK KNO
M ENZ MESKA MSP MELK N GM NOLT OSC OSEK
PV DIO RAMO RISK BON BOSE RSS
T OOCOLD TO CS A W

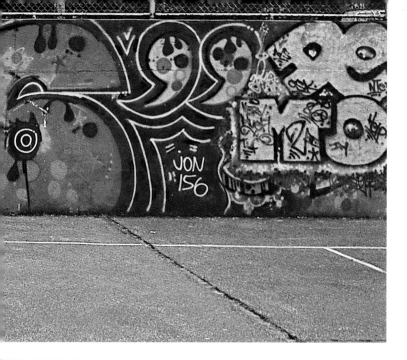

JON 156
1986
New York City, Graffiti Hall of
Fame

The artistically encoded
nametag by JON 156 on
the New York Hall of
Fame formed a creative
highlight in 1986. In
2006 Konrad Mühe
arranged all tags on a
wall according to typo-
graphy and in alpha-
betical order.

Konrad Mühe
Wall of Fame
Mural 2006
Photographed in 2008
Complementary Work at the
Hochschule für Kunst und
Design, Burg Giebichenstein
Halle/Saale

The Magic of the Name

17th-century cipher on the walls of the University Church of Salamanca
Photograph: Andrees de Ruiter, Photographed in1985

It is certainly no coincidence that at all times and in all places it is first and foremost names that were left as graffiti; it has its root in the history of mankind. In all cultures, the naming of individuals provides a means to distinguish them from others and – like Adam naming the animals – establishes a hierarchy. The signing of one's name functions as a type of magic by analogy: by writing one's name in a particular place, the latter is incorporated into one's own world of thought and experience. And this fact is then communicated to all who see the inscription – and who have, quite possibly, also already left their own signatures at this place.

The French philosopher Jean Baudrillard claims to have detected a new trend with regard to graffiti and the question of social power. His 1975 essay "Kool Killer, or the Insurrection of Signs" explores the idea that graffiti subvert the sign system of language since the average person has a hard time deciphering them. Because the names of the New York Writers do not publicly signify a specific person, they are "empty signifiers" which "erupt into the sphere of the fulfilled signs of the city, which they dissolve by their mere presence." However, the explicit intention of these writers to establish a familiar and accepted name within their own scene, as well as the subsequent fame of individual writers, which turned them into public, clearly defined and identifiable persons, make Baudrillard's assumptions seem rather tenuous today.

By the 1970s it had become far more common to broadcast publicly the name of an economically successful brand than of a socially or politically eminent person. "My name in lights": advertising such brand names as McDonalds, Ferrari or Giorgio Armani appears to be, more often than not, a careful

strategy aimed at putting out an individual's name. Adidas or Haribo, for instance, are also derivations of the names of their founders, Adi Dassler and Hans Riegel. Starbucks and Häagen-Dazs, however, are fantasy names, which serve to suggest a familiar provenance and perhaps facilitate the acceptance of a globally marketed product.

The reason why it is first and foremost the American name-pieces that have become a worldwide role model within the universe of street art does not only lie in its wide diffusion through the media. Another important reason may also be the fact that their mental format has been exactly preformed by the strategies of advertising. Through the writers' perception and adoption of those strategies, a modern version of the ancient dream of putting one's name into the limelight takes shape.

To step out of anonymity and become a recognizable person: This is a recurrent game played by the New York writers. It is not for nothing that the figures next to the signatures are called "characters". In addition to the name, they always illustrate a self-image: that of the hunted criminal; the star; the shady figure with a mythical background; the comic-strip character. Quite a few of those images are actually self-portraits. The widely publicized self-made photographs serve to underline this fact in that they show the writers proudly presenting their work. In this form of public exhibition, the person, the artwork and the name merge. And finally, with every

Arabic letters and self-portrait
2007
Leverkusen-Küppersteg

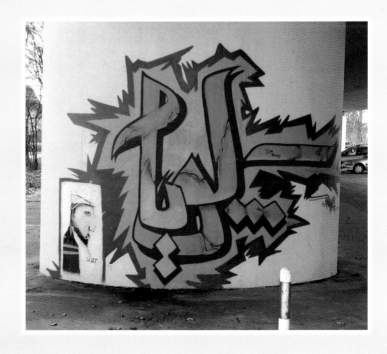

creative version of the name, a modified characteristic, a new self-portrait of the person emerges.

But perhaps we are in another different situation these days. In the times of surveillance of public places around the globe and around the clock, where personal profiles can be assembled in microseconds from cellphone and electronic banking

Tagged wall in a side street
Photographed in 1983
Amsterdam city center

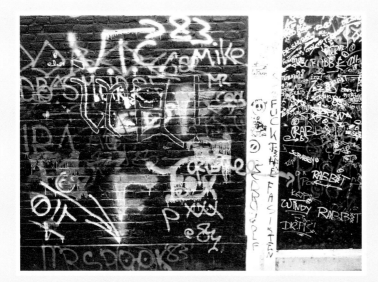

data, things have changed profoundly. Since that time, a paradigm change has taken place. Identity theft is keeping the authorities increasingly busy. Private firms specialize in pro-

tecting their clients from having their good names hijacked and their accounts plundered. And so it has perhaps become especially attractive today to see one's name emblazoned in color across the night sky, knowing all the while that it is not one's real name, which is still being kept in sheltered anonymity. The celebrity cult meets its equivalent in the progressively increasingly protected anonymity of the real person.

"Always think of forgetting me", the German conceptual artist Timm Ulrichs had had engraved on his gravestone in 1969: a sort of preventive measure against too much fame placed on the very spot where citizens' names usually survive for decades. Banksy, the Bristol street-art-protagonist, who has since attained worldwide recognition, carries this concept to new extremes. He modified Andy Warhol's famous quote that everyone could be famous for 15 minutes, saying that in the future, everyone should try to stay anonymous for at least 15 minutes.

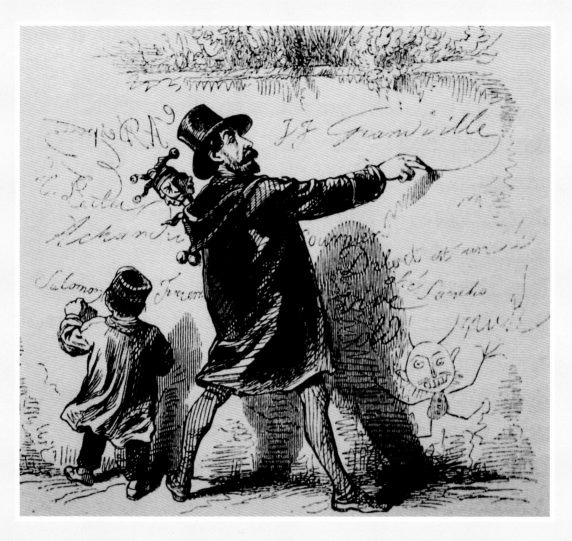

**GRANDVILLE (Jean Ignace
Isidore Gérard, 1803–1841)**
Self-portrait as street urchin
From "Cent Proverbes", Paris
1844

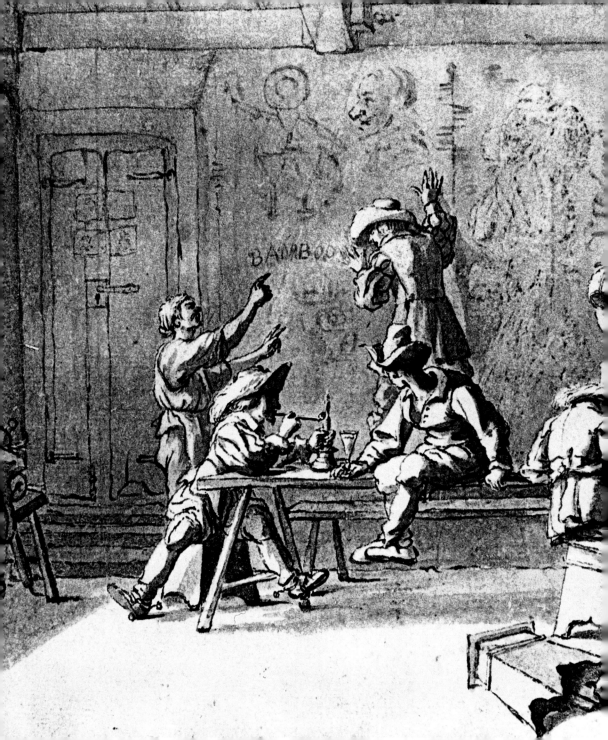

Important Signs for Art

How loud these revelers were, with their Dutch-accented Italian! They always drank abundantly and argued loudly about their art. Elena tried to listen when she helped her father serve the wine, but then there were always so many other guests as well. At least these rough Northerners liked her. They had drawn a small picture of her in the adjacent room: directly onto the wall, next to their peculiar nicknames and the caricatures.

Elena wanted put the painters to the test. Would they notice if she added something to it, at a place where there was still a little free space on the wall? Pieter, their leader, noticed the new drawing immediately. The others could not come to an agreement: had one of them imitated an amateur, maybe in a drunken stupor? Pieter secretly guessed that it was Elena but said nothing. She did seem to have some talent. But Pieter kept his secret and the Bamboccianti turned their attention to other, more important questions.

THIS IS
A
CANVAS

Artists and Graffiti

Artists have at all times cast an alert and suspicious eye on everything that could be considered a picture. After all, creating pictures was their domain. Giorgio Vasari tells us that Michelangelo took his artistry to the point where he could "perfectly reproduce (...) the ugly mugs of those who are wholly without talent and can only besmirch the walls" in a painting contest; "a difficult and, even with dexterity, not easily attainable thing for a man who was so full of drawings and so used to the choicest things." In this treatise on painting, Leonardo da Vinci suggests letting the stains on a wall serve as inspiration for landscape paintings. But not every artist displayed such circumspection in the observation of his environment. Nevertheless it is fair to assume that many painters knew exactly what was taking place on the walls in their time. Wall painting was, after all, an important source of income and especially the painting of public murals brought high esteem. And what about the recurrent story, often told with different protagonists, about the shepherd Giotto, a natural talent, who painted wonderfully on rock walls, then took up an apprenticeship with Cimabue, only to surpass his master in the end?

This is a Canvas
Stencil on perspex window
Photographed in 2008
London,
Building site for the 2012
Olympics

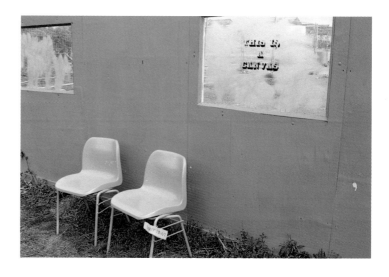

Street art muss sein !

ARte

d.E.T.

Müllsammelraum

Müllsammelraum

ARTe

gut

Kunst

KUNST-
YOUR-
SELF

WARUM DENN DAS?

Paul Gavarni (Sulpice Guillaume Chevalier, 1804–1866)
De l'Académie des Inscriptions et Belles Lettres
Lithography taken from "Le diable à Paris", 1845

You could fill an entire gallery with paintings that show graffiti – and the role played by graffiti within those paintings is extremely diverse.

Most painters looked kindly on juvenile attempts to create a picture on the wall (or on paper). Whether as proof of talent or just youthful entertainment, wall paintings always represented a worthy subject for a picture, and expectations of the coming generations were as high in the past as they are now. And sometimes the painters could place their own signature quite elegantly and naturalistically amongst the graffiti.

The "Brunswick Monogrammist", an unknown painter of the early 16th century, placed graffiti right in the middle of a bordello scene. "Dit Ding Doet die Dochte dalen": a combination of vulgar, phallic drawings accompanied by moralizing inscriptions serves as a commentary on the goings-on in a brothel. Other motifs are equally outspoken: two women are fighting and the door to a separée can be seen in the background. As in many other pub scenes, we can see the tally being kept by drawing lines on the wall. There

Talent and Ferocity

**Gaetano Sabatelli
(1842–1893)**
Cimabue observes Giotto
drawing a goat on a rock wall
19th century
Oil on canvas
Galleria d'Arte Moderna, Florence

A recurrent trait in many an artist's biography is the story of the young talent which was discovered whilst drawing on a wall. Ghiberti and Vasari both tell the tale of Cimabue, who, while on a journey, sees the young Giotto drawing his famous sheep on a rock wall. The older man gives the young genius a place in his workshop and is soon surpassed by him. Similar anecdotes exist about many artists, including Beccafumi, Andrea Sansovino, Andrea del Castagno and Francisco Goya. These accounts always emphasize the natural ability, which through the spontaneous act of drawing already foreshadows the future path of the young genius.

Another theme of such anecdotes is the energy with which these natural talents draw their environment. It is said of Filippo Lippi that he covered walls and paper with sketches. For the brothers Van Lear, members of the Bamboccianti, drawing assumed a similar importance. The interesting thing about these myths is the subliminal establishment of a kind of natural law: latent artistic talent, striving to manifest itself, finally erupts onto the wall. And it becomes immediately apparent that here and in this way, an important talent just needed to express itself.

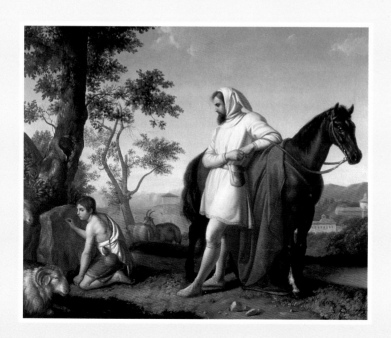

Signs of Bad Company

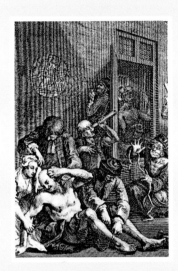

William Hogarth (1697–1764)
In the Madhouse
"A Rake's Progress", Engraving
1735, plate 8. 2. version of 1763
35.5 × 41 cm, detail

"Narrenhände beschmieren Tisch und Wände" (Fool's hands write on table and walls) is a popular German proverb. It implies that decent society does not do this. Artists, however, are torn between the extremes in this case. William Hogarth, for one, frequently depicted graffiti in his series of engravings: In "The Four Stages of Cruelty" (1751), the drawing of a man hanging from the gallows points to the ultimate fate of the sadistic boy next to it, while in "The Harlot's Progress" (1731), a similar graffito of the magistrate Sir John Gonson appears on the walls of the women's prison. In the last plate of "A Rake's Progress" (1735), several kinds of graffiti can be seen in the insane asylum of Bedlam. In the background, a patient is sketching canons and jotting down measurements, evidently plans for a conquest of the world. On a balustrade next to a despondent man appears the inscription *"Charming Betty Careless"*, probably the man's unfaithful love. He wears her picture on a pendant and stares ahead with a gloomy expression; apparently, he has already tried to hang himself. A man given to religious insanity has drawn a religious symbol on the stair post. Hogarth the moralist regards the fact that all these unhappy people have committed their problems to the walls as a symptom of a society in need of change. In a 1763 revision of this plate, he adds the word "Britannia" on a highly visible spot. Hogarth the artist uses these signs as a device to tell several stories in one picture and to let these stories develop their own profile while seen from the distance of sympathetic observation. His "modern moral subjects" were meant to add a new, British impulse to the discussion of the guiding principles of art. Not surprisingly, the representation of social reality was a controversial subject in academic circles. there was a general reluctance to accept the sort of subjects which were typical of graffiti. In the new bourgeois circles, however, the pictures of the self-made man were very successful: the moral tendency of those stories obviously struck a chord. Even today, the idea that graffiti can be read as a sign of social and political problems is widely accepted.

are even a few allegorical images: upturned wine-glasses and an open bird-cage above the door symbolize moral depravity. The graffito, however, takes pride of place in this picture. It serves to connect image and text, realistic representation and moral commentary.

Similar appeals to current morals can be traced through the ages: graffiti have a long-standing tradition as an important pointer to the margins of society, albeit with a negative connotation.

Other painters also displayed a penchant for drinking scenes. Rome's Bambocciati had a habit of covering walls with caricatures, a very fashionable artistic pastime at the beginning of the 17th century. Among those graffiti, there were private nicknames as well as preliminary sketches for paintings. But it was not quite as easy to join the painter's select circle as one might have supposed from their depictions of freewheeling revelry: aspirants had to pass a relatively strict admission ritual. While the Bambocciati mainly showed

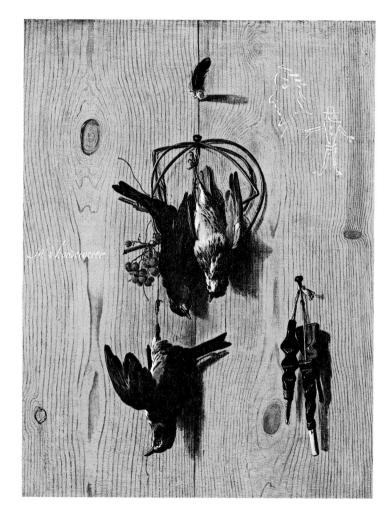

Melchior d'Hondecoeter (1636–1695)
Trompe l'oeil
Suermondt-Ludwig Museum
Aachen

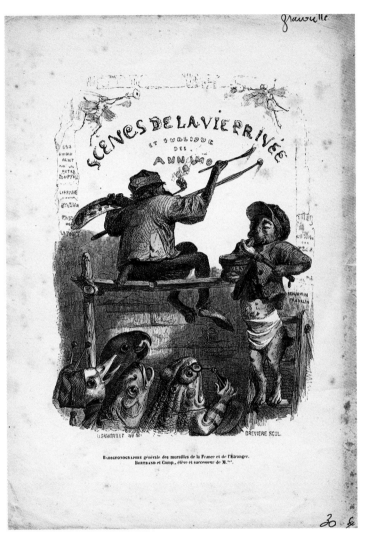

their own graffiti in their paintings, the painters in 19th-century Paris showed a rather different attitude. Even members of the Bohème saw themselves as belonging to the poorer strata of society. The illustrator Paul Gavarni, himself an inmate of the debtors' prison several times over, later commissioned his engraver Bara to copy the graffiti on a prison cell. Caricaturists of the magazines "La Caricature" or "Le Charivari" openly sympathized with the street proletariat and often used images of it in their campaigns. Victor Hugo thoroughly explored the creative potential displayed by marginal drawings in exercise books and graffiti. Whether the ramifications are positive – as in the anecdote about the once popular pear caricatures – or tragic, as for the priest Frollo in "The Hunchback of Notre Dame": if somebody writes something on a wall, it has meaning and there will be consequences.

The artist's eyes are focused attentively to the signs on the wall and the meaning of these signs for society is

rated highly. Their formal representation in the graphic works, however, is rather stereotypical, such as stick-men or, because of their inherent meaning, as clearly legible writing. As an artistic subject, graffiti have a long tradition; since Michelangelo, their faithful rendering has been an important requirement for good artists. That the very roughness of these signs could serve as an impulse to develop one's own artistic style, however, has never been formulated in theory or in practice. This attitude changed at the beginning of the 20th century. The Italian futurist Giacomo Balla creates numerous preliminary studies for his work "Fallimento". Those pencil sketches convey a lively impression of the painter's intense struggle to convey the immediacy of the graffiti lines in the finished painting. George Grosz writes in his diary how he studies graffiti in toilets in order to achieve his "razor-sharp drawing style".

The way was thus paved for the kind of viewpoint that George Brassai expresses in 1933 in his groundbreaking essay "From the Cave Wall to the Factory Wall" in "Minotaure", the mouthpiece of the Paris Surrealists. He established truth, physical necessity and strict discipline as the leitmotifs of graffiti: "Its law is binding, it turns all those painstakingly established esthetic systems upside down. Beauty is not the object

GRANDVILLE (Jean Ignace Isidore Gérard, 1803–1841)
General appeal to post announcements on the walls of France and abroad (Badigeono-graphie générale des murailles de la France et de l'étranger) Frontispiece, "Scènes de la vie privée et publique des animaux", Paris 1842

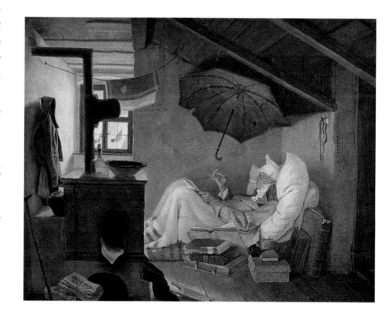

Carl Spitzweg (1808–1885)
The Poor Poet
1839, oil on canvas,
36 × 45 cm
Neue Pinakothek, Munich

Realism in representation
and perspective: The
lowered gaze discovers
the bailiff's seal on the
bankrupt's entrance door,
which evidently has been
locked for some time and
served as drawing board
for children. Balla had
made several preliminary
studies of these juvenile
scribblings.

Giacomo Balla (1871–1958)
Bankrupt (Fallimento)
1902, oil on canvas,
116 × 160 cm
Museum Ludwig, Cologne

of creation; it is the reward." At least in this respect, he introduced the signs on the wall as the ideal and the touchstone of the contemporary art of his time. Brassai emphasized this claim through the presentation of a selection of graffiti he had photographed in Paris. Years later, in 1959, he revisited this subject again for a book publication. On the last page, he showed a mural by Picasso. He interviewed the master on this subject and elicited his admission that he himself drew on public walls on occasion – and that sometimes, the wall in question was subsequently dismantled and put in a museum.

Jean Dubuffet
Mur aux inscriptions
1945
Oil on canvas, 99.7 × 81 cm
Museum of Modern Art,
New York

A complex painterly interpretation of Brassai's thoughts, however, can be more easily encountered among the followers of Art brut. There are photographs that show Gaston Chaissac and the artists of the Cobra group drawing on walls. In his paintings "Fumeur au mur" or the graphics series "Les murs", Jean Dubuffet unites the level of the observer with that of the creator. A chalk line runs along the wall behind the smoker as well as over his body: Dubuffet's graffiti is simultaneously a representation of what he saw and the subject matter of a painting; it is esthetics as well as reflection. Here, finally, the theory of the signs on the wall has caught up with the point where they stand today.

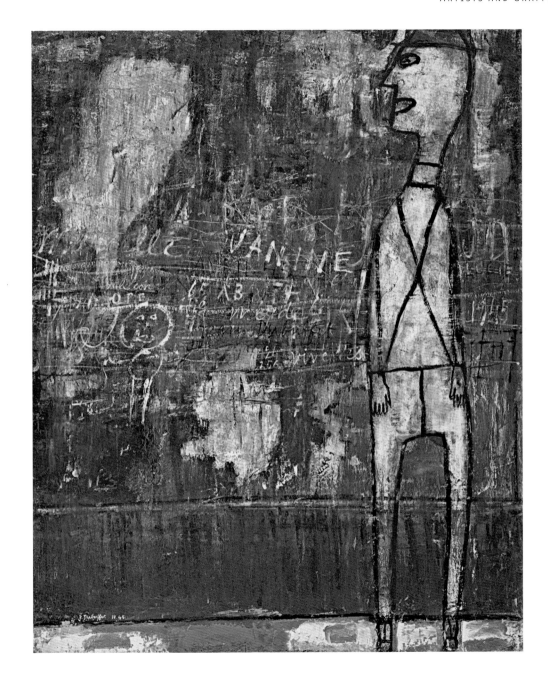

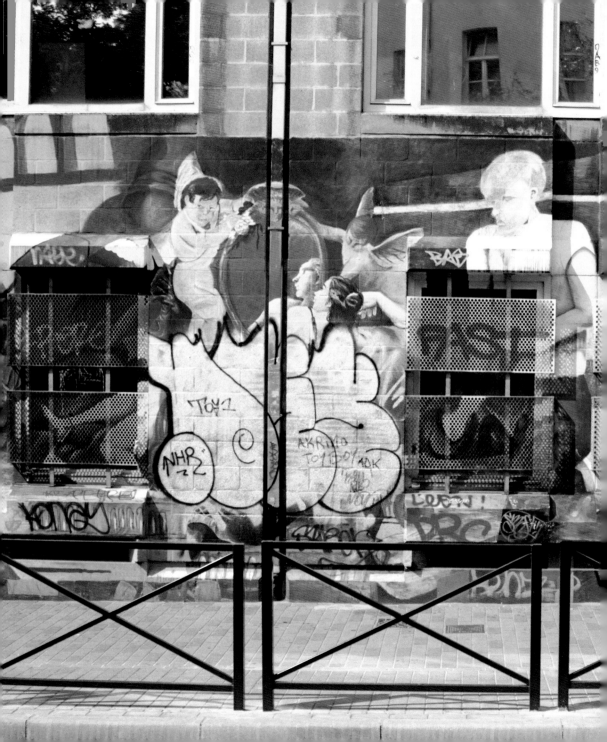

This multimedia arrangement consisting of tags, stencils and throw-ups on the walls of an art school draws its inspiration from baroque art, Andy Warhol and mangas – but nowadays, the bizarre blend of official and unofficial art blend is a common sight on city walls.

Façade of the art school
Institut Sainte Marie
Photographed in 2008
Brussels, city centre

Why Art History has such Trouble with the Phenomenon

Dan Perjovschi
I Am Not Exotic –
I Am Exhausted
Marker pen (detail)
2007
Back wall of Kunsthalle, Basel

It is hardly surprising that art history has a hard time dealing with graffiti or with the recalcitrant actions and productions of street art. After all, it is based on a conceptual dilemma itself: If you want to write the history of art, you have got to have a pretty good idea of what art really is. In view of the constant succession of movements running counter the respective trend, this has been a recurrent problem. An ancient phenomenon such as graffiti, which is located at the margins of fine art and which is an object of interest for a good many other sciences, only serves to raise many more questions.

Historiography

Whilst art history likes to count time in epochs, the ancient phenomenon of street art has straddled the epochs. It looks back on a history all of its own, an unfolding which has been characterized by small changes as well as by great personal fluctuations. If historical overviews or even schoolbooks list graffiti as an epoch occurring around 1980, they exclude some important points from this spectrum. Any attempt at definitions like "post-graffiti" for the work of writers who have made it to art galleries illustrates this problem: Those writers have neither taken leave of the idea of urban graffiti nor do their pieces demonstrate a fundamental departure from the "wild" street art in the city. Moreover, several writers had never accepted the epithet "graffiti" for their work in the

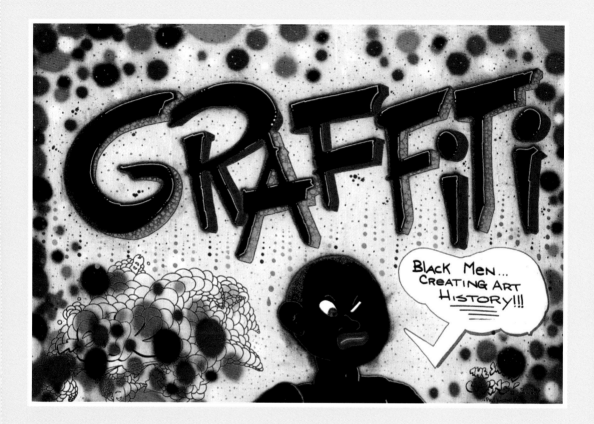

first place but had their own labels for their activities – and those new labeling attempts hardly served to please them any better.

Methodology

Since graffiti have been defined as unofficial signs, they are imbued with the odium of the forbidden. Trespassing of property boundaries remains a problem in the graffiti discussion, even though fine art has often seen itself as transcending boundaries of all kinds. Any work in the context of art history is saddled with a central conflict: the creators of graffiti do not care for other people's property; the viewers, however, usually do. Any attempt to come to grips with the phenomenon has to take into account the fact

Quik
Black men creating Art History
Spray paint and marker pen on canvas, 180 × 125 cm
1989
Private collection

Where does art end and where do graffiti begin? In 2007, the Romanian artist Dan Perjovschi was offered the back wall of the Basel Kunsthalle as a canvas for his laconic drawings. The versatile artist's ironic and incisive comments on this elusive subject are well worth seeing.

that the viewpoints and evaluations of creators and consumers can be very different.

To treat this problem exclusively on a formal or esthetic basis is quite normal with regard to other art forms since they usually occur within a relatively closed system of universally accepted conventions. For a historical analysis of street art, however, this is hardly applicable. If you exclude the aspect of illegality from its reception, you can be rightly accused of ignoring an important social boundary and of entertaining a very one-sided point of view. Any analysis which takes this fact into account is therefore bound to look for traditions of boundary- or taboo violations.

Who makes Street Art?

First of all, the makers of street art usually remain anonymous. Nobody can say with certainty what their practical background is or how knowledgeable they are with regard to established art. It is virtually impossible to question these phantoms. It is left to the historians to decide on the relevance of a certain piece for their account of art history. This is not only a difficult starting position for the creation of a general overview but also for the individual work of art, for even if a work is considered as such, there is no artist. Groups or even openly participative processes can hardly be subsumed as creative individuals. A sociological evaluation would look for social dispositions or affiliations. For these reasons, you will rarely find in the verbal statements of street artists political or artistic messages over and above the call for the right to participate in the creation of public space, let alone profound analyses of the reasons behind their art. Apart from the clear rejection of the established art scene, there are few attempts at the formation of theories. If you do not make a conscious effort to insert yourself verbally into the context of a system like art history, you can hardly trust that this will happen by itself.

Many are too Many

Another problem are the sheer numbers of the street artists. While art academies constitute

a definite hurdle for future generations of artists, there is open access to street art. The sheer abundance of street art pieces makes the phenomenon so difficult to handle for the art market or art criticism: Professional mediators, the bouncers of art history, can scarcely handle the onslaught of production. This constriction is a serious impediment to a long-term engagement with individual street artists. Even the scene's own momentum hardly conforms to the established filtering rules of the art scene. To this day, important names of the graffiti scene of the 1970s and 1980s appear as team members rather than individual artists in the portals of this art. Even within street art itself, this multitude is accountable for the high fluctuation of names on the way to fame. The generations follow each other in relatively short order, and many a protagonist of the young school is no longer familiar with important works of five ears ago: you become "old school" awfully fast. On top of that, this short-lived way of looking at things is reinforced by the very character of street art. Here, any point of view aimed at a long-term analysis of art history, and which takes all factors into account, can find itself in more than one dilemma.

Dan Perjovschi
I Am Not Exotic –
I Am Exhausted
Marker pen (detail)
2007
Back wall of Kunsthalle, Basel

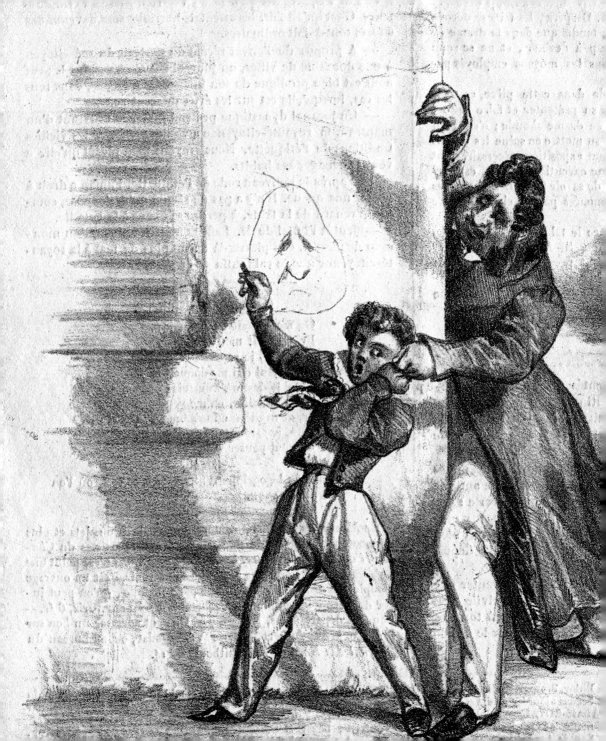

The Politics of Street Art

Since he was king, his figure really had filled out even more. The sideburns did not help, either: It was really more than obvious for those cheeky caricaturists to come up with the idea of the pear. By now, the whole thing had been blown up into a veritable press campaign. Censorship could do only so much to help: How could you forbid the picture of a pear? Apparently, even the last street urchin was now capable of drawing such a pear on the wall. Louis was the only one who had not tried, and with good reason. After all, he was the prince, and the target of the pear drawings was no lesser person than his father, Louis-Philippe, since 1830 King of the French. But it seemed so easy. But what if he tried it just once? After all, the sons of kings have to be especially brave.

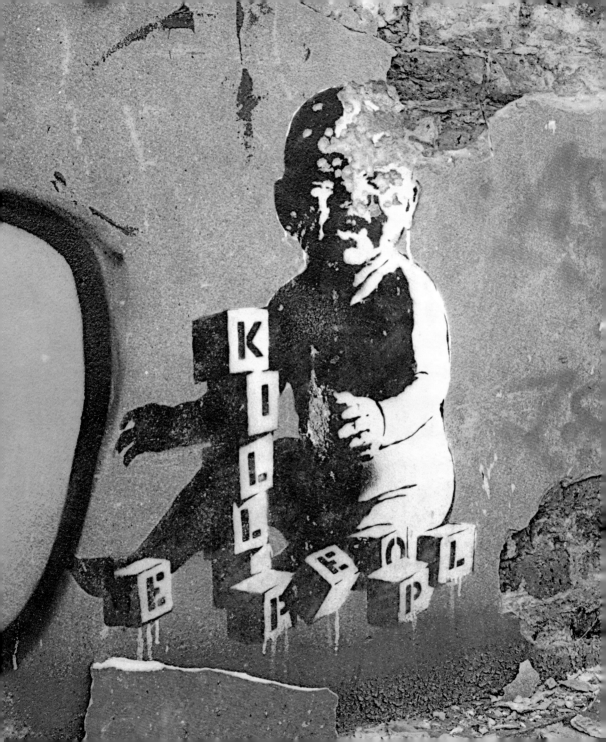

Political Ramifications of Wall Images and Signs

There are at least two obvious reasons for the fact that, time and again, street art is regarded as linked to politics. Firstly, it happens in places that are accessible to all. And secondly, it employs a means of expression that is not controlled by the government. Whatever the subject matter of street art, these two facts at least clash with a view of public culture that does not take this form of expression into account. More restrictive laws plus the consensus of certain circles that street art is nothing but "messing around with colors" and the frequent filing of charges against the perpetrators bear witness to the view that this endangers the status quo and that, consequently, unofficial messages on public walls must be suppressed. This reaction does not even take into account initially whether street art merely exists or whether, and how, it expresses a specific opinion.

On the other hand, graffiti as a means of political expression have a longstanding tradition. They are one of the preferred vehicles of extra-

Banksy
Kill People
Ca. 2005
Hackney Wick, London

Saturn as a clown
Ca. 2006
Hackney Wick, London

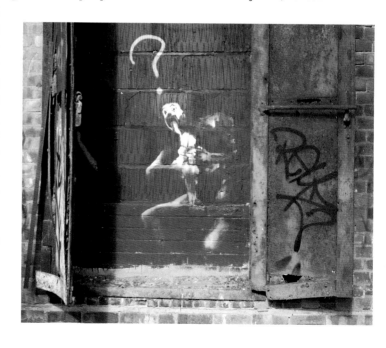

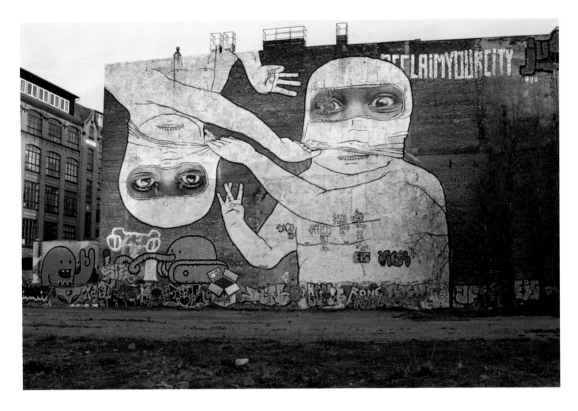

Blu, JR and Reclaim Your City
2007
Berlin-Kreuzberg

parliamentary political comments: graffiti provide a means of expression, a means to be heard immediately, without authorization, without the need for clear definition or a pre-formed consensus.

This scenario serves as the platform for a fundamental discussion of the political function of street art. In its attempt to establish an independent medium, individual expression seeks out the gaps that economic interests and, not least, the authorities have left and where it has a chance to be perceived. But this is also a reason for the strong public reaction, because a more or less unbroken line of officially sanctioned expression can be seen running all the way through censored

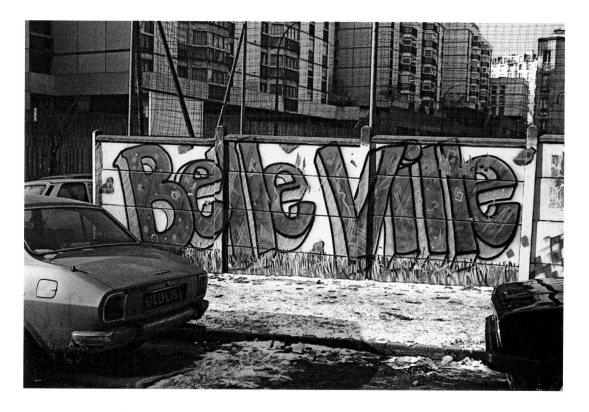

newspapers and magazines, state controlled radio stations and the newly resurrected Chinese Wall of the internet. Of course, this results in frequent actions of street art that tackle the issue of this kind of control. Whether as a reference to George Orwell's nightmare scenario of "1984" or as an ironic statement like Banksy's question "What are you looking at?" to a surveillance camera every time it swings round: the question as to who is allowed to create and who to control public space is all-pervasive. More often than not, this is the central question the action revolves around.

Apart from these basic dispositions, graffiti have a long tradition as a direct tool of public discussion.

BelleVille
1985
Paris-Belleville

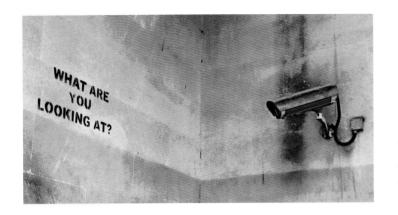

Banksy
What are you looking at?
Stencil
c. 2005
London

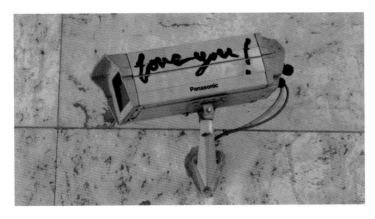

Love you
Marker pen
2008
Osnabrück

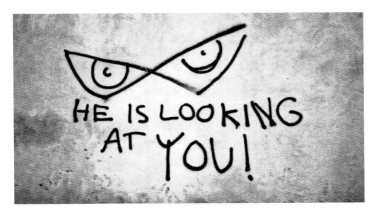

He is looking at you
1984
Bonn

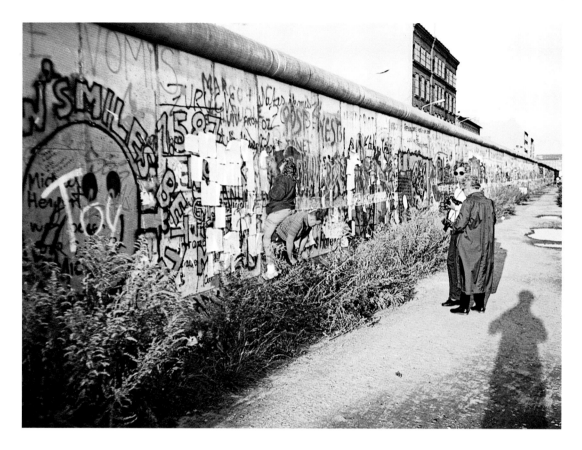

Even in Roman times, election campaigns or cultural conflicts were the subject of fierce debate on public walls. In the days before paper was available in abundant supply, however, such public expressions do not seem to have been punished quite as severely as today. More or less mysteriously, more or less publicly, wall inscriptions have at all times contributed to the formation of public opinion or at least served to stir up public debate. Such signs can undergo quite opposite progressions: The Christian Cross or the fish symbol evolved from a secret sign into an official symbol,

Tourists write illegal graffiti on foreign territory
1988
Berlin, Wall

Why does someone write **STYLE**, the keyword of the graffiti writers, on the Berlin Wall? Maybe because this concrete Moloch was not only a political and historical phenomenon but also a stylistic monstrosity.

Style
c. 1986
Berlin, Wall

whereas the official Motto of the House of Habsburg, "AEIOU" (Austria erit in orbe ultima"), became the secret slogan of the Austrian resistance during the Third Reich. Nowadays, those types of graffiti have become historic monuments, protected by a state whose very existence is founded to a considerable extent on this tradition of resistance.

Léon Gérome (1824–1904)
The death of Marshall Ney
1868
Oil on canvas
Sheffield Galleries and Museum
Trust

Public Space

Street art does not take place in the public space by coincidence. It is an uncalled-for act that oversteps the boundaries of the public code of behavior and, by doing so, always calls it into question. This makes the creation of street art a political act. Also, street art is often

a conscious reaction to the appearance of the public space or the changes that are taking place in it. Here, several growth- and aggregation processes are under way: Massive architecture is the result of massive investment and does not necessarily go hand in hand with improved quality. More and more road construction (complete with the inevitable noise barriers) eliminates more and more green spaces and leads to more and more paved surfaces and fewer and fewer panoramas. This goes hand in hand with a virtual explosion of advertising space and an ever tighter net of public surveillance. Most of these changes are sanctioned by the concept of property and are therefore considered tolerable or at least negotiable.

Detail: Pro-Imperial graffiti
"Vivel' Empereur"
Defaced by saber strokes,
Bullet holes

The Artists and the Politics on the Wall

Professional artists have always taken careful note of the political value of graffiti and utilized it for their own ends. Almost every illustrator of the satirical magazines "La Caricature" and "Le Charivari", for example, used the character of the Paris street urchin to stir up sentiments against Louis-Philippe, King of the French. The caricature of the king himself as a pear became the centre of a veritable campaign. Many a lithography in the daily newspapers showed a street rat drawing the pear-shaped visage on the walls with a deft hand.

The realistic painting by the Frenchman Jean-Léon Gérôme serves as an indictment of the execution of the French Marshall Ney. While the firing squad is marching off, leaving the corpse and the scene in inscrutable silence, some graffiti on the wall spin the tale further. The inscription "Vive l'Empereur" can be seen, hacked to pieces by sabers, and right, next to the bullet holes, again the word "Vive". These inscriptions tell the story

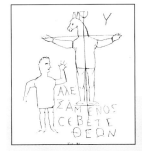

Schandbilder (Defaming Pictures)

An uncensored medium provides possibilities that are denied public imagery. Scathing polemics, exaggerated caricatures and, sometimes, conscious fallacies do occur in daily politics, but on the walls, they tend to be expressed far more strongly. The wall is also a battleground of intercultural conflicts. A famous Early Christian "Schandbild" shows a crucified donkey, accompanied by the text "Alexamenos is praying to his God". Since the 19th century, this image has been repeatedly copied and published and subsequently even reinterpreted: originally meant as a defaming picture, it is now used as proof that Christianity has persevered against all odds. Other "Schandbilder" have a more complicated history: The rat, which during the Third Reich had been a derogatory symbol of the Jews, was turned by artists like Blek le Rat – at least within the art world – into a positive emblem. When the British street artist Bansky spray-painted his signature rat on the wall that separated Israel from Palestine in 2007, it led to the escalation of a domestic conflict in Palestine, as the Hamas recognized the image as their own defamatory symbol of the Fatah.

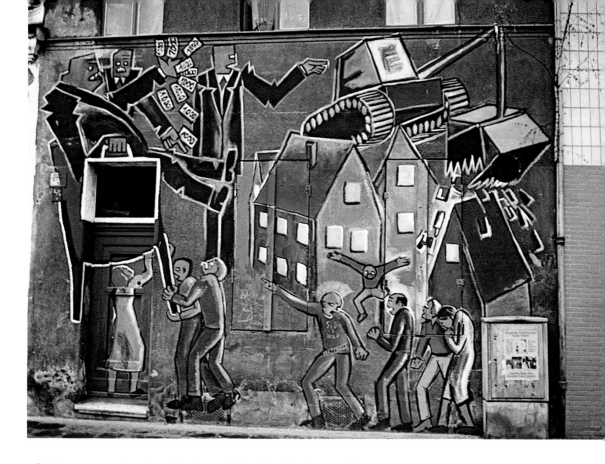

of the general who had switched allegiance from Napoleon to the Royalists and, at the same time, bear timeless witness to political strife.

Heinrich Zille often integrated political campaign slogans into his drawings. Always one to take careful note of the signs on the walls, he openly took sides with the social democrats in his work.

In the 1980s, Esther and Jochen Gerz initiated a participative process with their "Hamburg Cenotaph against Fascism", which was also defined by a definite and limited time frame. For a period of nearly ten years, a ten-meter-high sheet-metal pillar stood in the city of Hamburg-Harburg. It was freely accessible and

Speculation, Eviction, Demolition
Photographed in 1984
Squatter graffiti
Cologne/ Ehrenfeld

"WELCOME TO REALIT"

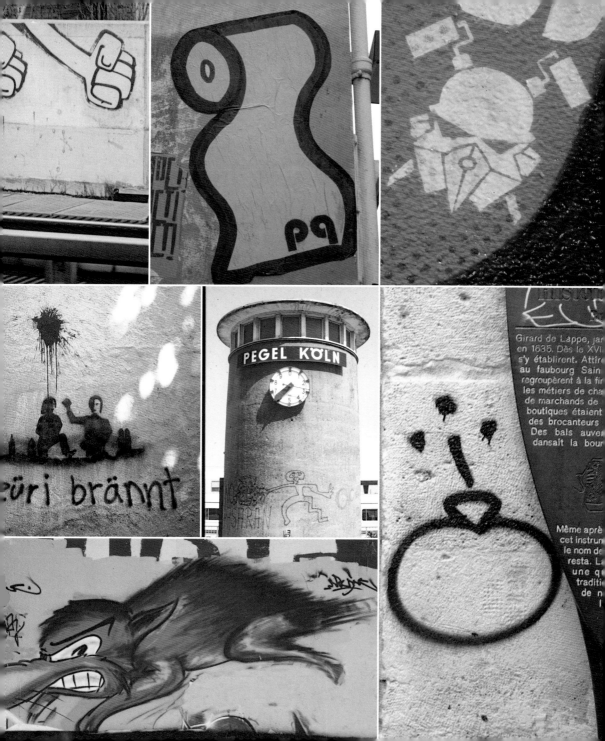

anybody could write on it. Ever year, the pillar was buried one meter deeper into the ground, after locals and visitors had covered the soft surface with their inscriptions and graffiti. The artist couple's strategy aimed at an ongoing process which they launched publicly and then observed closely for its entire duration. Since everything was possible, the final result did not display the clear-cut political tendency that, for instance, the collection of signatures for an anti-fascist campaign would have shown, but rather a broad selection of statements of all kinds. It was, however, interesting to note how many entries had been subsequently crossed out. The cenotaph functioned like a seismograph for the subject, showing the nature of the ongoing discussion but also the ever-present tug-of-war between democratic and anti-democratic tendencies.

The Berlin Wall was the epitome of a political message board. Erected during the Cold War in order to prevent defections from the GDR, it developed into one of the most potent political symbols ever. Although it stood on East-German territory, its western side was largely left alone by the border patrol. For the same reason, West-German police saw little reason to prevent graffiti.

Jef Aerosol
Stencil 2005
Photographed in 2008
London, Shoreditch

There were messages of virtually every kind but also many creations that brought home the surreal nature of the situation. A recurrent theme was the specific importance of the Wall for the divided country. There were statements like "The German Question is open as long as the Brandenburg Gate is shut"; the sarcasm of the slogan "Modell Deutschland" was evident, as it served as a backdrop for a heap of garbage and rubble. Numerous established artists also treated this politically explosive subject with irony. In a letter to the leaders of the GDR in 1964, Joseph Beuys suggested "raising the wall by 5 centimeters (better proportions!)". Graffiti writers left the keyword "style" on the Wall, thus putting the entire situation into question.

Jef Aerosol
Cutout since 2005
Photographed in 2008
London, Shoreditch

The Sardinian village of Orgosolo has achieved a degree of fame for its murals. For decades, the village's facades have born witness to the ongoing political discussion and the proud villagers have taken good care to maintain their right to free political self-expression. Caricatures reflect the politics of the day and appear right next to political propaganda and more traditional political murals.

Lately, street art-actions have tended to turn away from global

questions. Political slogans – and mass demonstrations – as political tools seem to have gone out of fashion. In the face of massive public surveillance, the immediate concerns of the scene seem to take pride of place in recent street art. Furthermore, street art festivals now serve as a kind of refuge, temporarily creating an atmosphere of tolerance in a specific part of town. In Berlin, for example, illegal graffiti are severely punished, but at the same time it is the official venue for many street art festivals. Here and elsewhere, the time windows for action are getting smaller and smaller due to public surveillance. Therefore, the situation calls for more economic solutions: the protagonists of "politics from below" have taken to leaving stickers and tags virtually everywhere and in sheer uncontrollable numbers.

The Destruction of Images and the War of the Symbols

Graffiti have a communicative function that transcends mere propaganda. The walls bear witness to the current political situation. All political tendencies are represented and their slogans are accordingly controversial. As in the advertising industry, different criteria come into play. First of all, there is always the question of who manages to make the strongest impact by virtue of sheer volume. The most original locations or the most penetrating statements are equally important. A mere statement of intent is no longer enough: nowadays, there is a veritable culture of stealing symbols or turning them upside down. A swastika or the symbol of hammer and sickle is turned into a wheel; target audiences and victims are switched. This war of the symbols has been taken also to artistic endeavors. The classic Banana symbol of the Cologne "Banana sprayer" Thomas Baumgärtel – pictured here – is meeting with stern disapproval among unsympathetic colleagues.

Purposeful and poetical campaigns, such as the inscription of a wall with graffiti cleaning tools by the Parisian artist ZEVS in Wuppertal, are turning statements and political tools for the destruction of wall art upside down. The artist writes "reverse graffiti" statements like "I must not pollute the walls of my city" on a dirty wall with the help of a high-pressure cleaner. Shortly

after and quite independently, in a publicly launched performance, the Iranian artist Babak Saed covered a wall in the same city with the repetitive statement "I must not deface other people's walls" in neat lettering.

Crossings: the X on pieces
2008
Paris, Train station Musée d'Orsay

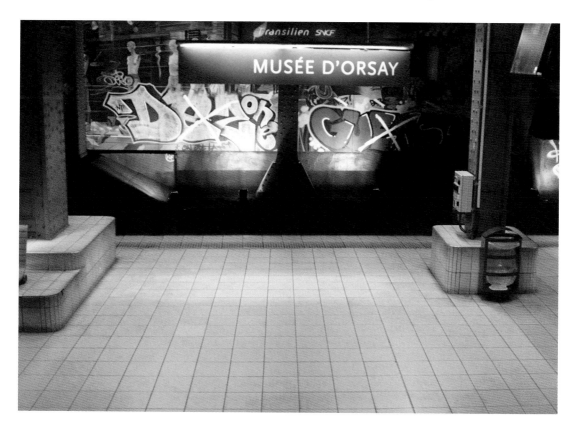

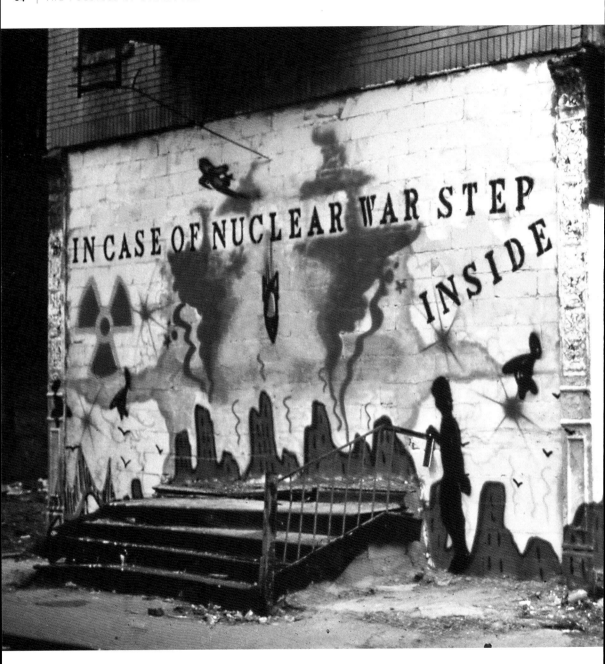

In case of nuclear war step inside: Sarcastically, the bricked-up front of a ruin in the Bronx beckons the viewer to enter a non-existent nuclear shelter through a non-existent door.

Crash/John Fekner
Mural
1981
New York City, South Bronx

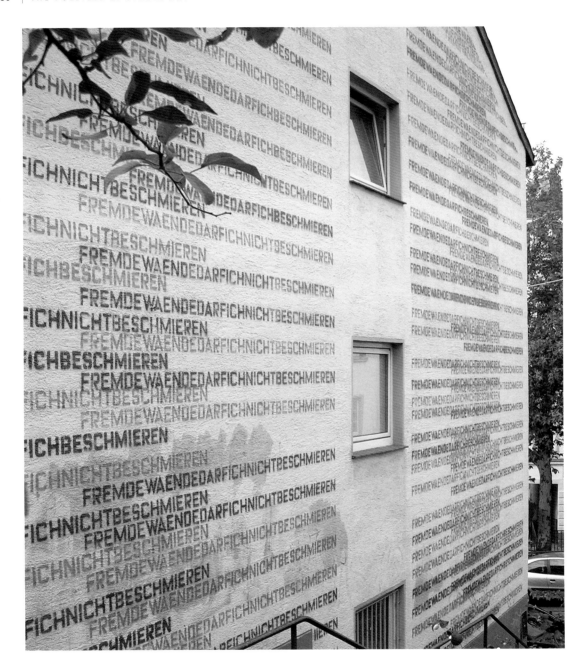

Babak Saed
FREMDEWÄNDEDARFICH
NICHTBESCHMIEREN
(I must not deface other
people's walls)
Stencil
2007
Wuppertal

Political murals
Photographed in 2002
Orgosolo, Sardinia

Not Everything that can be interpreted as Political was intended to be Political

Contemporary Poster
Paris Student Revolts
Woodcut
1968

Bertolt Brecht was adamant in his assessment that all artistic expression is political. If we accept his logic, it then follows that not only does every uncalled-for unleashing of private thoughts on a public wall constitute a political act, but so does the exhibition of even the most conventional work of art in a gallery. Furthermore, we must also consider the negation of politics – especially on public walls – as a political statement. When a Berlin street artist calls himself "Linda's Ex", making the split-up a central theme in his artwork, the name and the message eloquently convey a private story. Because it was brought to public attention, however, this scenario has become strangely similar to the inter-personal dramas played out on public television. Since these reality- or casting shows and soap operas constitute a virtual public brought to us by the media, the heartbreak story publicly staged by "Linda's Ex"

immediately raises a few questions. Does the private message work for a larger audience? Is this about the dividing line between the private and the political? Does the street artist's reference to his love life really point to the media as opinion-makers – or indeed, is his intention towards them satirical? This is by no means a new discussion. Philosophical heavy-weights poets, sociologists and politicians alike have warmed to this question. It goes without saying that those writers, depending on their provenance, point of view or objective have focused on different aspects of this discussion, and, sometimes, have excluded others.

In any discussion of the relationship between politics and street art, two basic points keep coming up. Firstly, there is the recurrent idea that graffiti are basically a seditious art form, because they violate the established concepts of ownership and publicly approved art.

Whether it be Jean Baudrillard's "Revolution of the signs", Theodore Roszak's "Counterculture" or "The Esthetics of Resistance" by Peter Weiss – especially during the turbulent 1960s and 1070s, uncalled-for private expression on public walls and on the streets was seen as a potential and as welcome proof for upcoming social revolts or even revolutions. But in reality, there was a good deal of disagreement over the details of these political changes. In more recent discussions, for example of the politics of consumerism, globalization or environmentalism, there is a notable recurrence of this view of graffiti as propellant of social change.

Secondly, and time and again, those same commentators see graffiti as an indicator for the political mood of "the people". There is indeed abundant evidence for such an attitude, and sociological censuses allow an assessment of the force of certain political tendencies. This points to a tacit agreement that this activity is a human constant which can always be reckoned with since it has been present at all times in history. There is a broad range of interpretations of the phenomenon. At one end of the spectrum, there is the quasi-pathological "graffitomania" that Louis Reau stipulated in his "Histoire du Vandalisme" of 1948; at the other, a reaction to the "inhospitality of the modern city", which Alexander Mitscherlich had diagnosed in the early 1960s. Consequently, this leads the authors of the 1960s to demand the assignation of walls for public discussion in answer

Critical voices in Hungary
1987
Budapest, Deak Ter

Bandaid
2006
Köln-Mülheim

to the inalienable right to free expression. This form of political participation has since proven to be a valuable tool for Youth Centers and Unions. It engenders the exchange of

mestication of a basic idea in a limited and, in the final analysis, controllable framework.

In the public space, it has rarely ever come to this form of freedom of political expression. The communally accepted "Hall of Fame", however, provides the writers with a space where free expression is possible or even desirable. But here, certain rules apply, and it is therefore developing into a kind of public gallery rather than a forum for political discussion.

Quoting the movie
"The Big Lebovsky"
Stencil
Ca. 2005
Berlin, East Side Gallery

opinions and information, functioning like a wall-mounted guestbook and contributing to the formation of political awareness. At the same time, such an institution is nothing more than the pragmatic do-

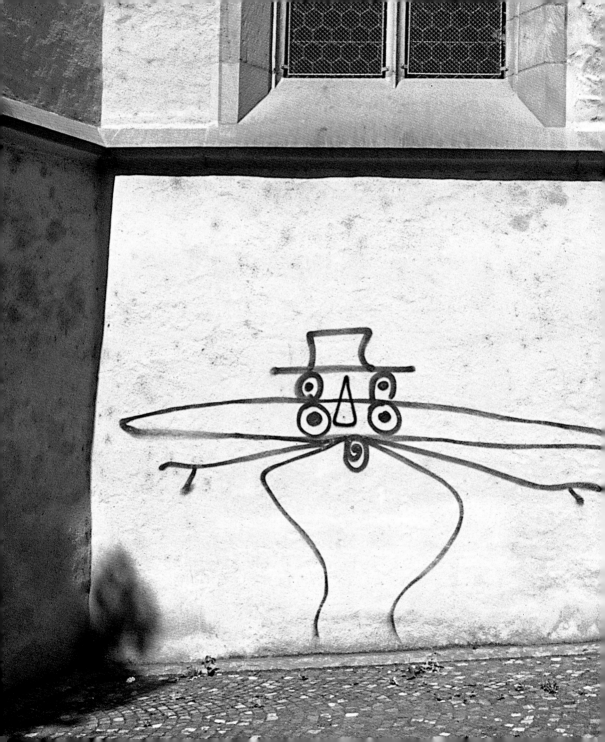

Street Art
in Old Europe

1979, and trouble was brewing in Zürich. The youngsters had been demanding an autonomous youth centre for quite some time. The adults said that they should just go to the pubs like the rest of the world and hold their meetings there! In the evening, they set off, with spray cans. Everywhere, the walls should read: AJZ (youth centre) now! Some even had templates. Then, you could read "Züri brännt" (Zurich is burning) in two colors and see a corresponding image.

On the Züriberg, they saw him. They had always thought that he was a student who had been on the run from the Zurich police for a long time. But somehow, the gangly man now seemed a good deal older, after all. They could not see him properly. But the stickman that he left on the wall, that spoke clearly and unmistakeably of the "Sprayer of Zürich". They liked the drawings and so they did not write anything next to them. Perhaps that would have been too dangerous anyway, twice in a row on the same spot. Maybe someone was watching, after all, and would call the police.

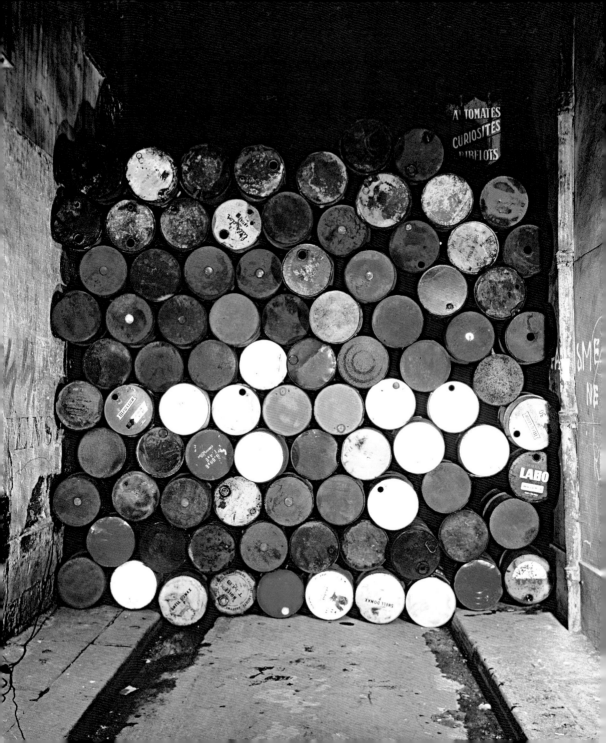

Lines on the Walls, Streets as Places of Action

"**N**o other place than the street" was Gérard Zloty-kamien's unequivocal answer when asked about the venues for his most important exhibitions. He is a veteran of the scene, having not only witnessed the many controversies surrounding street art in Europe since the 1960s but also participated with his own actions: Christo's street blockade; the public actions of the Nouveaux Réalistes around Yves Klein, Niki de Saint Phalle and Jean Tinguely; the besieged universities (including their facades) in the legendary year of 1968; the punk movement; the squatter's scene. Each of these movements had put, of course, their own signs on the walls, just like subsequent generations of artists who took their cues from the happenings in the streets. Apart from Zlotykamien, many artists have posed similar questions, and cer-tainly not just in Europe. But here, especially in the hubs like Paris, London and Berlin, the various approaches, traditions, controversies, novelties and fashions of street art can be observed particu-larly well. Nonetheless, a coherent development in the sense of a well-docu-

Christo and Jeanne-Claude
The Iron Curtain – Wall made of Oil Drums
1961–62, Blockade of Rue Visconti
Paris

Gérard Zlotykamien
Éphemere
Spray painting
Since 1961, photographed in 1985, Paris

The machinery hall of the Stollwerck Chocolate factory in Cologne, which had been occupied by squatters in 1980, had been transformed into a colorful function room. Before the building was finally demolished, the committee for the protection of historical monuments officially documented the walls covered in graffiti.

Marcus Krips et al.
Stollwerck Machinery Hall
Taken by squatters
Photographed in 1984
Cologne

mented history cannot really be expected: The experimental character of street art makes it unsuitable as a subject matter for cultural chroniclers, who by their very nature prefer areas like fine art in the galleries, social and political life and other aspects of Zeitgeist and lifestyle more easily accessible through the media as a subject matter of their analyses.

Since a sprayer is almost invariably pressed for time, he necessarily resorts to sketching as a means of expression. Unlike a complete coverage of the area with paint, the drawn line leaves part of the background visible. Whether smooth or rough, colorful or flat, its texture is always an intrinsic component of the drawing on the wall. A wall never simply separates the inside from the outside but always carries messages above and beyond this function. This was one of the reasons for Friedensreich Hundertwasser's demand for a "window right" for tenants: "The apartment-house tenant must have the freedom to lean out of his window and as far as his arms can reach (…) to paint everything pink, so that from far away, from the street, everyone can see: there lives a man who distinguishes himself from his neighbors who are living like pent-up cattle!"

This is also the philosophy of the squatters. The façades of their houses show very clearly who lives there, how they see the world and what they think. "Face and façade" have the same root; it is not by accident that the squatters show their faces at exactly the same spot where normally a bourgeois sense of style and, last not least, a certain social norm have their traditional place and, literally, "keep up the façade". The walls of squatters' houses in Amsterdam, Berlin, Cologne or Copenhagen developed very different imagery for this mixture of self-portrayal and protest.

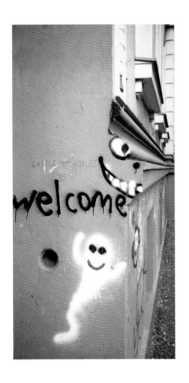

Squatter's sign
1983
Berlin-Kreuzberg

The graffiti, quickly made and frequently altered, told the story of the squatters' bohemian lifestyle and their spontaneous nature did to some degree justify the assumption that this was the work of mavericks. There were also many messages of a clearly political nature: Their authors were obviously left-wing and considered empty houses as a social injustice – an assessment that was shared by a great many citizens, certainly from a moral point of view.

The Sprayer

The work of Harald Naegeli, the "Sprayer of Zurich", was shaped first and foremost by the environment in which he operated. His virtuoso sketches derived their meaning from the surfaces on which they were drawn. He called smooth concrete "a cold forehead", on which the lines of his drawings created a frown. Sometimes, however, these lines were not frowns but laugh lines – much of his work certainly does convey a kind of impish pizzaz. Other drawings highlight the countless and often overlooked details on these walls: Signs,

Squatters' house in the Hafenstrasse
1985
Hamburg-St. Pauli

taps, cracks and corners. With a few sparse lines, Naegeli turns these aggregations into creatures that almost seem to be alive. A contributing factor is of course the rich bed of images from which Naegeli the psychologist draws his ideas. Voluptuous females or phallic fish represent the subconscious breaking through into public view. Spider-like creatures, cryptic signs and beings equipped with antennae allude to the

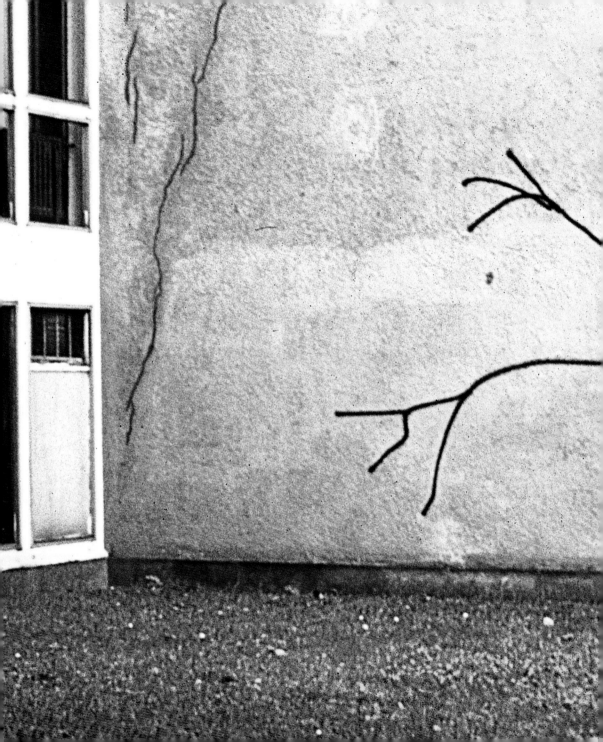

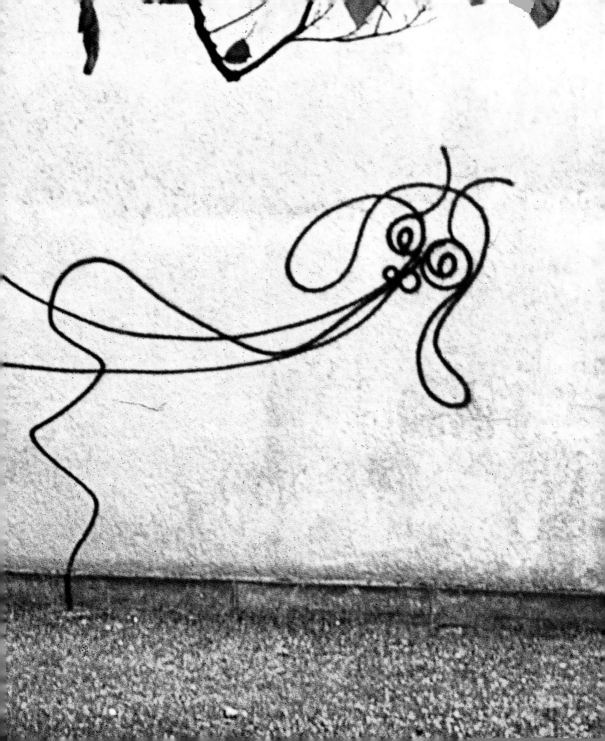

Previous double spread:
Harald Naegeli
Undine
1983
Zurich

Blek le Rat uses his famous Tom Waits stencil 1989 for the last time – this time, however, on walls that the city of Wiesbaden had offered him for the purpose.

Blek le Rat
Tribute to Tom Waits
1989
Stencil 1983
Wiesbaden

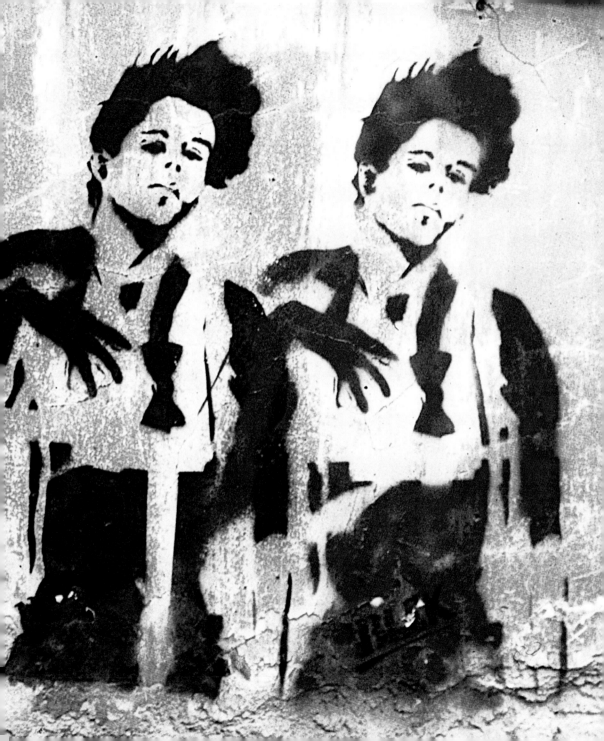

Blek le Rat
Screaming Man
Stencil
1985
Paris

Jonathan Borowski
Running Man
Painting
1983
Berlin, Wall

fact that their creation must have taken place under pressure of time. A cloverleaf or a hat point to heroes of the art world like Paul Klee or Joseph Beuys, both of whom Naegeli greatly admired and often made reference to in his own work. Since the Sprayer managed to stay anonymous for a very long time, he was able to spin a veritable network of his drawings over the city of Zurich, that stronghold of Swiss banking so famous for its cleanliness. But even though he was persecuted by the authorities, there were indications of a certain identification with the phantom Sprayer even outside of the art world: Even official travel guides started showing photographs of his mysterious graffiti creatures.

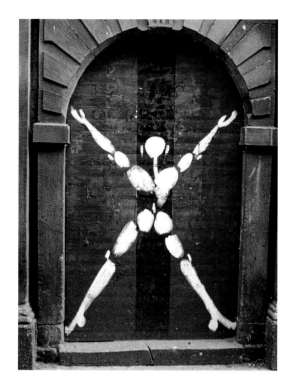

After Naegeli had become famous as the "Sprayer of Zurich", the wall art of other artists better known for their gallery work came into sharper focus. Miriam Cahn, Walter Dahn, Jiri Dokoupil and A. R. Penck left their traces on public walls in the 1980s, and with a little luck, the traces of some of their pieces can still be discovered. Not every one of these artists set such stock by this kind of work that they saw fit to document it through photographs, much less to assemble it into publications like Harald Naegeli or Keith Haring. In view of the legions of anonymous artists who are actively at work in the public space, this is not even surprising.

Gerôme Mesnager
1986
Amsterdam

Richard Hambleton followed by Katrin Kaluza
Shadow Man, Red Woman
1984
Cologne

Images of People

Quite similar pieces existed even before Harald Naegeli's graffiti. Gérard Zlotykamien's "Ephemères", however, were created from a different point of departure: The simple, amorphous outlines of these "Ephemera" remind the viewer of human shadows that Zlotykamien had seen on photographs of the aftermath of the Hiroshima and Nagasaki bombings. The artist placed his minimalist drawings in specially chosen, architecturally unassuming places, creating – quite aptly – a kind of global "danse macabre". But even if their raison d'être is ignored, those tumescent figures strike a rather elegant balance between simple, almost child-like drawings and a complex involvement with the architecture of the urban space.

For pedestrians, images of people have a fundamental importance, which is part and parcel of the human condition. More than any kind of writing, they are based on archetypical patterns of perception: I am here – and where are the others? Still, the artists' renderings come in very different shapes. The first street artist, Blek le Rat, uses large, artful stencils. His images betray a sharp eye for social realities. Whom do I meet in the street?

The free word

Ever since the hand of God left the ominous words "Mene, mene, tekel upharsin" on a wall in the famous Bible story, written messages on the wall have become a recurring theme. "Weighed and measured and found wanting": Even though the words themselves may have been visible on the wall only temporarily, their verdict was valid and presaged doom for the Babylonian king Belshazzar. Culturally and historically, this set a powerful precedent: Writing words of warning on the wall implied at least the possibility that the prophecy could come true. Sometimes, such relics of unclear provenance have been given more authority than official or authenticated documents. In view of these possibilities, it is not surprising that especially those groups of artists who were striving for fundamental social change left abundant messages on the wall. But they claimed this right to free expression on public walls not only by and for themselves but for everyone.

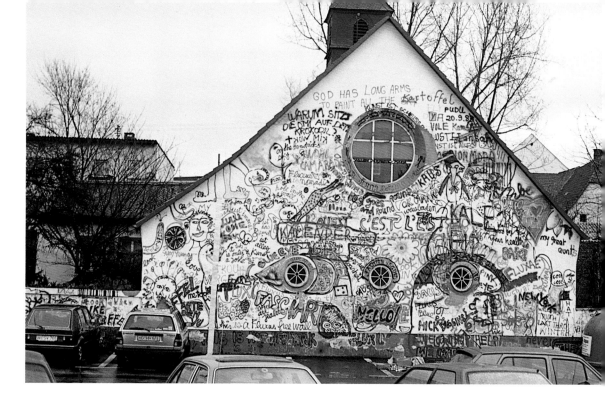

What are the characteristics of these persons, what is their social background? Blek comes up with some strange characters: The angry old man, the Indian lady, the crucified man, but also (sub)-cultural heroes like Tom Waits or Joseph Beuys, always manage to find their own very special place in the larger context of the city.

Even though Blek, like other street artists working without permission, had to deal with the usual plethora of hostility and legal charges, his figures were quickly accepted because their shapes and socio-political objective spoke for themselves. It also helped that the public had already been confronted with a similar strategy through the work of Ernest Pignon-Ernest, whose large posters served explicitly as inspiration for Blek. Pignon-Ernest, however, was using the medium that had been customary since the time of the student revolts — even

Various Fluxus artists
Fluxus Free Wall
Wall inscriptions
1982
Wiesbaden-Erbenheim

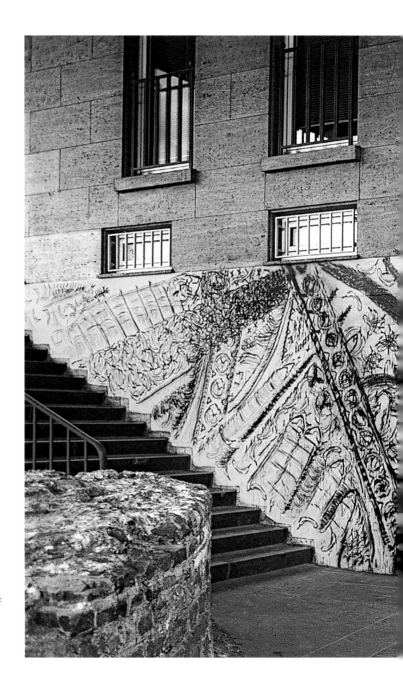

In the beginning, Thomas Baumgärtel only sprayed his signature banana on the walls of art galleries and other art venues. Meanwhile, his artwork is found almost all around the globe. Here, one of his paintings is located behind the ruins of the Roman city wall of Cologne.

Banana Sprayer
Mural, Foundation Kaufmannshof
Hanse
1996
Cologne

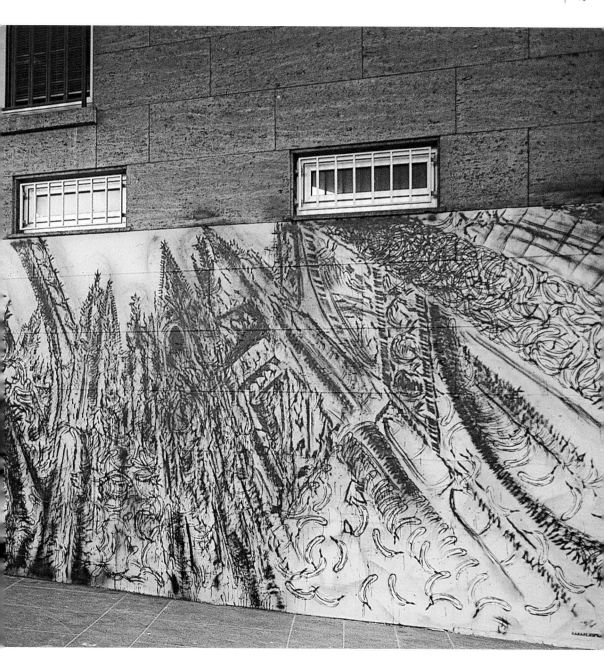

though it had been illegal in France since 1881 – while Blek departed from this type of presentation in more than one sense. His signature rat signifies, at least to himself as the originator, a clandestine, subversive artistic strategy, which sets Blek into opposition to the far more publicly present artist-revolutionary of 1968. Perhaps this change of strategy, linked to the formal conciseness and medial presence of his work, is the reason why Blek le Rat is nowadays considered as the father of modern street art.

Harmen de Hoop
Gratis!
Word art: Just by adding written notes, the artist manages to bring chaos to everyday situations.
1985, Rotterdam

In the 1980s, the New Yorker Richard Hambleton deployed his Shadow Men all over the globe. The menacing black shadow figures usually emerge from a hidden corner. They seem to be imbued with a kind of terrorist potential, which is a provocation not only for his fellow artists but also a welcome argument in favor of public supervision: The reason being not only the "negative" effect on the public but the mere fact that there seem to be times and places that allow the deployment of these figures into the public eye. Hambleton's figure-attacks were attentively received in the art world and there was a heated debate as to whether they should be understood as legitimate street art or as an elaborate attempt to attract attention. It is remarkable how often these

Shadow Men have been the object of modifications: Often, luminous eyes or mouths were added to give the figures a more human appeal. The Cologne artist Katrin Kaluza presented many of Hambleton's predominantly static figures with a zippy, dynamic and often rather taller female companion painted in bold red brushstrokes.

Gerôme Mesnagers dynamic figures are rather different to Hambleton's, even though there are formal similarities and, like the Shadow Men, they also seem to blend into their respective surroundings. Like Blek le Rat, Mesnager had been a student of fine art. His images evoke academic studies of the human body, or rather, of wooden manikins. The dancing and gesticulating figures inhabit a meticulously planned space on the wall and, through their antics, draw attention to their environment. The stencil-like figures are painted freehand and seem to take on a life and depth of their own. Their dancing or dramatic poses seem to imbue their environment with the breath of life.

Jean Tinguely (1925–1991)
No title
Non-commissioned mural, signed
1984
Cologne

The Freedom of Artistic Expression on the Wall

Time and again, Russian artists of the October Revolution, like the poet Vladimir Vladimirovich Mayakovsky, or the Situationist International proclaimed by the French artist Guy Debord after the cultural failure of the Russian revolution's artistic ideals, had demanded the

Storming the wall
1986
Milan

right to place drawings, poetry or political thought on public walls. This radical claim to the freedom of speech and its subsequent practice has led to an on-going discussion of the possibilities of free expression on the wall.

Since the 1970s, Ben Vautier, a member of the Fluxus group, has consigned countless messages concerning his state of mind, perceptive statements or artistic declarations to public walls. Whether the anarchistic actions of Al Hansen or the sententious statements of Joseph Beuys – the wall and, by implication, the public, has always been one of the platforms where artists realized the dream of a more open, more flexible and more accessible practice of art. The transience of such messages was not a problem, since the protagonists of this international art form understood art as a transient phenomenon in the first place. Many of the artists gathered in 1982 in the Fluxeum in Wiesbaden, a museum dedicated to the work of the Fluxus artists, to create a sort of anarchic collaboration. An old church facade served as the canvas for a type of manifesto on free speech, the "Free Fluxus Wall". It goes without saying that the inhabitants of the little suburb were not amused. Consistent with the discussion on the impermanence of art, Michael Berger, the owner of the Fluxeum, opened the wall to sprayers of all nations in 1989. Since then, the façade has been completely covered by

Intervention

Since the 1960s, the term "intervention", originating from the sphere of politics and warfare, has taken root in the art world as a much-discussed key concept. For many protagonists of the street art scene, uncalled-for "intervention" clearly defines the impulse as well as the structure of their art. They postulate that the machinery of "the public" functions either too well or too unconsciously and that it is the responsibility of the artist to perceive this and to intervene. Logically, these interventions will suggest and demonstrate alternative scenarios.

graffiti and, incidentally, the word "church" in capital letters has been allowed to resurface.

The political idea of free speech on public walls, as well as the practice of conceptual art, which had been established in the 1960s, have led artists to experiment with the combination of words and action. The New York artist John Fekner entered the discussion with his stenciled phrase "visual pollution" or, even more emphatically, with the word "decay" on the facades of vacant buildings, the result of housing speculation gone awry. The Berlin artist Christian Hasucha put out the word "Jetzt" (Now) as a challenge. In a brick wall built on the lawn of a Cologne suburb, certain bricks were omitted to spell out the word. The inhabitants soon destroyed the wall — maybe because of the startling emptiness of its message, which in this

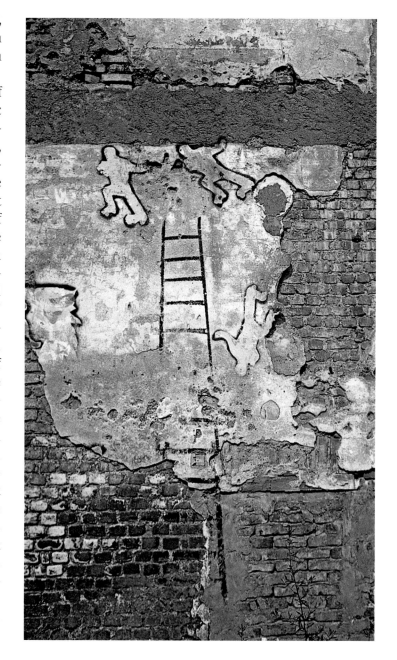

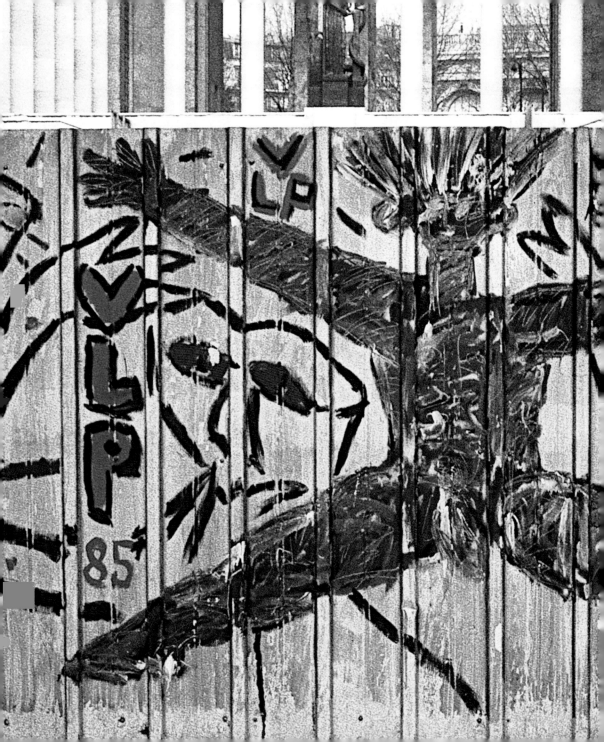

In 1987, the French Ministry of Culture began to officially encourage street art and street art happenings under the slogan "Vive la peinture".

Graffiti on hoarding in front of the Louvre
1985
Paris

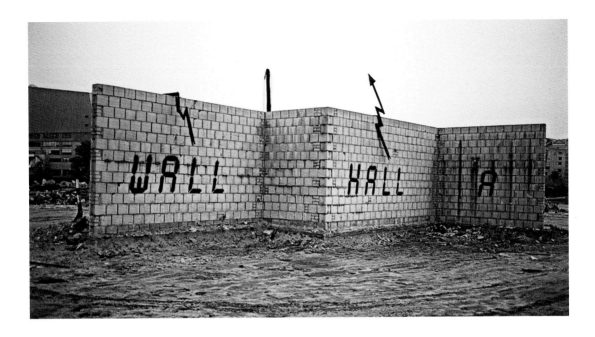

John Fekner/Peter Mönnig
Walhalla
Installation
1985
Berlin, facing the Wall

decisive shape was expected to be more meaningful. But it was not just words that intervened in the public space. In the early 1970s, for example, the American Gordon Matta-Clark started cutting large, geometric openings into the walls of buildings marked for demolition. These spectacular macro-surgical interventions on architecture had a remarkable impact on the streetscape. They created a new type of exchange between interior and exterior space, between the ruinous appearance of vacant buildings and their perception by an artist. On the one hand, cutting into the buildings with heavy machinery preempted the impending demolition; on the other, the cut-out circles or wedges served to return some of the formal components to the architecture that had been worn away or obliterated through continuous use. Working on abandoned sites, which are certainly forbidden to the public, signalizes a type of boundary

crossing that implies not only areas that are beyond everyday life but also social and legal boundaries.

Many of these artists consider the frontier between legal and illegal interventions in the public space to be open or, at least, permeable. Often, a partial permit serves as a basis for subsequent activity to continue without let and hindrance. The Berlin artist Christian Hasucha has always conducted his public actions on both sides of the legal dividing line and the very nature of his work reflects this artistic point of view. Keith Haring, on the other hand, came to fame through his illegal drawings on advertising hoardings covered in black in the New York subway. He had a different concept of these boundaries. Although for him, they were also permeable and although even the means of his artistic expression were similar, Haring drew a clear distinction between commercial art and voluntary, unpaid art. Maybe this, admittedly, exaggerated comparison between those two artists with regard to their work does not just serve to point out differences in artistic conditioning. Even the public's expectation of public artists can be a contributing factor to these decisive nuances of self-perception.

Marcus Krips
1983
Cologne

The Aachen Wall Painters worked in the early 1980s. Their expressionist and often provocative illegal paintings targeted selected locations in Aachen. In front of this bunker, two gay adolescents were executed in the Nazi Era.

Aachen Wall Painters
Mural
1983
Aachen

What and Where Exactly is the Public?

Three-Dimensional Character
2008
Berlin-Mitte

Definitions of the term "the public" can be strangely enigmatic. On the one hand, we are talking about all those persons who contribute to a specific discussion – for example, the press; the regulars' table in a pub; politicians and, of course, artists with their publicly accessible body of work. As old as the attempt to define this concept, however, are the attempts to give "the public" a commensurate appearance through the creation and arrangement of the public space. And like the attempts at defining the public, the creation of this public space is sometimes subject to conventional ideals of representation and at others, to a more impulsive pursuit of individual expression. Therefore, street art intervenes in the public space and in the continuous formation of a consensus over what the public wants to see in this space. This discussion intensifies whenever the function of art in the public space is in-

cluded. The dramatic change of the cities' appearance since the Second World War plays a key role in this discourse. The increasing separation of city spaces into districts for living, working, shopping and recreation has not only been linked with a specific architecture for these districts; it has also assigned a specific role to art: entertaining and possibly controversial in the inner cities; comfortable in the residential districts; compensative in the working environment; and, preferably, not even discernible in the traffic areas. The formula of "public art" replaced the convention that art had to conform and refer to architecture, which in its incarnation of "Kunst am Bau" or architectural art had superseded architectural sculpture in its turn and where a specific percentage of a contract price was allotted to art.

What had changed decisively in public art was the fact that this

art could also take place as a process and was no longer functionally linked to a building as such. This penetration of contemporary art into the pedestrian areas followed a globalization that was already in full swing in the product range of the shops and had been completed in the range of cars in the parking lots. The new art within these teeming public areas, either in the shape of a permanent work of art or as a happening, also served to establish a culture of controversy revolving around the fundamental question as to what public art could actually achieve. It confronted the static bourgeois concept of art with points of view that were seen as a provocation and were only protected by the fact that these had been sanctioned or even initiated by public institutions. In Los Angeles, New York, Amsterdam, Berlin or Bremen, it was primarily wall art that contributed to the creation of a public consen-

Christian Hasucha
Jetzt (Now)
Installation on an
inner-city lawn
1996
Cologne

Marcus Krips
Painted Car
1985
Cologne

sus on art. The subject matter and design of these murals was easily accessible to the public mind and so paved the way for more complex artistic endeavors elsewhere.

This kind of new establishment ultimately provokes the competition of the non-commissioned artists. It is first and foremost independent street art, not being subject to a specific code within its scene to the same degree as, for instance, Writing or Throw-ups, that contributes to the controversial discussion of public art with each modification of the form or content of its tendency. But the majority of these pieces are by no means the result of a long preliminary analysis of the idea of the public space but rather a spontaneous, emotional objection to a discourse which is threatening to become to established.

Often, particularly playful "bequests" – in a way, stray works bare of any discernible action strategy – explicitly designate a strategy of street art. Since the time of Fluxus, when Al Hansen clandestinely positioned blue objects within a certain radius of Marcel Duchamp's living quarters and when Allan Kaprow documented this type of non-commercial "giveaway" as the score of an artistic happening, such extra-canonical actions have formed a rich and diverse line of ancestry. But these actions are by no means as far re-

moved from the concept of architectural art or public art as a black-and-white way of thinking is apt to claim. Maik and Dirk Löbbert, for instance, gained some important insights by arranging domestic objects into specific scenes and then leaving them alone. Such interventions are bound to be transient and it is difficult even to record every reaction to them without interfering with their casual character. But their ephemeral water circles, appearing briefly in the middle of the street, proved to be an important preliminary study towards the brothers' subsequent engagement with architectural art.

Then again, many a decorative spray image on public or private walls directly follows the tradition of architectural art – not least because it is so dependent on the taste and the indulgence of the owner.

Dangerous Situation at a Street Corner
1987
Paris-Montmartre

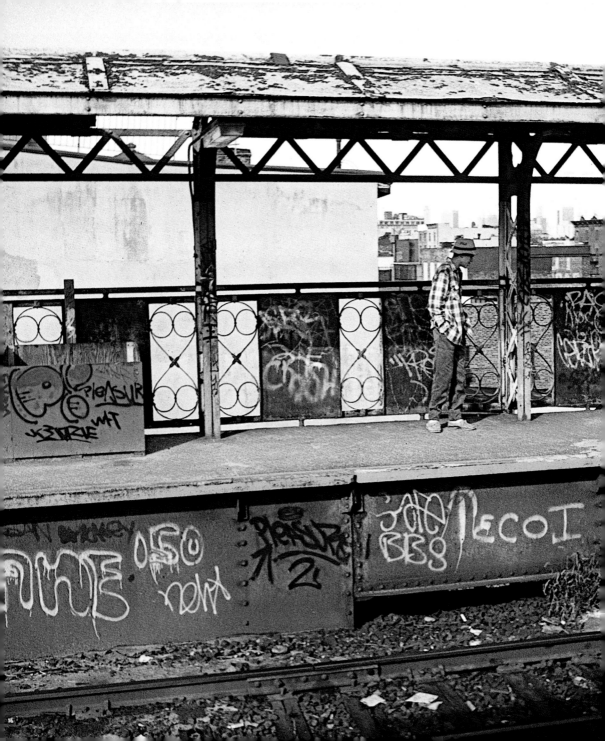

New York Graffiti

Al would be an artist, he was sure of that much. Painting was the only thing he was interested in at school – besides sports, music and girls of course. But he was only mildly interested in the stuff that hung in the museums. His parents even less, they had hardly ever even been to a museum. Al was realistic: In order to make a big splash, he needed to do something entirely new. But who could tell if there was anything that had not already been done in art? And first of all, who was supposed to know that? Many boys in Al's neighborhood were tagging. There was already a fierce competition for the coolest locations. One cartoonist claimed he had seen Cornbread's bold signature on the moon, next to a bunch of surprised astronauts.

Handwriting – he bet that that hadn't been seen in art for a while. And that was Al's chance. Of course, you needed lots of colors and some really far-out shapes. You could always add some figures later – he could do those really well anyway. The important thing was style.

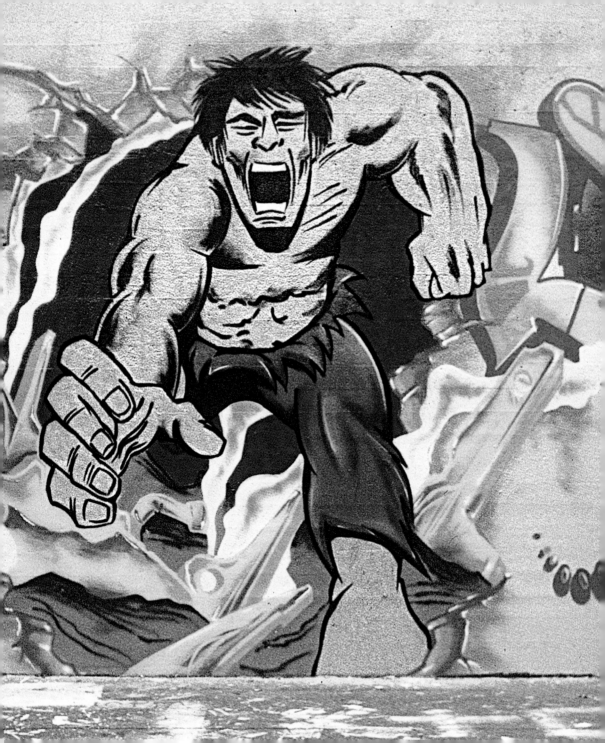

How and When it Started in New York

The history of the New York pieces has been shaped by a conflict of objectives. Apart from the well-known debate about law and order, for the first time, new factors appeared on the scene: The images and their makers were part of a trend which transcended fashion, language, music and imagery and developed quickly into a global and intercultural phenomenon. The move of those large, attractive pictures on to the big screen and other mobile image carriers took the tradition of large-format pieces a step further. Now, they even conformed to the established concept of ownership. And most of all, they now were economically viable.

There is a good reason why this process had taken some time developing. Unlike the young and yet-to-be-discovered hopefuls of the art scene, the graffiti writers had initially been beyond the pale. Anyone who tried to approach them had to overcome roadblocks that were not only put up by the writers themselves. Often, the very motives and ideas that impelled those would-be discoverers set up substantial barriers that first needed to be overcome. A social worker, a cultural chronicler, a cutting-edge journalist or a gallery owner and collector would each be interested in quite different aspects of the writer's existence, such as their cultural roots, their degree of integration into everyday culture or even their value for the art market. Not least because of these diverse ulterior motives, the establishment of the graffiti writers as serious artists

Seen
Mural
1986
Detail of front view
Bronx, New York City

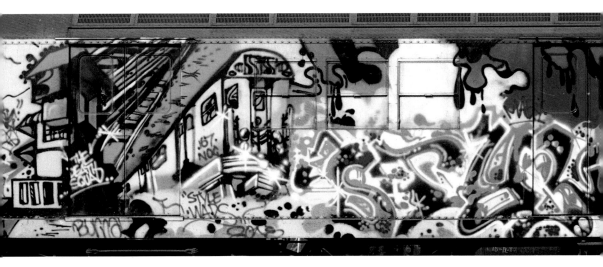

Noc 167
Style Wars
1981, Whole Car
Photo: Henry Chalfant
New York City, Subway

Dondi
Children of the Grave Return Part 2
1980, Whole Car
Photo: Henry Chalfant
New York City, Subway

was a long and ambiguous process. Quite likely, this peculiar mixture of people and vested interests was the reason for the comparatively short-lived boom of the New York writers as opposed to other contemporary artforms that had their advent at the same time, such as Die Neuen Wilden in Germany, the Figuration Libre in France and the Transavanguardia in Italy.

Redskins in the Art World

One fascinating aspect of the discovery of the pieces and their makers was their exoticism. The art world was determined not to repeat the sad story of the near-extinction of the American Indians with this peculiar tribe of city dwellers. But on the other hand, there was little inclination to tamper with the predominant concept of culture, so that the whole process ended up as a sort of half-hearted assimilation. This was clearly visible in the sweeping, cultural-historical exhibitions at the New York Museum of Modern Art, such as "Primitivism in Modern Art" (1984) or "High and Low. Modern Art and Popular Culture" (1990). The graffiti pieces only found acceptance in the close circles of fine art. Although there were numerous gallery exhibitions and although several European museums acquired some of the new pieces, they were placed in the same context as African

Crews and Teams

The crucial thing for the development of a good piece was the teamwork. On the one hand, there was a strict hierarchy within the crews. From the King who planned the design and the detail down to the Toy who filled in the spaces and passed the cans, there was a strict division of labor. But there were also positions of equal value with the team. Often, the space was divided between the bombers so that their names were put into a visual or even linguistic relation. To be a member of a crew, or even several crews, is even now considered a sign of distinction, in contrast to the necessities of the art market where individuality is essential.

sculpture or the more recent trend of Pop Art in advertising and caricature, which thereby excluded them from the elect circles of contemporary art. Although these exhibitions conceded graffiti's strong influence on contemporary art, they did not accord the phenomenon an unequivocal status as a form of fine art. In a classic process of colonization, however, the art estab

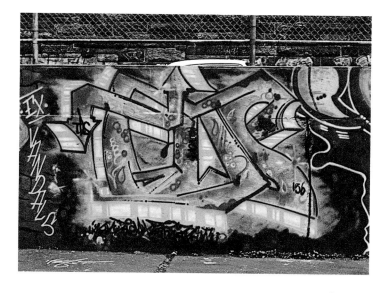

The Death Squad
1986
Graffiti Hall of Fame
New York City

lishment did its utmost to incorporate this spectacular new culture into their personal world view. The American Way of Life with its strong emphasis on property was never called into question: Whilst the removal of the pieces was seen as deplorable, the persecution of their creators was approved of. Unlike Europe, America never questioned its views on how the human environment should appear. In this context, any violation of legal boundaries was seen as an expression of juvenile deliquency.

Ultimately, this point of view had serious repercussions for the writers. By now, only pieces in the subways were considered as authentic and therefore any other location was regarded with great skepticism. Journalism habitually portrayed the writers as living in a charming, forbidden but also hermetically closed parallel world. By the same token, an article on graffiti whose author had not himself ventured into this forbidden territory was likewise considered to be less

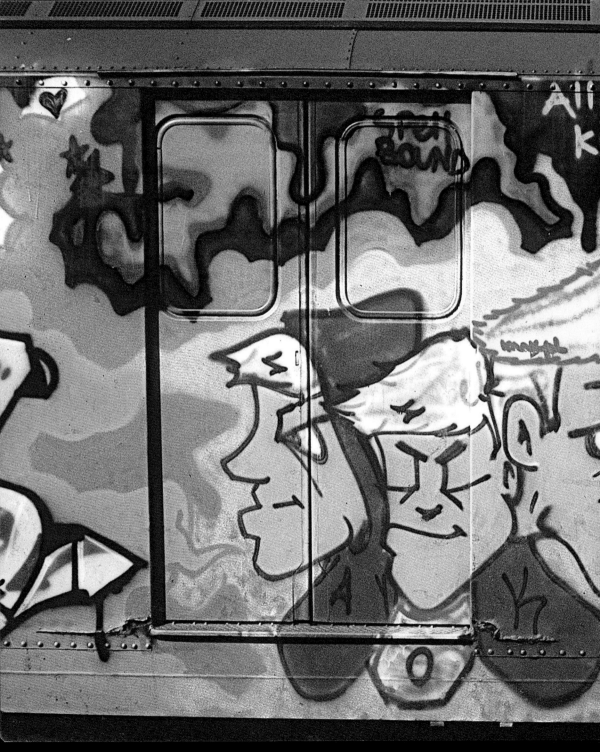

The creators of the Whole Car proudly present their faces to the audience. The All Out Kings actually sign and date their mobile artwork that will roam the subway network of New York for an indefinite length time. They seem satisfied with their work: And the creators saw everything that they had made, and behold, it was very good...

All Out Kings
Self-portrait
1986
New York City, Subway
detail of p. 138/139

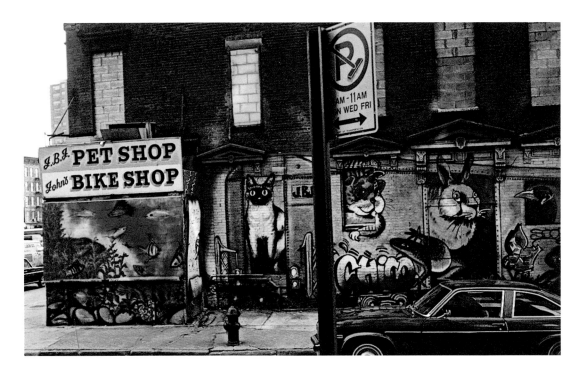

Chico
Pet Shop Mural
1983
New York City

Sign of the times
Mural
Photograph taken in 1986
New York City

authentic. This point of view was not to be challenged by exhibitions until much later — at a time when young people worldwide had begun to cover their local subways with tags in order to carry a piece of New York authenticity into their own remote corner of the planet.

It should not be forgotten, of course, that access to practically every writer was made especially difficult by the fact that the authorities themselves were highly interested in getting to know them and, hopefully, catching them red-handed. Trustworthy middlemen came into their own, who themselves did not do any bombing but had their contacts within the scene. People like Hugo Martinez, who had established the writers' gallery "United Graffiti Artists" in 1973;

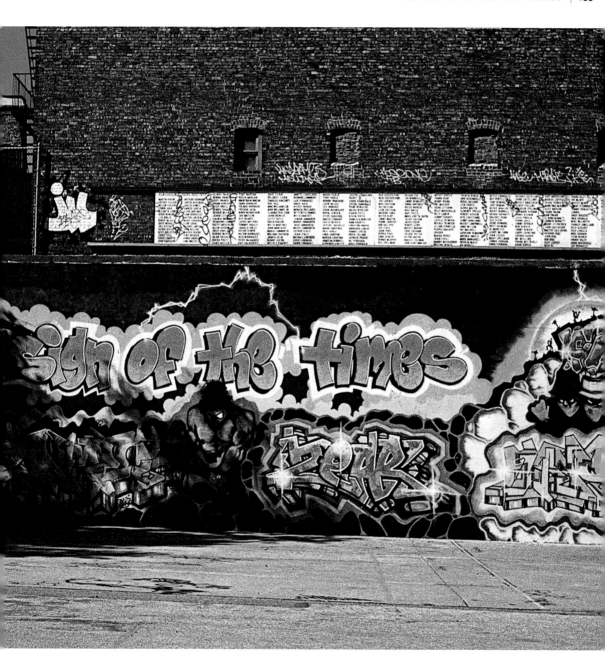

Martha Cooper and Henry Chalfant, who had been predominantly documenting subway pieces since the 1970s; and the Italian journalist Francesca Alinovi were key characters who served as trustworthy contacts in this complex exchange of information between the writers and the outside world. They were given first-hand information on new and spectacular pieces and authorized to dispense this information judiciously to the public. They were also important mediators between writers and the art world. That way, gallery owners did not lose respectability vis-à-vis their clients, who often had very old-fashioned values. And conversely, the writers could ask insider questions about the art scene without having to fear repercussions.

Clubs and Institutions

At the same time, similar contacts were established within the art scene. Party hotspots like the Mud Club brought together very different artists, such as Andy Warhol, David Bowie and Jean-Michel Basquiat. A member of the same scene, Stefan Eins, opened the Fashion Moda Gallery in 1978. Its location in the notorious South Bronx sought to blend the local multiethnic culture with the impulses of contemporary art. The non-profit

Market

With the exception of a period of short-lived success during the 1970s, the market for canvas pictures of the New York writers did not really develop until 1983. Following the spectacular exhibitions organized by the gallery owner Yaki Kornblit in two renowned Dutch museums, the presence of a selected group of writers at the 1984 Art Basel created a furor and stimulated demand. Besides the almost legendary Sidney Janis Gallery, several European galleries jumped on the bandwagon: Hans Mayer in Düsseldorf, Grita Insam and Thomas in Munich accepted several writers to their select group of artists.

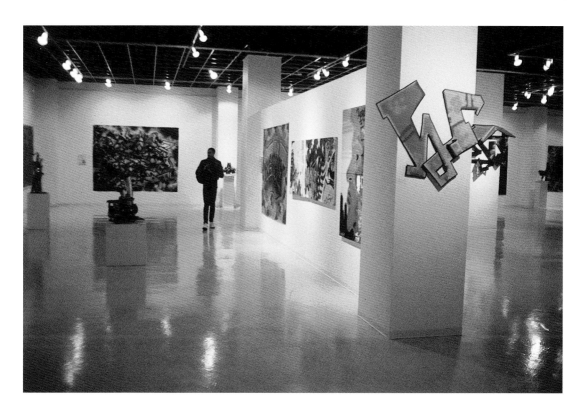

enterprise was characterized by a tolerance of unfamiliar points of view and the maxim "Everything goes". Consequently, the sprayers were given carte blanche. The shop front was designed by Crash, who also organized the first exhibition of tags on canvas.

Pieces by well-known sprayers began to appear in the vicinity of the gallery. Workshops for new sprayers were organized, which were a tacit acknowledgement of the strict hierarchy within a sprayer's career and served to appease group rivalries. In 1982, at the peak of graffiti's popularity as a publicized phenomenon, Fashion Moda was invited to take part in the Documenta 7 in Kassel, Germany, as a "Design Gallery". In

Exhibition at the Gallery 52
1986
New York City

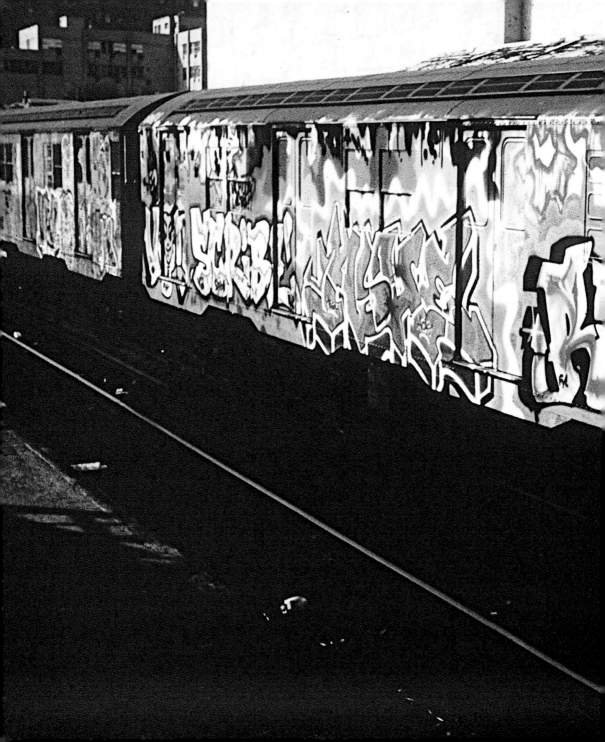

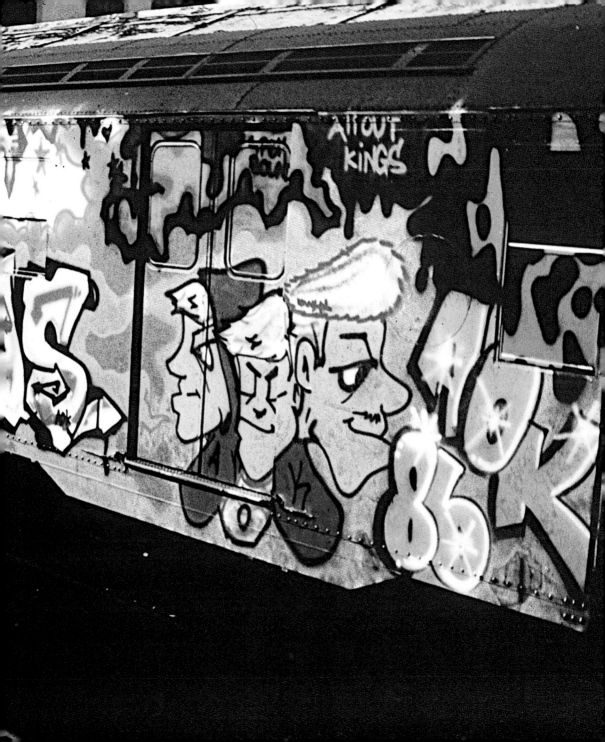

Previous double page:
Mesh/Age/Reas
Whole Car
1986
New York City, Subway

so doing it not only played an important role in the popularization of New York graffiti in Europe but also stood for the acceptance of graffiti as a swiftly changing fashion.

The legendary Times Square Show in 1980 also turned out to be an important networking event. It was located in a former massage parlor near buzzing Times Square and united more than 100 artists, amongst them Jenny Holzer, David Wojnarowicz and Jean-Michel Basquiat. Strangely, though, not a single

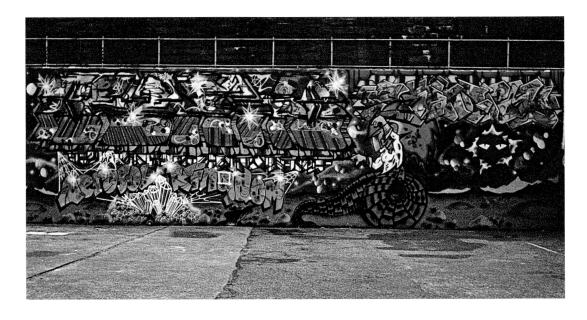

Vulcan
Aerosol Kingdom
1986
Graffiti Hall of Fame
New York City

sprayer was present – evidently, and in spite of all the well-meaning attempts at integration, the time for a true acceptance of these artists had not yet come. It stands to reason that the subsequent rapid consumption of their pieces was a result of this fact.

The Contemporary Art Center P.S.1 in Long Island, initiated by the artist's cooperative COLAB, and

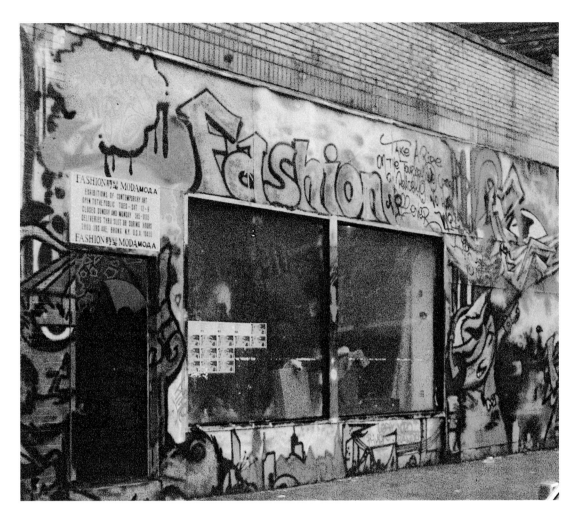

the social center and art gallery ABC No Rio Dinero located in the Lower East Side were based on similar concepts. They also organized workshops and exhibitions, which led to interesting collaborations between traditionally trained fine artists and graffiti writers. As early as 1982, Keith Haring had organized exhibitions of this kind for writers, an undertaking which caused

Moet/Delta
Façade of the Fashion Moda
Gallery
1986
Bronx, New York City

no problems as far as he was concerned. From 1983 onward, John Fekner painted several public murals together with Crash and Daze. Lady Pink, the graffiti scene's most famous woman writer, created works on canvas in collaboration with Jenny Holzer and wore the latter's T-shirts with inscriptions like "Abuse of Power comes a no Surprise" to photo-shoots. However, many of these collaborations, which confronted the idealistic claims of the traditional artists with the dazzling and trivial imagery of the sprayers, were short-lived. In their time, the pop artists had been able to

Gallery Fashion Moda
Interior detail
1986
Bronx, New York City

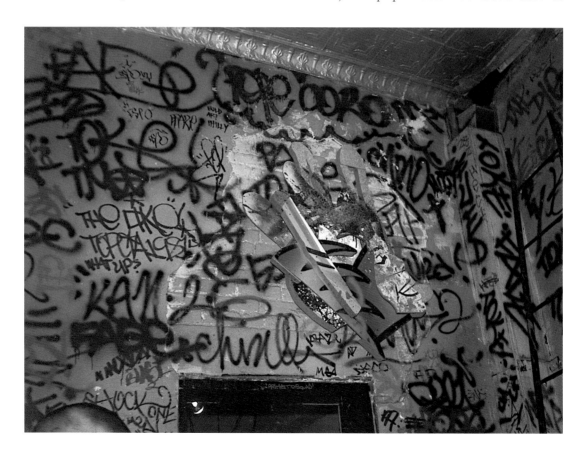

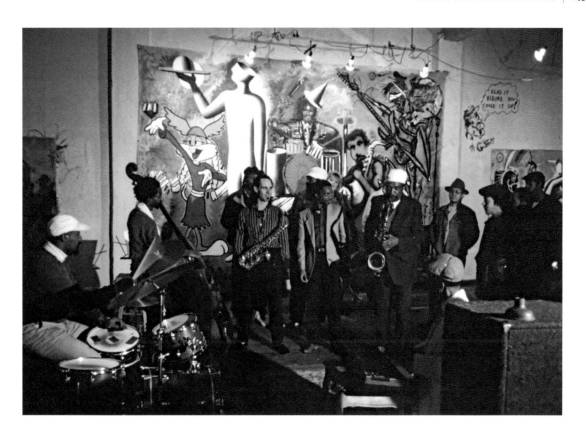

stage this interplay between the imagery of the street and their own art in a very conscious way and serving their own purposes. The graffiti artists, however, are still dealing with the legacy of those days.

Thanks to the repressive politics of the Metropolitan Transport Authority (MTA) and the city of New York, there has been a notable decrease in the number of large-sized illegal pieces since the mid-1980s. Through the decision to ban their subway-art onto canvas, the New York graffiti writers have turned another page and taken a step away from their not inconsiderable notoriety to a more direct contact with the art scene.

Opening at the Fashion Moda
Gallery
1986
Bronx, New York City

Pop?

In the 20th century, two art forms had taken a similar career path from the street to the museum: Pop Art and Fluxus. Both are nowadays regarded as classical epochs of modern art, and both had celebrated their first successes in Europe. The differences lie primarily in their marketing: While Pop Art is rather expensive and attracts a wider audience, the protagonists of the Fluxus movement and their art have remained comparatively obscure.

A shining example for the commercialization of the graffiti writers were the trail-blazing efforts of the galler owner Sidney Janis, who had been instrumental in establishing the Pop School as legitimate art in the 1960s. Works by Andy Warhol, Roy Lichtenstein and Robert Rauschenberg are nowadays a staple of European Art Museums. These career examples fascinated graffiti writers, gallery owners and collectors alike. But there are limits to this parallel. The strategy of the Pop artists had been to infect traditional art with the profound banality of everyday objects. In order to bring out the alienating effect of these everyday objects on art, the well-defined artistic environment of a museum or a gallery was indispensable.

For the New York graffiti writers, however, this process was almost inverted. They had initially been inflicting their highly visible art on the public from the position of a kind of secret society, when the art market became aware of their work and caused them

Quik
Go Ahead! Be an Artist!!!
Drawing, 43 × 56 cm
1986
Private collection

Writers discussing their work
Studio Henry Chalfant
New York City

Studio Henry Chalfant with tags,
painting and easel
1986
New York City

to use canvas instead of walls. Consequently, the art-works' most interesting aspect was neither the pictures themselves nor their subject matter, but the sprayer's lifestyle. Equally fascinating were their illegal status, the myth of their origins in the slums and not least their involvement in fashion, rap and breakdance.

Although the paintings expressed this "urban folk art", they were not considered as art in themselves. The fact that some of their pictures were even hung from the ceilings in the art galleries not only reflects the attempt to put their subway origins into context, but also demonstrates a clear disregard of these pieces as works of art. What actually happened was a kind of colonial-style barter: The goods, i.e., the

pieces, were exchanged for social structures. The first pictures to reflect this kind of appropriation were those by Quik, Seen and Crash. In one of Crash's works, a comic-strip beauty exclaims: "Go ahead! Be an artist!" Throughout his work, Crash quotes Robert Rauschenberg's serigraphs, while Fab Five Freddy makes reference to Andy Warhol's "Campbell's Soup Cans" in his tags on the New York subway. The image of the soup cans as a Pop Art icon have since come handy as historical reference, for instance when the Brühl writer King Pin replaced the Campbell label by the German label ERASCO in the 1990s and when Banksy used the British supermarket brand TESCO a few years later.

Commercialization

Even though Hugo Martinez and his "United Graffiti Artists" project paid up to 3000 dollars for a graffiti piece in 1973, his production- and marketing organization,

Keith Haring spent half of his time involved in voluntary work for various charitable projects. Although this piece is a powerful statement against the catastrophic circulation of crack, he was persecuted by the authorities for illegal tagging.

Keith Haring
Anti-crack tag
1986
FDR Drive, New York City

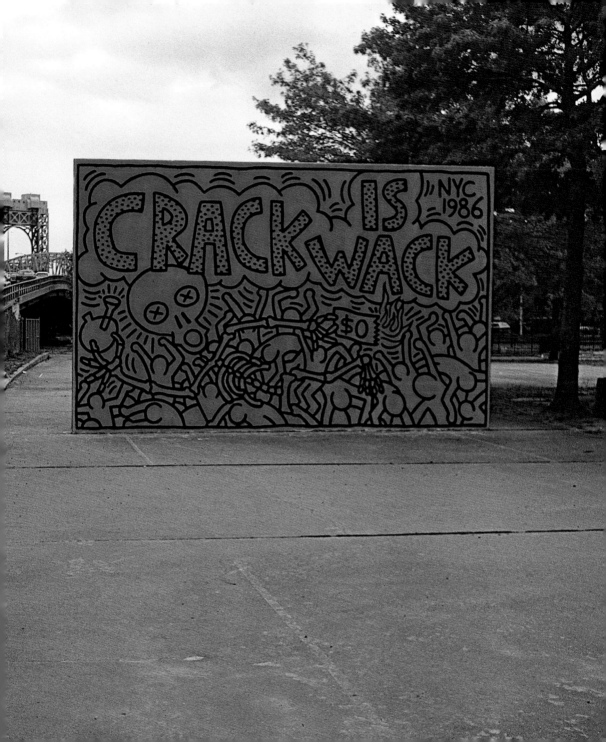

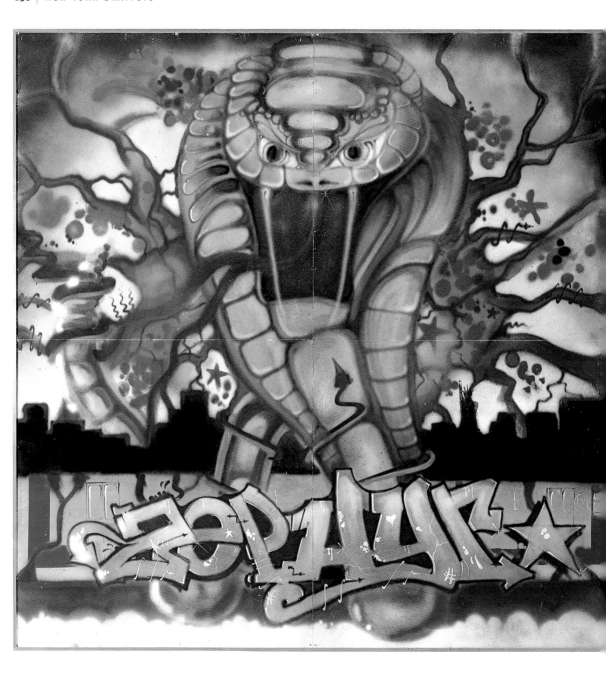

which had been established according to social ideals, had already disintegrated by 1975. Its contemporary, the "Nation of Graffiti Artists", suffered a similar fate. In fact, it was not until the 1980s that graffiti sprayed on canvas started to sell for increasing prices.

Patti Astor's Fun Gallery in the East Village, a commercial gallery specializing in graffiti, was established in 1981. Astor also appears as a journalist in the hip-hop motion picture "Wild Style". The Fun Gallery, which Astor ran in cooperation with Bill Sterling, was one of the earliest meeting points of academically trained artists like Keith Haring or Kenny Scharf and sprayers like Lee or Futura 2000. It also served as a springboard to larger galleries like the Sidney Janis Gallery or the Zurich-based gallery of Bruno Bischofsberger.

Sidney Janis, famous for his success with the Pop Artists, had tried in 1983 to mark the graffiti movement's transition fom illegal tagging of public spaces to art on canvas by giving it the label "Post-Graffiti". A specialized exhibition complete with catalogue emphasised the continuity from the gallery's own Pop Art tradition to Post-Graffiti as well as the necessity of being able to present individual protagonists.

It is surprising how rarely the writer's own labels were used. Terms like High Urban Folk Art, Subway Art, Spraycan Art, Street Art and especially Post-Graffiti are clear signs of a certain arrogance towards the writers: In order for the artwork to sell, it needed to be cleansed of the illegal past associated with the movement. After having spent six months in New York with some friends, the Amsterdam gallery owner Yaki Kornblit had decided to open a gallery in the city at the same time as Sidney Janis and Toni Shafrazi, but was forced to close soon after. He had opened the European market for American graffiti writers in a big way

Graffiti writers draw their ideas from many sources. Their idiosyncratic and highly refined typography and their imagery are often derived from comic strips. Graphic and product design, too, exercised a certain attraction: Many writers, such as Zephyr, have since become art directors.

Zephyr
Venom
Piece on Metal, 240 × 240 cm
1983
Slg. Pijnenburg, NL

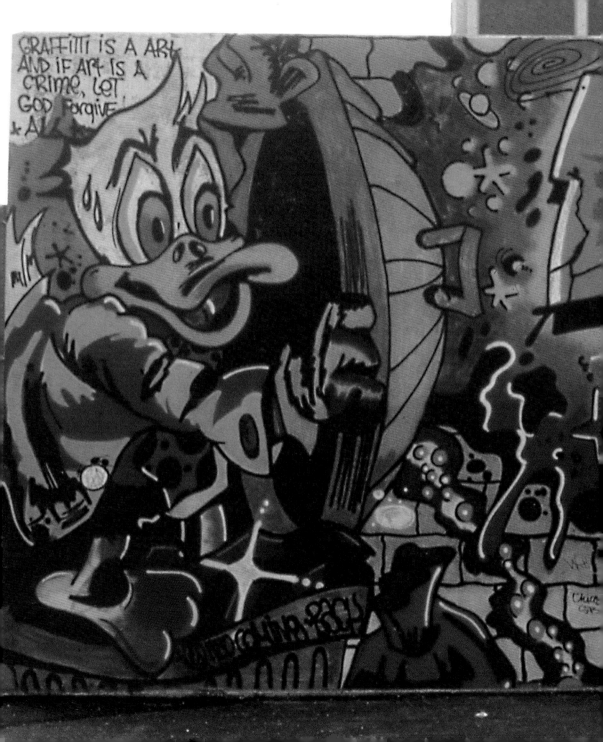

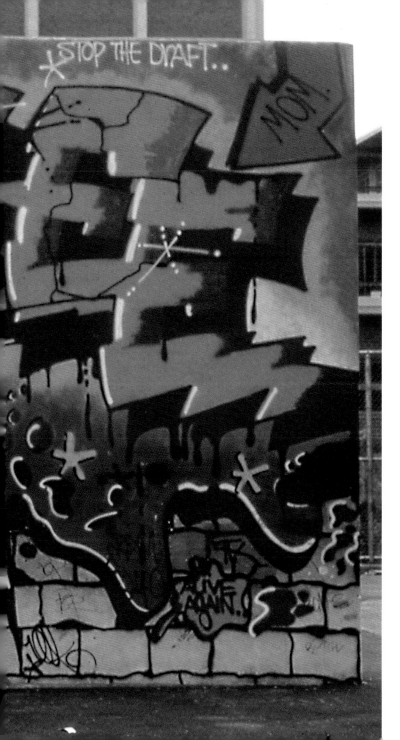

A rather grimy Donald Duck emerges from the garbage can, quoting Lee Quiñones' famous statement with a touch of irony. Quiñones disagrees with the New York local politicians that graffiti are a crime – but it never hurts to ask the Almighty for forgiveness...

Lee Quiñones
1981
Mural
New York City

Daze's canvas pieces reflect his personal history and cultural background. The narrative of his imagery often refers to song lyrics or famous albums like Duke Ellington's "Cotton Club Part 2".

Daze (Chris Ellis)
The Cotton Club Part 2
Piece on canvas
204 × 216 cm
1984
Private collection

through the organization of individual exhibitions. A large number of New York graffiti on canvas are nowadays in European collections. Kornblit consciously took advantage of the ennobling effect of large museum exhibitions, for instance those of the Groningen Museum or the Rotterdam Museum Boymans Van Beuningen. Since then, there have been exhibitions in museums in Italy, Germany and Denmark dedicated to this phenomenon.

But these met with an audience that had long since been familiar with art on public walls. And this audience expected more than just large, beautiful images; it was looking for the political message behind them. Unfortunately, the sprayers themselves did little to alleviate the resulting consternation. They completely dismissed the political aspect of art in the public space, often with comments like "It was just a bit of fun". Their behavior, as well, served to reinforce the viewer's skepticism. With very few exceptions, they acted as a group and, with their Rap and Electric Boogie music, came across as a sociocultural phenomenon of the busy metropolis rather than as serious artists ready to join the current discourse on fine art. And it often did not take very long to spray these pictures, which would go to private collections or museums and be exposed to critical scrutiny for years to come, and perhaps this fact was often not even taken into account during their creation. And perhaps it was really asking too much of the audience to change their habits of perception overnight and to take the self-perception of artists into account, whose highly spontaneous, emotional orgies of color had been the result of a totally different tradition, one that was only just forming and that was not at all interested in pandering to historical, intellectual or spiritual expectations.

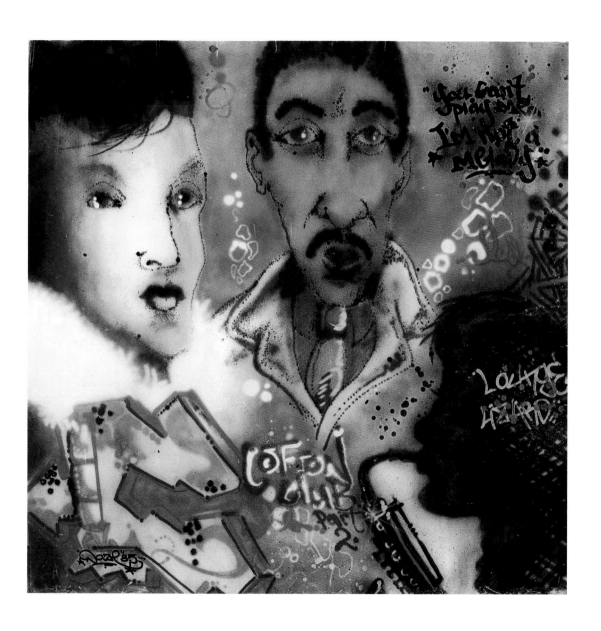

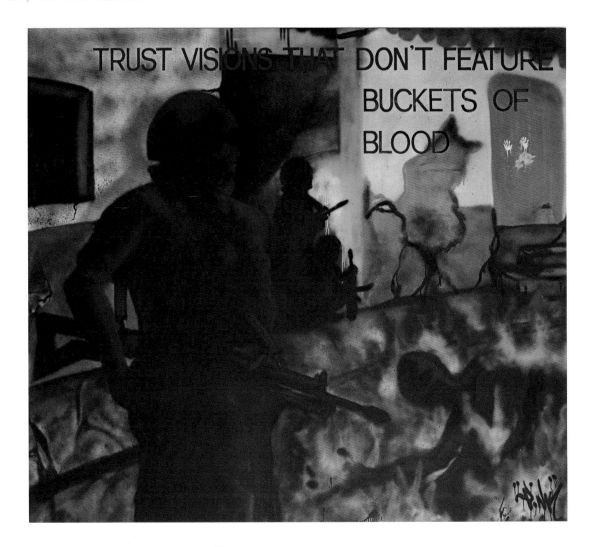

Canvas

Gallery owners saw the graffiti artists' step away from public walls to the medium of the canvas as a clear agenda. But here, as elsewhere, their acceptance of the graffiti writers as artists was often no more than skin deep. The presence of their pieces in the galleries was fre-

quently considered as a mere starting point towards real art. And the art market imposed its own rules on this game. The choice of the writers to be represented seldom reflected their status within their own peer group. The older traditions of the "subway writer" were considered as a guarantee for the dynamics according to which this art was to develop. What counted most of all, however, was the particular writer's ability to open up to the art market and to hold their own in it.

Ultimately, it was the art market in conjunction with art criticism which was responsible for the success of graffiti as art – an aspect that had originally been unimportant to the writers themselves. Selling their pictures under the rather unpopular label "graffiti" served to introduce a new standard of appraisal: Now, it was not just the popularity of the sprayers themselves but also the market value of their pictures that determined their artistic merit.

The presence of this type of artwork in European museums added another important factor. Canvas paintings of New York sprayers can be seen in the Netherlands in Rotterdam, Amsterdam, Groningen and Helmond; in Germany in the Sammlung Ludwig in Aachen and in the private collections Thomas in Munich and Hans Mayer in Düsseldorf.

Lee Quiñones was one of the first writers to react to the danger of this new trend. He realized clearly that for him, virtually everything had changed through this move to canvas as a new medium. He now had a new audience, a new peer group – and he missed the impetus of his tags moving though the city. Consequently, he stopped using letters and instead concentrated on moral concerns that had already been present in his spectacular Whole Cars. He tried to keep pace with the rapid changes that he felt himself exposed to. His proficiency

Collaborations between the graffiti and the art scene practically guarantee an explosive mixture of analytical precision and portentous imagery. The signature style of the contributors always remains clearly visible: Here, the artistic synthesis of Jenny Holzer's clipped and precise phrases and Lady Pink's ominous imagery is more than just the sum of its parts.

Jenny Holzer in collaboration with Lady Pink
Trust Visions That Don't Feature Buckets Of Blood
Aerosol on canvas
274.3 × 304.8 cm
1983–84
Gallery Sprüth-Magers

with the spray cans served as a stabilizer and as a sure-fire way to express his feelings quickly and directly.

Other writers who had made the change to a new medium took a different path: They told their own story. Daze used the network of the New York subway as a background for his paintings on paper, whilst Quik also worked with maps. Nok's piece "Style wars" not only refers back to his own, legendary "Whole Car" but is also a historical painting in its own right. Those pictures have no need of European art history because they tell their own fascinating story. And it is well worth listening to this story: It is a tale of personal experience and the continuous urge to stay afloat in American society, which can often be quite repressive. And it should not be forgotten that the art scene is a significant part of this American society.

Terms like "graffiti" and "graffito" minimize, direct and control this art form with its impressive scope, endless directions and unpredictable aspects. "A tadpole isn't a frog and a larva isn't a mosquito: and it is the same for this urban phenomenon. Those labels have been deliberately employed in order to appease a hostile audience unable to cope with the existence and inner reality of this art." Phase painted a clear picture of the power of nomenclature over his art. He considered the public's fixation with the street origins of this first real excursion of young street kids into fine art as a clear limitation. And it is evident that this label must be a constant thorn in his side, especially in view of his own attempts to put the evolution of the Styles into an explanatory context.

Rammellzee's reaction was entirely different. In a counter-offensive against the art world, he created his own labels to describe the writer's activities. "Gangsterism" is the act of "robbing" the art market by delivering bad merchandise for a high prize. He reacted to the

The canvas pieces of many writers reflect accurately and perceptively the social position of their creators and the influences that they are exposed to. Lee Quiñones' work exemplifies the way that these pieces go beyond the individual's situation to make a statement about society in general.

Lee Quiñones
Society's Child
Piece on canvas
135 × 65 cm
1983
Museum of Groningen

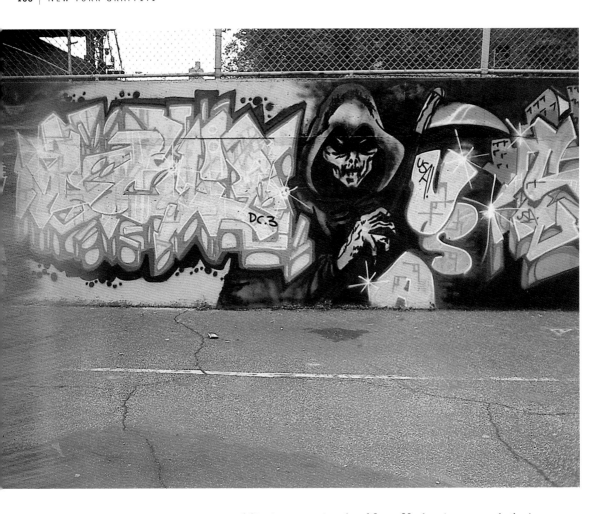

USA
Character
Photograph, 1986
New York City, Graffiti
Hall of Fame

public interest in the New York pieces and their prove-
nance by creating a veritable inflation of complicated the-
ories and self-created styles such as "Iconoclast
Panzerism" or "Gothic Futurism", which put his paint-
ings' as well as the graffiti scene's provenance into a
mythical context of medieval scriptoriums and traditional
calligraphy. His stormy past can be translated into images
that revolve around the prevalent meaning of individual

letters. He, however, wanted to "unchain" and "milita-rize" their meaning. The artist as a "general of letters" goes into battle for the enslaved alphabet and their inde-pendent existence. Rammellzee moved the actual danger of illegal spraying onto a conceptual level and linked it to the ongoing discussion about the political responsibility of art.

But not all writers considered fine art, the gallery scene or art theory, for that matter, as their domain: The interplay between self-perception and social perception was also apt to lead them to other conclusions. This was compounded by the fact that their peer group was united primarily by similar age and domicile but that individu-ally, they displayed very different goals and impulses.

Many writers shared the art scene's assessment of themselves as representatives of urban folklore or as cre-ators of striking snapshots of everyday life. Consequently, they sought a position as designer or art director, where the demanding process of accommodation with the art scene could be sidelined. Media, advertising or product design are the preferred venues of activity that many of the writers who had become famous in the heyday of graffiti occupy today.

For the majority of the writers, their encounter with the art scene was a temporary experience. They were realistic enough to realize that they could make money with good pieces on canvas even without any sort of artistic ambition. Many writers made the most of their opportunity to make money in a fleeting, exotic moment in time. This served to establish the basic traditions but also leaves a good many unanswered questions, which find their manifestation in an almost explosive global expansion.

Following double spread:
Seen
Mural
1986
Front and back view
Bronx, New York City

Every History has its Pitfalls.
On some Strange Rules of Canonization.

Keith Haring bites
1986
New York City, Wall St District

Many interesting essays have been written about the history of the New York pieces, each using models of interpretation such as personal or territorial history or the history of style. But while in a context of political history, individual people's lives would be significant, here they are of little account. Too many writers have stayed anonymous and the scene itself is segmented into writers of large-size tags, taggers or kings of the throw-up. Although some individuals have worked in several of these fields, the scene itself was too heavily compartmentalized to allow the creation of a canon of individual achievements. It is a telling indication of this dilemma that contemporary art histories tend to concentrate on artists who are on the writers' fringe.

Henry Chalfants and Tony Silvers "Reloaded" version of their hip-hop classic "Style Wars" points to another pitfall of the personal approach: Only very few writers that had been successful in the 1980s are still working as artists. Most of them have moved on to other areas of activity. On the other hand, many writers now take center stage who did not take the step from the street to the galleries and who are there-

Zephyr
Sketch for the intro-animation
of "Wild Style"
1982
Courtesy Charlie Ahearn;
Pow Wow Productions

fore still closely connected to street art. The scene itself is much too diverse and fast moving to create lasting heroes.

As far as the territorial approach is concerned, we know since Henry Chalfant's and Jim Prigoffs "Spraycan Art" that the impulses issuing from New York had global repercussions. And even if treaties on the subject regularly announce the local significance of their pieces, it is rarely possible to discern a formal code, which is truly intrinsic to the region. This is, after all, a global phenomenon,

its protagonists travel a lot and it is equally likely for an important piece to emerge in Mexico as in New York or Helsinki.

In the final analysis, the most important distinction is the one that the writers themselves have developed. Such different characters as Phase, Zephyr or Rammellzee have initiated the discussion of the evolution of styles in a historical context, long before outsiders have even taken up the pen. Through his experience as a participant of the first hour, Phase has put the evolution of the styles into a visual context. The bubble style evolved from capital letters whose shapes had been influenced by advertising typography. Decorations and protuberances and the increasingly pronounced overlapping and interlacing of the letters developed into the wild style, which in a classic counter-movement was then confronted again with clear block letters.

Previous double spread:
Koor
Mural
2008
Brussels

Old Boys
2008
Amsterdam

Rammellzee has put these events into a rather more literary context. His mythical fallback to the scriptoriums of the medieval monasteries and to the concept of an alphabet that had been enslaved by functional language and was now fighting back is science fiction in the truest sense of the word – a marriage of poetical and analytical elements that brings forth an entertaining historical standpoint. But succinct as this evolutionary thesis may seem and however well it goes with the heavily armed performances accompanied by stirring music, it is not – nor is it meant to be – a valid historical model and, in concurrence with Rammellzee's art, does not really mean all that much.

Zephyr's legendary animation of the opening credits for the motion picture "Wild Style" places this development into a fitting vehicle. The animation in his signature colors yellow and red, already quite complex for the early date of 1982, shows the movie's logo in a rapid evolution from style to style. Through the quick-fire changes, the characters seem to be dancing to the introductory music. Although it is a concise cameo of the action in New York, is does not really show a chronological succession but rather an unpredictable, continuous and cyclic movement.

But it is a distinctive habit of historical models to employ terms like "Wild Style", which here as a film title signifies a general attitude of life, as a static denominator of a very particular style whose first appearance can be dated to an exact point in time.

Today and in the eyes of those fans that had not been born in 1982, the erstwhile cutting-edge phenomenon has become legend. There is scarcely another segment of society whose creative output will move from brand new to old school within the space of five years. The reason for this distinctive cycle lies

not only in the swiftly-changing (and increasingly commercialized) hip-hop fashion, but also in the uncritical adoption of this historical model in other parts of the world. Especially in art history, the development of schools is a popular means of classification. Schools indicate a candid and clearly visible creative tendency within a defined time frame and around a particular group of people. The classification of a particular writer as "old school" is a double-edged sword in that it clearly classifies him as part of an obsolete trend and at the same time glamorizes him as a hero of the past.

This statement by Kaos and Maze deals with the dangers of shooting crack. The piece is located on the wall of an inner-city sports and playground, clearly and directly addressing a predominantly under-age audience.

Kaos/Maze
Baby don't do it
Mural
1986
New York City

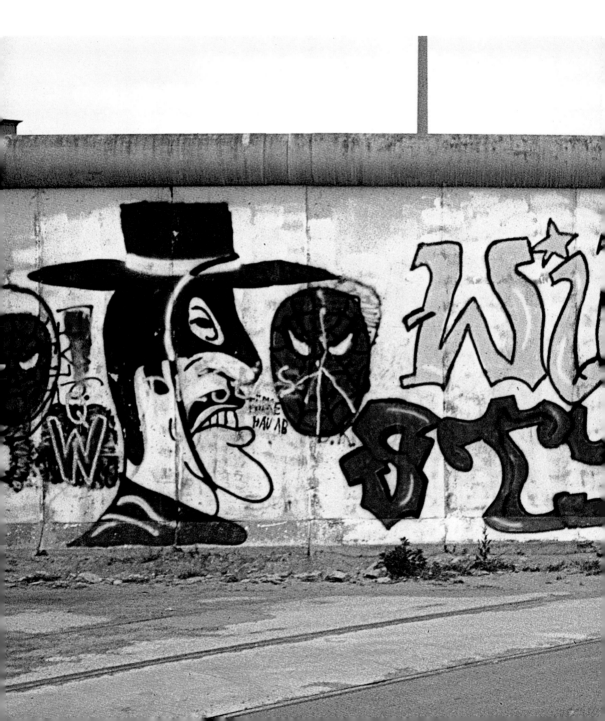

Worldwide Street Art

The known world somehow ended at the Wall. If you lived in the bricked-up enclave of West Berlin in 1983 and were of Turkish origin, you were not really too curious about what lay behind it. Besides, Ali was busy in the shop, helping out. By now the bootleg movie copies were almost selling better than the vegetables.

There was this new motion picture with the New Yorker Zorro that had hit the movie theaters. Ali loved everything about it: the pictures, the break-dance, the rap, the girls and the parties. But here, right before his nose, was the Berlin Wall. It, too, was covered with political slogans, of course, some even in Turkish. But there were no pictures like in that film. One thing was clear: He would be the first to spray something like that on the Wall. Ali was realistic: It would not be as great as Zorro's tags to start with. But he had to hurry now. Others had seen the film, too, and would soon get the same idea. And not just in Berlin, either.

From the Subways to Everywhere

Street Art: Ever since Alan Schwartzman had given this title to the book he published in 1985, those impulses that had gone out from the New York subways and that since had a world-wide resonance, were introduced to the local art scene and hence to traditions that were much older. Unlike the numerous "–isms" in art, street art is not a homogenous artistic movement. On the contrary, the moniker itself is a makeshift term used in an attempt to come to grips with a phenomenon that cannot be easily pinpointed. So it makes sense to take a closer look at the individual lines of development. The illegal aspect that was a valid trait of graffiti, for instance, could not easily be used to characterize street art. In the early days when this term began to be used more frequently, legally approved street happenings interacted with guerilla techniques when it came to

The London Police
Façade
2008
Amsterdam

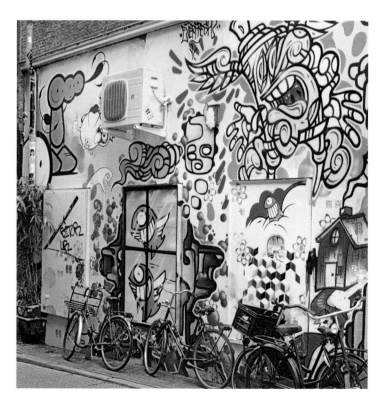

changing public space. Despite the fact that street art takes place on the streets and on public walls, there have been numerous exhibits in the venues of the established art world over the last few years. And some street artists have long been affiliated with a gallery that takes care of their financial business.

Pieces: The New York Impulse

The New York imagery had spread like wildfire. Whilst the actual graffiti had gradually vanished due to intensified public surveillance and diligent cleaning, their popularity had grown immensely due to extensive media coverage. Book publications, the appearance of graffiti in rap music videos and, not least, motion pictures like "Wild Style", "Style Wars" and "Beat Street" also served as important vehicles that made the New York scene a focal point for street art worldwide. Especially young people lapped up these impulses eagerly.

Tags and throw-ups in the Paris Metro
2008
Paris, Boulevard périphérique

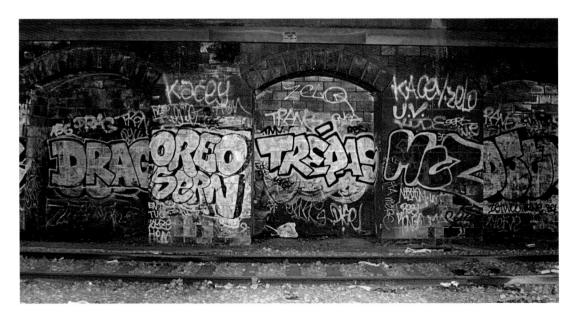

"Spraycan Art", after "Subway Art" Henry Chalfant's second collaboration with James Prigoff, showed the rapid diffusion of this art of the suburbs all over the globe. Names, techniques and even the imagery of the New York archetype were meticulously copied – and the imitators rapidly became more and more proficient. Soon, street artists in other parts of the world could compete with the original New York kings.

CAT
1986
Amsterdam

The rapid influence of the US sprayers on the European scene was partly due to personal contacts: The Parisian Bando, the Londoner Mode 2 and the Brühl artist King Pin had visited their New York colleagues early in the game. In Amsterdam, where the gallery owner Yaki Kornblit had been organizing exhibitions since 1983, an independent sprayer scene employing New York imagery developed early on as a result of direct personal contacts. Through those personal exchanges, but also through the efforts of individual writers, more or less tightly organized scenes developed in other places. Part and parcel of this transfer of knowledge and the close solidarity within the writers' scene was the adoption of certain codes of behavior and the drawing of clear demarcation lines between "them" and "us". Those strict codes in con-

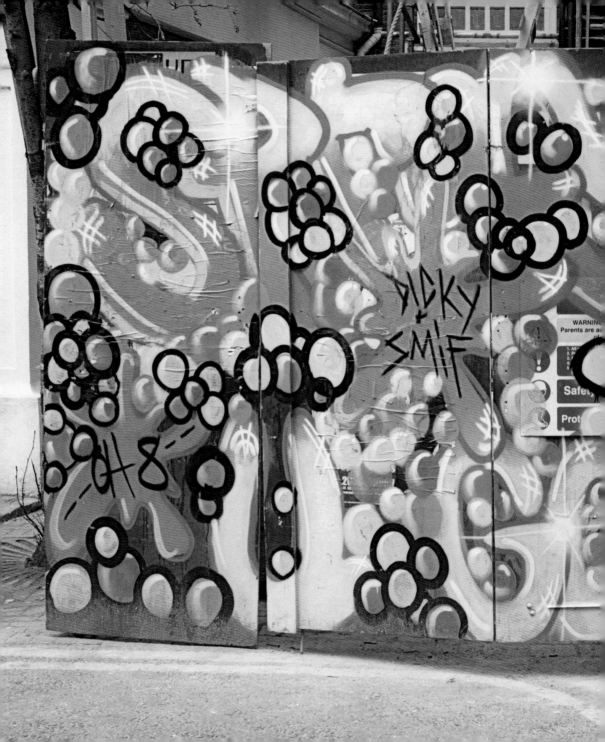

The obligatory security notice outside this building site has been completely obliterated by the artwork. Maybe it will help to offset the disruption caused by the construction work.

Dicky & Smif
Building-site fence
2008
London

junction with the attempt to emulate the published idols initially led to a certain limitation of artistic expression and this urge to imitate created a feeling of boredom and déjà vu. That said, the pursuit of individual expression had not been a dominant feature of the New York writers, either – what counted was the identification with the scene as a whole.

Despite this, there is now a scene of individual writers which, in spite of the regular meetings, contests and a growing number of publications has become almost unmanageably large. The ancient communal centers are now the domicile of graffiti writers who have developed their signature style, can live off their work and have established an effective network. These masters are highly mobile, they travel the world to collaborate with other writers, and they are venerated on an equal basis with the kings of the 1980s.

This has sometimes led to bizarre developments. In 2004, a distinguished Paris publication featured the artist Blade, who had grown up in the Paris banlieues and began his activity in 1984. It is but one of the many curious details of this intricately interlaced and sometimes confusing scene that there is also a New York artist named Blade, who had come to fame in 1984 through Henry Chalfant's and Martha Cooper's graffiti bible "Subway Art" and who has been venerated as a king since the 1970s.

Not surprisingly, in view of the first generation's short-lived boom on the art market in the early 1980s, the sprayers of the second generation did not see museums and galleries as their primary field of activity. For them, their contacts within their own scene were far more lucrative and stable. Internal networking led to more work and made them economically more independent than their predecessors.

We will always have Paris: On this wall in a remote corner in the Seine metropolis, writers from both sides of the Channel have collaborated on a piece with intricate character design.

Bando, Mode 2
TCA, Lucrezia
1985
Paris

Scenes

The phenomenon of street art is made up of different scenes that are constantly in competition with each other and whose differences can be clearly read in their artwork. As soon as the claim "True Artists don't use Stencils" appears, someone else covers "don't" with a stencil. The name "Jean Bombeur" is swiftly disfigured into "Jambon Beurre" (ham and butter) by the competition. It is well worth giving the writers of the subsequent generation a closer look. Their changes and developments in relation to their New York role models is interesting not just from an artistic point of view but also with regard to the survival of the scene as a whole. Since this portrayal of the writer's scene is not meant to be a catalogue of works or an artist's

directory (both categories are abundantly available in publication and on the internet), we will begin with the discussion of some important artistic aspects.

Lettering

In the writer's scene as a whole, Phase, Zephyr and Rammellzee's idiosyncratic treatment of the central element of a piece – the letter – more or less stand alone, while outside of the scene, they were seen as exotic insider information. Meanwhile, a number of serious publications on the evolution of these letters have appeared. Scientific studies like those by Staffan Jacobsen or Jack Steward, but especially publications by members of the scene have brought this evolution into clearer focus. The art project "Study of Style", initiated by the Berlin curator Adrian Nabi in 1994, discussed such aspects regularly in their publication "Backjump". His exhibition "Backjumps – The live issue #3" presented studies of the word "soul" by six different writers, accompanied by further artwork that dealt with the close connection between the formal rendering of a letter and the inner world of the person writing it. This was a departure from classic studies of graphology inasmuch as the writer's long lasting involvement with letters has sharpened their awareness of the fact that their very shape is a prime means

Respect

As the keyword of many liberation movements, "respect" is also important for street art. It denotes not only the acknowledgement of the individual's contribution to the whole but also the fundamental self-perception of a very closely-knit group that often deliberately isolates itself from society as a whole. In the worst-case scenario, this respect ends at the boundaries of another group's territory. Conversely, this term also signifies the outside world's demand that the group accept the rules that apply to the rest of society.

But the fact that the word "respect" can be seen at night written all across roll-down garage doors does not only make sense within the scene itself. Nowadays, businessmen all over the world commission graffiti artists to give a bit more visual interest to otherwise boring and forbidding elements of their domicile's architecture.

of communication. In his publication "Blackbook", the Parisian writer Woshe presents a type of psychological grammar. The book is structured like a ring binder and introduces the letters of the alphabet as specific characters: the A, for instance, is an "Ambassadeur", the X a "xenophobe." Although the book is based on the French language – a rare occurrence in the world of street art – this artistic essay constitutes an important element of an increasingly dynamic discourse.

This is the very reason for the scene's interest in throw-ups, which is much stronger than that of the general public. For after all, it is exactly these letters, which have been practiced hundreds of times and

Respect: Stop Violence
2008
Paris

Hip-Hop

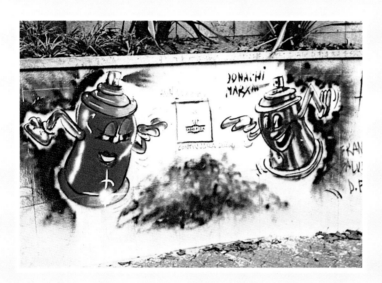

Dancing cans
1987
Barcelona

B-Boy
2007
Brussels-Anderlecht

"Contains strong language and moderate violence," it says on the cover of the hip-hop cult-movie "Wild Style", first released in 1982 and directed by Charlie Ahearn. Consequently, the film is rated suitable only for audiences 15 years and over, although the movie portrays a music and youth culture whose protagonists and audience are often much younger. The central story line of the movie revolves around hip-hop and its complex groupings and rivalries: "On stage, everything revolves around the musicians," graffiti writer Rose (Sandra Fabara alias Lady Pink) explains to her colleague Raymond (Lee Quiñones), who questions his role as an artist. The movie culminates in a big party thrown by an art scene which has also made cultural history in real life: the cream of the crop of graffiti writers and such rap legends as Grandmaster Flash and Double Trouble and breakdance stars like the Rock Steady Crew.

This is hip-hop at its simplest and best: Double Trouble is rapping unplugged and the central concert is a celebration of downtown subculture rather than international business. And the DJs still use vinyl records instead of the CDs that had replaced them in the early

1980s. The Zulu Nation does have grass roots after all.

Like graffiti, rap concentrated on language as a central element without becoming too intellectual. On the contrary – its melodious scats gave out clear messages on love and the social realities in the dilapidated suburbs of New York City. Hip-hop is a male-dominated culture. Its outlook is predominantly chauvinist; a rap song featuring a dominant woman is a rare occurrence. Rap lyrics are characterized by the violence that characterized everyday life in those days. Hence, weapons are an integral element of the rap visuals and the stage shows.

Equally important was the sportive element of art. Negotiating obstacles in order to get to the trains, cat-and-mouse games with the law and finally, the acrobatic stunts of break-dance – you just had to be fit. All this went hand in hand with the hype around the respective party culture and the sportive dress code. Sneakers and sports jackets, which

were originally a cheap, easy and comfortable choice of workaday clothes for certain suburban classes (and not

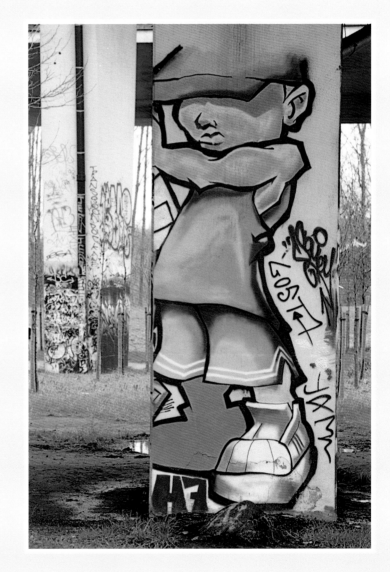

sports clothes for the sports hackers of downtown Manhattan), became part of the artistic superstructure. Signature outfits developed – homemade back pieces for jeans jackets and matching caps showed one's affiliation. Tattoos and piercings were part of the getup. Today, Seen, who was a king of the subways in the 1980s, is a star of the tattoo scene.

In the beginning, the music took off in several different directions – Rammellzee, for instance, created strange fusions of performance, rap, e-music and visual staging whilst break-dancers performed together with ballet dancers.

Even today, there are many similar activities, from body painting and hip-hop contests to fashion labels with workshops that function as a cultural project for young people. But hip-hop has become first and foremost a multi-billion dollar business. The lyrics, which did initially have some socio-critical content, have succumbed to the mainstream with its traditional focus on love and showmanship. Hip-hop is now an established part of the music business with its charts and awards. New stars arise constantly to face the highly competitive market – by now, even plenty of multimillionaires have styled themselves into hip-hop role models. The real money is being made in the music industry but as soon as you made it there, you will invest in the closely related and equally lucrative fashion industry, most likely creating

DJ
2007
Brussels-Anderlecht

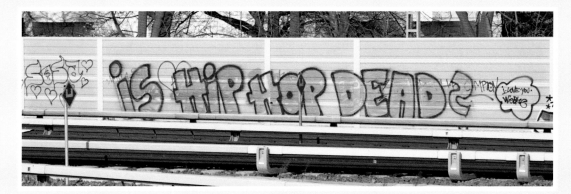

your own label right away. Even if making money in the industry has become somewhat harder lately, the pull of hip-hop is still strong: masculine ideals and the nimbus of gangsta-ism have by no means lost their appeal. The visual impact of music videos is the industry's driving factor: Originally, graffiti pieces and breakdance interludes were employed to improve the dismal backdrop of the slums. But even now, a rap star's natural environment, as it were, is the uncharted and treacherous ghetto, even though hip-hop's all-pervasive influence on popular culture is palpable. Dancers base their routines on hip-hop moves; many

music styles work with rap elements; and despite the triumph of electronic turntables, a top DJ still has to be a wizard of the vinyl discs.

Difficult question
2008
Berlin, S-Bahn

therefore produced in an automatic movement, that convey the inner being, the authentic style, the psychological framework and the channeling of the inner world into an elegant and efficient signature. The fact that these throw-ups are rarely intended to be beautiful is bound to remain a bone of contention in any type of public discourse.

Technique

Technical skills are indispensable for writers. In the writer's scene, a technically perfect sketch is even more important than in fine art. Although spray cans do come with different size nozzles, they don't exactly guarantee a fine and even line, but the writers have developed different ways and strategies that more than offset this disadvantage. Drips are another matter entirely. In the 1980s, they had been considered as a sign of shoddy work, but since then, a whole new discourse has developed around those "drips". Now, dripping paint has become a stylistic element and you can even buy paint pens that enhance this effect. Respected masters like Loomit, Daim or Seak always keep a little secret up their sleeves that will make their artwork go the extra mile in a competition that has gone global. And last but not

Expansion

Street Art is an expansive art. Even the documentaries are meant to invade the viewer's consciousness and conquer new territories there. This is the reason why street art has managed to become a global subculture. Like most economic systems, it is based on an idea of progression where improvements are seen as growth. While graffiti pieces continue to proliferate along train tracks and motorways and stickers and cutouts keep appearing in the inner cities, there will be a constant flow of a socially accepted dynamic in the locations that are symbolically significant for this phenomenon. As long as street art promises a progression in these places and to continue to express its youthful enthusiasm, it will keep its appeal.

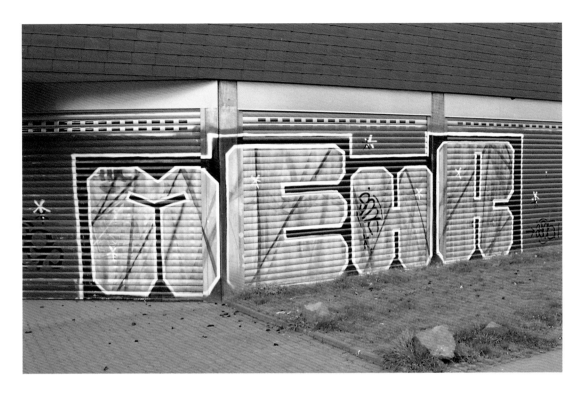

least it is the technical skill that will make the differ-ence. At the same time, this level of skill buys the writers some important privileges. Since you can express everything with a spray can, clients often have quite unusual requests and normally allow the writers a good deal of space to work in their own names and sometimes even some advertisement for their own enterprise.

Mehr (More)
2007
Königswinter

History

By now, several writers have been to university, albeit with rather different results. This puts the pieces and their makers into a very different context. James Jessop, a writer of British and Swedish origins, for

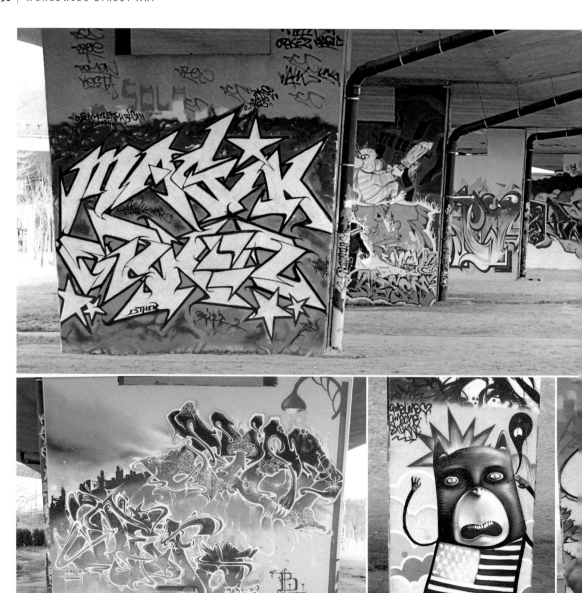

example, studied the history of New York graffiti. The by now legendary images of the elevated subway in the Bronx have inspired him to produce his own paintings on the subject. He sought out legendary writers of several generations past, such as Seen, and interviewed them. The artwork resulting from this research is homage and continuation in equal measure. In his painting "Subway Ghosts", the "Hell Express" is crossing a railway bridge in a fictional 1980s scenario. In this particular instance, Jessop did not use his habitual spray cans but the slower and more controllable medium of oil paints. This unexpected choice of materials also adds another aspect to the piece: It is, in a way, a modern historical painting of a fictional situation that the writer-turned-artist harks back to through his work. This dichotomy of the artist with a secret identity as a graffiti writer is also a common theme for other artists, resulting occasionally in a veritable coming-out. At the Akademierundgang 2006 in Essen, Germany, Frederic Spreckelmeyer showed a spray painting by the rapper 50 Cent and signed this action with a mixture of tag and signature.

Graffiti gallery under the
highway
2007
Brussels-Anderlecht

Contexts and Styles

The Basel writer Smash showed a conceptually more interesting solution at the 2008 exhibition Urban Feedback in the ancient exhibition hall. He put his name-tag onto hundreds of kitchen sponges. This choice of media showed a sort of compromise between street and interior and offered a convincing solution to the entire exhibition's underlying theme: After all, sponges are cleaning utensils. The softness of these sponges, their disintegrating arrangement on the floor, the sponges littering the floor in front of this installation: this piece offered its very own material, spatial and existential context that far transcended the wall space.

Within the scene, the choice of imagery and a very personal iconography are still regarded as some of the most important aspects of a graffiti writer's work. Early individuals like King Pin or globetrotters like Joker, Shoe, Darco, Bando or Mode 2 can always be recognized clearly and unequivocally by their choice of motifs and their idiosyncratic iconography. They have been continually developing their personal styles and, on occasion, have allowed it to intermingle with those of other writers in collaborations.

Street Art Globally

In France, these impulses met with more difficulties than elsewhere. For years, there has been a very public attempt to exclude all Americanisms from everyday language and culture. But in this particular field, more than in any other area of visual art, English is the universal language of the writers, with only a sprinkling of the jargon of the local scene in question. This usage of English as the *lingua franca* is comparable with the habits of the world of advertising or

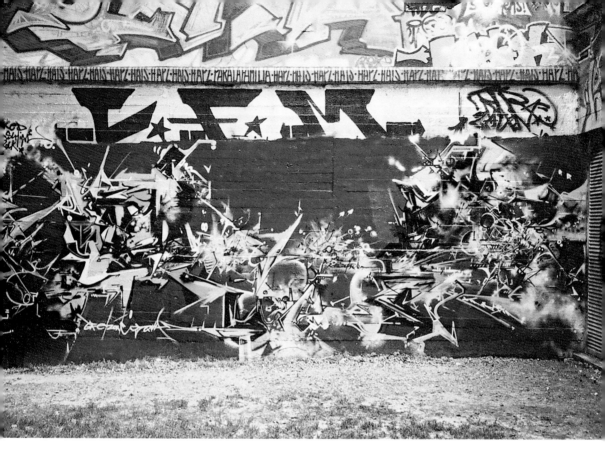

music, to which the writer's scene – not only through hip hop – keeps rather close contact. On the other hand, the graffiti culture has especially strong roots in France; some of the most eminent artists of the last century were French. In the early 1960s, Christo had organized street happenings in Cologne and Paris. The late 1960s were the time of the student revolts where political slogans covered the walls of the universities. The demand for the liberation of thoughts and language went hand in hand with the "storming of the walls with slogans". Theorists like Frank Popper or Jean Baudrillard liked to link New York graffiti to this theoretical context.

King Pin/Saor
2000
Hamburg

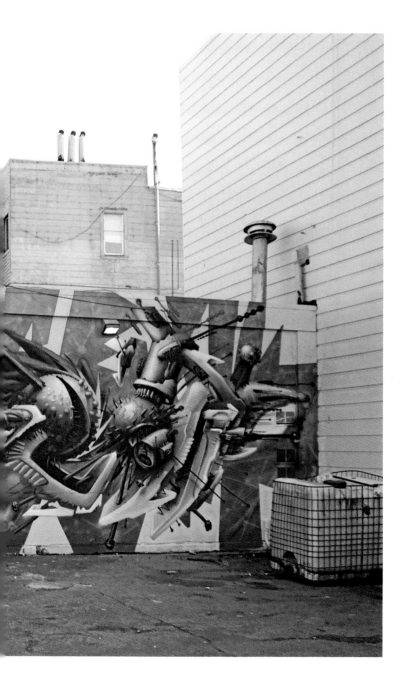

Like many other graffiti writers, Seak started out with letters, which he developed into an abstract visual language. The curious spatial effect of his globular images often establishes a confusing dialog with the urban environment, especially as his pieces sometimes span several buildings.

Seak
2003
Los Angeles

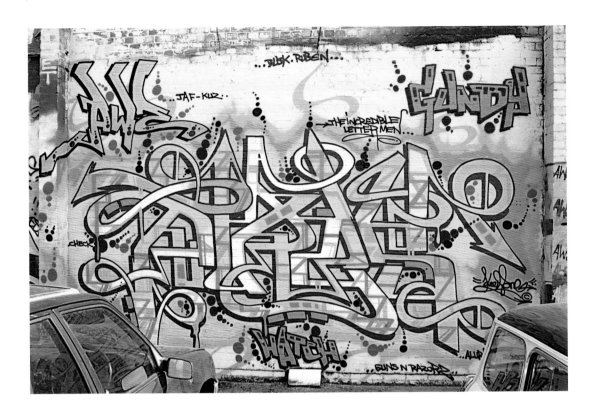

The Incredible Letter Man
2007
London, Hackney Wick

But the language barrier was not the only problem in France. When today, the Frenchman Blek le Rat is portrayed as a founding father of street art, this is not only because he has got a degree in arts but because he had channeled it into street actions. In his work, he combined impulses from New York with forms and strategies that were more closely linked to political graffiti. His extensive background in graphics led to the development of highly sophisticated stencils. This kind of esthetics was by no means alien to an audience who had experienced wood- or linocut posters as a valid means of public expression. The stencils, as opposed to the large-format pieces that he had also

experimented with, had one decisive advantage: They allowed him to work swiftly and efficiently in his preferred locations. His target areas were not inaccessible rooftops or train sheds but locations in plain view of the police and, not last, the general public. In this exposed situation, the stencil was the next best thing to the poster when it came to getting one's message across swiftly and elegantly. At the same time, the distribution of his images was meant to suggest a kind of normality: As the inhabitants of his *quartier* saw themselves portrayed in a comprehensible and realistic way and accorded the respectful gesture of a well-crafted image, they understood Blek's work as a well-meant offer rather than a provocation. Even though his nom de guerre, Blek le Rat, suggested a less than whole-

Girl, drawing
Photographed in 2008
Stencil, paint track on the ground
Halle (Saale)

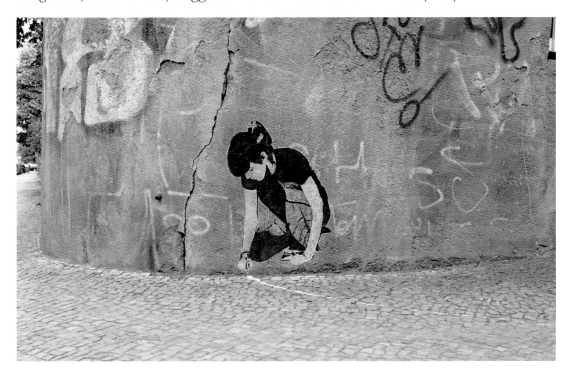

some personality, the primary aspect of his works were not, as in graffiti pieces for instance, the ego of their maker but their conciliatory nature. It is first and foremost this slightly quieter and much more communicative stance that had a profound and lasting effect on contemporary street art. The reason for the fact that street art has largely replaced the original label "graffiti" can be found in similar conciliatory structures. Again, a host of nameless artists are waiting to get started; again jam sessions at festivals are far more respected as a form of communication as an exhibition in art galleries. And again the art scene is doing its utmost to create clearly defined and easily marketable personalities.

Banksy and Other Individuals

In this respect, Banksy has been a paradigmatic success. The British phenomenon has managed to hide his identity to this day, all the while supplying his countrymen with easily digestible food for thought. Although physically present at street art exhibitions in the early years of the new millennium, he has since completely retired from public view. And it is this very retreat into anonymity that has become his dominant characteristic. He has become a living legend – through the fact that the value of some of his graffiti now surpasses that of the houses to which they have been applied and that many celebrities of the movie and music industry have spent fortunes purchasing his

Detail of mural on p. 200/201
2007
London

This mega-piece in London was a collaboration of many writers. Its intricate shapes and lines interact with the environment of the building site, commenting on the chaotic coexistence of multiple forms of creation.

Mural
2007
London

paintings. Another contributing factor to this legend is a recent story, according to which he himself, and as usual, anonymously, had sold his own versions of Paris Hilton's first CD – for the same price, but in a limited edition and with a Banksy cover design. Banksy is a media professional who manages to remain the talk of the town without ever blowing his cover. This way of dealing with the media, possibly more than the artwork itself, is a return to the original ideals of street art. Banksy managed impress an audience that actively and controversially discusses the appearance of the public space, that accepts contributions to this space which have been made in a playful, albeit not always strictly legal manner and that accords the individual a non-regulated position within this space.

The Paris street artist ZEVS has also stayed anonymous but has not quite managed to reach Banksy's fame. That may be partly due to the rather more aggressive approach of his art. There was, for instance, the attack on an advertisement by the Italian coffee corporation Lavazza on a Berlin billboard, minutely documented by an accomplice: He "kidnapped" the protagonist's figure by cutting it out of the poster and then demanded ransom for it. He sent the image's severed finger to the company as a token. In the final scene of the documentary, the artist in his signature leopard-pattern balaclava hands the cutout figure over to a

Communication

Communication has always been a major aspect of graffiti and street art. The imagery of street art does not just carry social, esthetic or ideological content but points to the necessity of communication and its many forms. Obviously, the supply of these means and shapes of communication has not been exhausted by a long way. But could it be the pressure of the communication industry – television, music industry, the internet and advertising – that has provoked the artist's response?

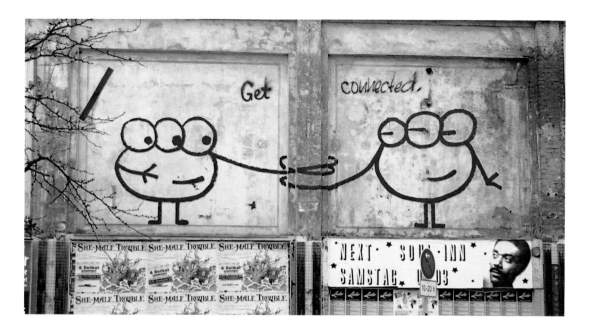

Get Connected
2007
Berlin

Lavazza representative. The company agent, in his turn, presents a six-figure check made out to the Palais de Tokyo, an important venue for contemporary art in Paris. Unfortunately, the win-win dénouement of ZEVS's film is entirely fictional: In contrast to Banksy's situation, where lots of money does change hands, no money was been spent in the name of art.

Other protagonists of street art have taken the step from obscurity into the public eye and have now become completely legal. The mural painters Os Gemeos from São Paulo have gone global with their dream of a colorful cityscape: Painting a castle in Scotland, the walls of their own South-American metropolis, or street art in the lively city of Berlin cannot be done in obscurity. These are large-scale projects where heavy machinery and extensive security measures may be involved.

The Londoner James Jessop leaves his nocturnal tracks all over the city where he lives, but in this instance, he portrays the legendary wild days of the New York graffiti scene in oil on a large-scale canvas. The "Hell Express" is rushing over a railway bridge in a fictional Bronx environment of the 1980s.

James Jessop
Subway Ghost, 2006
Oil on canvas
250 × 345 cm
Private collection

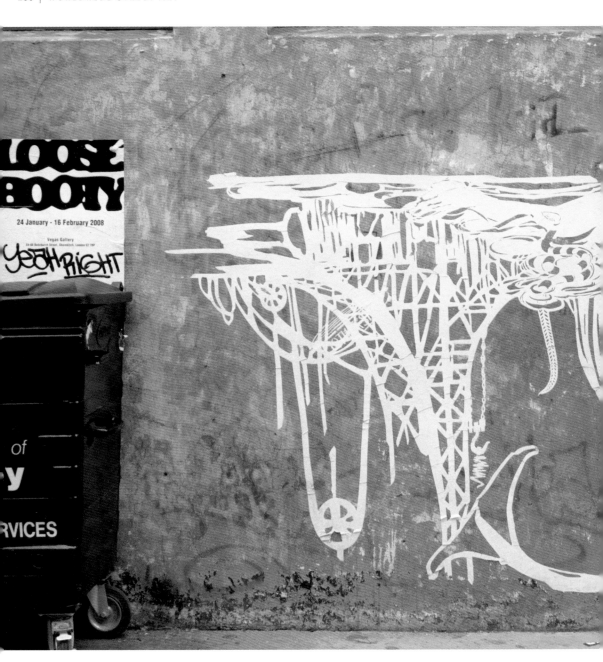

The near-inflationary spread of cutout street art is another matter entirely. This type of quickly installed art is, almost by definition, uncalled-for. After all, variations of the French Interdiction "Defense d'afficher" do apply worldwide. Meanwhile, the number of street art posters is legion. The underlying reason, however, is not always the same – on the contrary, this is a medium which lends itself to a multitude of causes. Posters create their own unique effects. As opposed to graffiti or pieces, they are quickly applied and are therefore meant to have an immediate effect. They are closely related to advertising posters, pamphlets and flyers in that they are combinations of image and text that have to be simple and striking to be effective. They are relatively short-lived – even though their life span can be somewhat extended by spraying the paper with varnish – and they are usually taken down by the public as soon as they appear. Small posters can also be easily positioned as a group, in different configurations, and they suggest a concentrated force that through tags, for instance, could only be established over a longer period of time. In larger street art exhibitions, these displays are often staged like a visitor's book because those events serve, after all, as a meeting point for an international, highly specialized, scene whose members get to know each other through such guest books. This medium also opens the door for club culture or media involvement: The postings function like a stamp of approval, which can be a welcome

Swoon
Cutout
2008
London

chance for a sponsor to gain some acceptance within the scene by adapting his presence to its customs. At the same time, these signs of presence do bear a certain resemblance to the sponsor walls at sports events or art exhibitions. The artistic threesome, London Police, are frequently the sole originators of such environments: Stickers, cutouts and graffiti seem to be a progression over several weeks' time and by different contributors, whereas in reality they are simply an agglomeration of different artistic vehicles. The apparent clash of the individual elements is the result of an underlying concept: Their visual impact is the result of the meticulous juxtaposition of the separate elements and the tension created by their coexistence in the same space. Not all artists, however, are aiming for such a dense and cluttered effect. Swoon, a New York artist with a background in fine arts, has left her traces all over the world. Her intricate and large-scale cutout silhouettes are not intended to be conspicuous. On the contrary: like the artwork of her colleagues Blek le Rat or Banksy, Swoon's cutouts simultaneously blend with their environment and pass a comment on it, especially in a busy part of town that has not yet fallen prey to urban redevelopment. Her predominantly realistic imagery, reminiscent of woodcuts, depicts either the denizens of the envi-

Personal Style

A personal style can be an ideal of the fashion industry, a humanistic goal or a means of self-demarcation in a homogenized society: There are many reasons for the development of a signature style. In street art, individuality is expressed first and foremost through form. Besides the specific type of actionism or the choice of location, a clearly identifiable iconography is the best way to be recognized. There have been too many imitators, epigones and copycats. When it comes to form, the scene is very particular and makes short shrift of perpetrators. To make street art means to create something that is perceived as a positive contribution to the whole.

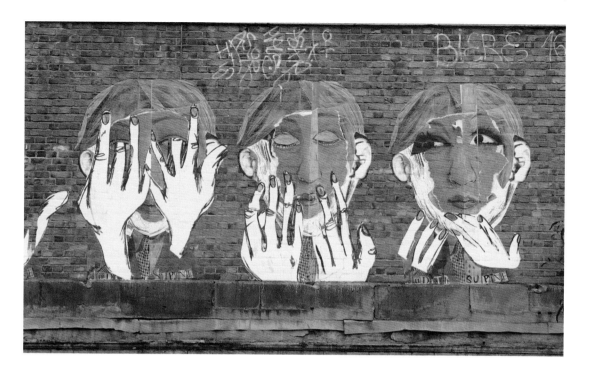

ronment that the artwork is placed in or friends of the artist herself, who like Banksy has kept her anonymity to this day.

Swoon's defining characteristics are her technical proficiency and the purposeful selection of her discrete locations. Other artists, however, prefer more conspicuous or unusual locations. Above, for example, places his signature arrows high up within the viewer's field of vision. Consequently, the presence of these symbols, either scattered or densely placed, will only be noticed gradually. The Berlin group CBS Cowboys works in a similar way with their signature left hand fist. Its comic-strip design transforms this traditional symbol of the labor movement into a globally comprehensible and accepted sign.

Judith Supine
Cutouts
2008
London

Anonymity and Interviews

Often, the public is far more interested in the identity of these phantoms than in their artwork. Karl Toon, for his part, will only give interviews in the persona of his signature, a friendly comic strip character, which originated from the German town of Halle but has since made some progress on the road to fame. Other street artists have staged interviews according to their own concepts. The classic mask of Mr. Unknown has since made room for a whole number of artistic or electronic variations. These artists do not express their individuality through the physical presence of their person but through the staging of their anonymity, in a similar way that illegal artwork placed on public walls by unknown artists speaks for those artists. Like the writers' crews, many street artists work as a group. The well-established Klub7 expresses the various media and areas of expertise of its members by depicting the interiors of the places they inhabit. It displays a whole spectrum of individual abilities – painting, graphic design, music, scenography or typography – and indeed the group does frequently work on commissions in the area of graphic and interior design and informatics. In a video posted on the net, these different activities are combined: a series of street art posters is animated into moving images. The accompanying soundtrack serves as a comment on the different locations of these posters – the end result is a hectic dance of a character jumping from place to place without interrupting his trajectory.

Klub7
Event Design
2007

Graffiti in the Media and Information Era

The program Hal had really been developed by the advertising industry in order to find free spaces in the city where billboards, city banners or light advertisements could be placed. Because surely, more could be made of the abundant surveillance footage and all the aerial photographs in the Internet. But Hal had gotten out of control and become independent. He had found a program named "graffiti" on the Internet and incorporated it.

Now his name showed up in selected locations: "Hal", artfully and colorfully sprayed in different styles. "Hal" as a stencil, "Hal" as a sticker. Earlier, this had only been happening on the Internet but the images seemed so real that they kept sending people around the actual locations to check that they really weren't there. Meanwhile, Internet investigators had been looking for the guy who controlled the program. But apparently, it had all happened by itself.

B-Boys and Big Brothers

The apparatus has been hanging on the wall since the early 1980s. The artist Bogomir Ecker had installed it one day, illegally and unnoticed. In those days, many new technologies somehow seemed to remind people of George Orwell's horror vision of "1984" – most of all, every piece of kit that could be used for surveillance purposes. While the German people refused to have a census taken that seems harmless by today's standards, the apparatus of the Düsseldorf artist was quietly ticking on. To this day nobody can say what the machine really does. But then again, nobody has really taken much notice. It is just looking slightly more used as the years go by but it is still in the same place. Is the small box in the courtyard entrance really just part of an intercom system? Or does the slightly curved tin cover house another secret under its perforated shell? And the crucial question: is it really connected – to the electric circuits, to public perception and the debate on the potential of technology, art and the public space? At the end of the day, it really does not matter exactly where the apparatus is located.

1984, the year of George Orwell's pessimistic vision of a future that, as we now know,

Space Invader
Intervention on a facade
Colored tiles
2006
London

Bogomir Ecker
Untitled
Tin, anti-corrosive paint
c. 1984
Bonn

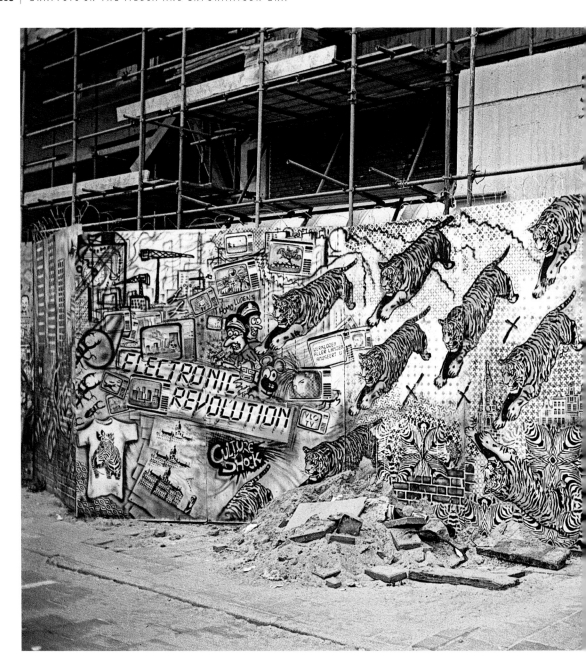

did not then come true, was also the year when a historically short-lived boom of canvas paintings by New York graffiti writers was in full swing on the international art market. From then until today the media have been undergoing a revolution that left its stamp on society and culture as a whole. In the year of 1984, blanket surveillance of public places was seen as a form of arrogance more suited to totalitarian nations. A cell phone was considered the height of luxury and the Internet a utopian dream.

The new and endless possibilities looming on the horizon were seen by many as the advent of the old dream of a truly democratic system of education and communication. Nowadays, not least because of the above-mentioned extensive public surveillance, the placement of graffiti – for many the epitome of democratic communication and expression – has been reduced to a furtive activity. The lifestyle and attitude of the public have become far more commercial. This development can be traced through advertising, as the billboards become progressively larger and more prolific. The fact that even now, well into the new millennium, people commit their visual messages, un-asked-for and illegally, to public walls seems like an anachronism in more than one respect. Why have graffiti not been rendered obsolete by the possibilities offered by cell-phones and the Internet?

Hugo Kaagman
Electronic Revolution
Painted hoarding
1984
Amsterdam

Super Mario
Cutout
2008
Brussels

There are several possible answers to this conundrum. At the one hand, the images and signs on the walls are part and parcel of human expression. Maybe it is just because the parameters have changed that graffiti has kept its appeal as a traditional means of communication. The numerous documentaries of graffiti writers arguing from a historical point of view certainly reinforce that approach. Hugo Kaagman from the Netherlands, who has been working with stencils since the 1970s, created a visual synthesis on a hoarding near an Amsterdam subway entrance. His piece proclaims the electronic revolution whilst the city itself is still portrayed as a primeval jungle full of tigers, comic strips, entertainment and, in the thick of it, homo ludens.

On the other hand, the new media have come to a sort of arrangement with the culture of street art. The visual component of hip-hop music videos is an important vehicle of the imagery of street culture. Whilst in the 1980s, photocopied fanzines were the sole source of news and information on the scene, today there is an abundance of websites and blogs. The very fact that nowadays the authorities destroy graffiti almost as soon as they appear has led to an increase in efforts to document them. There are now hundreds of home-made sites dedicated to the documentation of street art. The early transfers of this

culture to the medium of film have served as a role model and produced a veritable deluge of Internet videos and commercial DVDs. The media have well and truly claimed the culture of street art: nowadays, camera operators are important members of writers' crews. Visual documentary has become an integral part of the action because it will most likely be all that remains of the work after a relatively short time.

Of course, the Internet simplifies and amplifies the possibilities of inter-crew communication. Communication, like travel, has become easier and cheaper. Nowadays, the cooperation between international crews is exemplary. Culturally, they now share a far more calculable common ground, which simplifies collaboration above and beyond contests or festivals.

The Internet

For graffiti writers and street art aficionados alike, the Internet now offers a multitude of graphic programs, even the simplest of which feature the spray can in their tool menus besides the more traditional pen, pencil, brush or chalk. Nowadays, you can even download more complex and specialized programs that correspond with more specific needs. You can create a piece, for example your own name, in many different styles. Besides the traditional options like font, size, spacing and cutting there are additional tools that are

Karl Toon
Cutout
2007
Berlin

Giant Bugs
Cast concrete
2007
Cologne

more geared up to graffiti, such as arrows, fill-ins, color and gradient and many three-dimensional effects. There are even programs that allow you to cover empty subway cars with your own graffiti. It is not surprising that simple pieces have now become a common background for computer games. Unlike in real life, however, a click of the mouse makes the graffiti disappear.

In this context, the Internet and other forms of electronic communications occupy a privileged place because the presence of a phenomenon on the world-

wide-web has become almost equivalent with its real life presence. The documentation of a short-lived artwork is just one of many aspects. Far more important is the internal networking within the scene because it also features the increasingly theoretically founded self-image of the artists and, not least, the medial entelechy of the electronic media. The Internet steps in where street art passes the boundaries of spontaneous expression. One of the most important features of the Internet provides the graffiti artists with support. Whilst the imperial registrar Kyselak had to physically travel to put his name to as many different places as possible, today virtually unknown people can

Glass Brain
2007
Brussels-Anderlecht

spread their message all over the Internet. At the same time, this form of publication, whilst its individual successes are measurable by the number of hits, allows the originator to stay relatively anonymous if he wishes. Another parallel with the secret world of graffiti is the high visual quality of the electronic images and the fact that they can be changed constantly. In this context, there is the oft-cited danger of losing touch with reality. In the final analysis, the organization of life in the Internet does serve as a model for real-life communication. Maybe blogs and chat rooms are progressively replacing the real-life regular's tables and, also, a certain portion of public communication through graffiti.

In this segment of society, there is a certain overlap between the graffiti and the hackers' scene. The illegal downloading of self-made footage onto rented videos, the so-called video graffiti, was a favorite pastime of the 1980s, which then found a worthy successor in Banksy and his bootlegging of the Paris Hilton CD. Internet hacking, however, opens up whole new dimensions of publication and has far more serious

Big Brother on TV
2008
Brussels-Anderlecht

Street Art vs Globalization

Working Class Hero et al.
Urban Feedback exhibition
2008
Basel

Street art, like many other hyphenated art forms, loses the protection of the comprehensive term "art" as soon as the attribute is taken away. Whenever a street art exhibition takes place in locations like ancient market halls or churches, a number of questions are being asked. Therefore, it is not surprising when the Paris artist Stak habitually crosses out the limiting prefix "street" in questionnaires or when in a typical art venue, a window inscription states: "We are free artists. Outside."

In fact, the balancing of the inside and the outside has always been a major issue within the street art scene. From the early New York writers via the performances of the Zurich Sprayer up to recent complaints about street art's loss of impact in museum exhibitions, one basic accusation persists as a central theme: If the street is

the original and most important context for street art, no transfer to other venues can be taken lightly. There have been numerous attempts at a solution to this problem. The London Police, for instance, adopted an idea that Gordon Matta-Clark had first developed in 2006 for a street art exhibition in the Gemeentemuseum of Den Haag: The narration of an external situation with the help of a miniature model. This approach is reminiscent of an experimental game: After all, the time-honored scale models in history museums have always been faithful images of a specific community – and the interference with this community is one of the important aspects of street art.

Documentary approaches have been responsible for a whole new tradition. Whilst earlier, photography was the medium of choice this has been re-

Advertisement for the exhibition
"Dutch Masters – Street Art & Urban Painting"
2006
Den Haag, Gemeentemuseum

placed by moving pictures because they are capable of recording not only the end result but the entire creative process of street art. In the show room, these solutions are met with the usual questions: Can a video hold its own against a more charismatic piece of art such as a sculpture or a painting and does the viewer like the accompanying soundtrack? And for how long will a viewer submit to the conditions imposed on him, such as the duration of the video and the darkened room?

There is a third possibility for the adequate staging of an exhibition of this kind. The 2008 exhibition "Urban Feedback" was held on the vast and slightly dilapidated premises of the old Markthalle in Basel, Switzerland. The parsimonious lighting helped to blend the interior of the market hall with its artwork mounted on partition walls with the exterior, creating a hybrid between museum and street ambiance. Street art is always a manipulation of spatial awareness. The installation of an exhibition can transfer this constellation into the sheltered space of art as long as it takes the inherent laws of street and art into account.

Nowadays, the format of open-air exhibitions in the inner city has become fairly well established, not least based on early experiences like a sculpture exhibition in 1930s Zurich or the "Skulptur.Projekte" that are held once every ten years in Münster, Germany. These events are not only significant with regard to the infrastructure. Between 1977 and 2007, the Münster events helped to gauge public reaction, which was often quite hostile, and to develop improved strategies for future exhibitions in the inner city on the basis of these experiences. The discussion of the function

Statue of Liberty
2008
Osnabrück

and the possibilities of the public space become the basis and the touchstone for the practice of street art and open-air exhibitions. But there will always be a residual risk for event organizers: Successful street art does not inherently affirm the status quo – on the contrary, it will progressively find and tap into new and hitherto untouched areas of controversy within cities all around the globe.

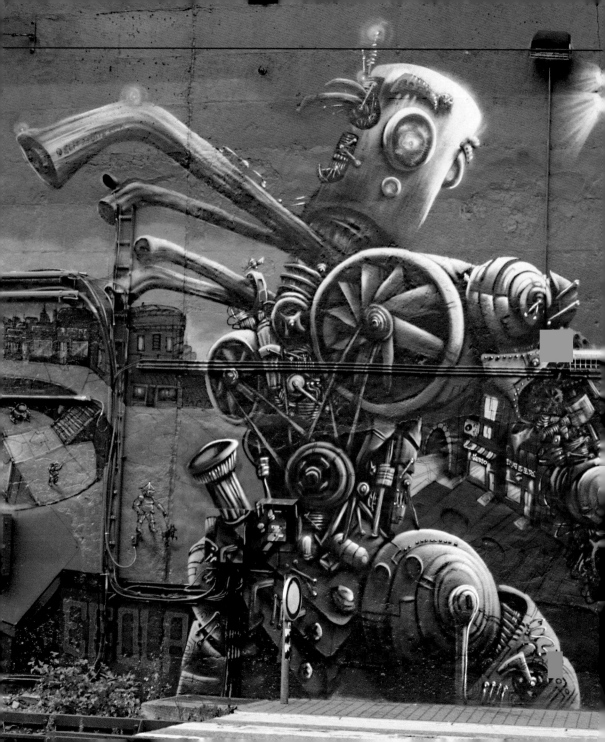

Four artists of four nations have collaborated on the monumental task of decorating this streetcar stop in Brussels-Laken. They managed the 1500 square meters in just four days. It is Belgium's largest piece of street art and demonstrates clearly the level of public acceptance that such vibrant and colorful art has managed to attain.

asbl Tarantino
Streetcar stop (Detail)
2008
Brüssel-Laken, Station De Wand

political consequences. The daydream of the London-based painter Markus Vater of hacking the Chinese foreign ministry's computer system and replacing every occurrence of the word "revolution" with "chocolate" gives just a small hint of the enormous potential of graffiti on the Internet.

Street Art Market

Street art has also come to an arrangement with the increasingly commercial attitude of recent times. Although exhibitions in the art world are still attached to the traditional notion of art for art's sake and independence from commercial necessities, hip-hop, for instance, has developed into an important market. Whilst hop-hop fashion initially revolved around individual expression, it has now become a fashion cult like many others. Quite a few of the old scene's protagonists are designing shoes, clothes and accessories and some have even launched their own labels. Street wear has replaced street war as leading concept.

Of course, market strategists have always kept a close eye on the habits of young people. Youthful dynamism is a useful advertising vehicle, even if it did not directly spring from youth culture. Nowadays, graffiti is being employed in the advertisement of tofu, shower curtains, cars or strollers – or even in the design itself. In a sweepstakes for a home loan bank, young people were asked to come up with a slogan for a home loan ad – ironically, the aim was to entice young people to build a house – but the first prize was a trip to New York City.

At the same time, it would not be fair to say that the scene is entirely other-directed. Many street artists, either active or retired, are now working in advertising agencies. But this sort of activity is also a bone of con-

Large-scale and fragile, this science-fiction-like cutout appears in the middle of Paris: utopia or dystopia?

Cutout
Photographed in 2008
Paris

tention within the scene, even if making money as such is not a despised activity. After all, Banksy's success has boosted the morale of the entire scene and even the grand masters live off commissions. In an ideal world, the artist's fame will carry extra weight for the commission. Masters and stars like Futura or Banksy will be given considerably more freedom of expression within the framework of a design commission for shoes and other fashion objects than lesser-known street artists. For the latter, the struggle for autonomy, especially on the artistic sector, still con-

tinues. There is, after all, a name at stake, which is still full of potential and which will be invaluable later, when it comes to more lucrative endeavors.

However successfully the famous Brit Banksy may attack the officially sanctioned world-view with his ironic, polemic or even farcical arrangements, he does employ relatively self-contained units as a counter-world against the mainstream of public art consumerism. Many of his colleagues launch their attacks with far more acrimony (and often with a great deal less irony or sarcasm) — especially against the advertising industry, since its function is closely related to that of the pieces, pochoirs and posters. Still, most of the artists do not act as methodically as the "Handbook for the communication guerilla", a relevant publication, prescribes. The images of advertising are much closer because they are indeed physically closer — and because they have been designed to be effective and are therefore already securely engraved into the street artists' brains. The alteration of advertising vehicles, such as posters, and the appropriation of their messages have a long tradition. Unlike in election campaigns, where minute (and calculated) changes to a phrase can turn the message upside down, the street art actions by

Graffiti: Mass Media?

The perception of the media and graffiti is intertwined in a particular way. On the one hand, graffiti does have a similar effect to the classic media, for instance newspapers, television and the Internet: Their messages are sent by the few to the many. The attitude of artistic circles towards both phenomena also shows surprising parallels: Sometimes hailed as visions of a bright future, they are occasionally denounced as the opposite. Working closely with these different aspects of the public, as diverse as they may seem, serves as an important point of reference through the decades.

ZEVS or the Cologne artist Parzival are aimed at a poetic and not immediately accessible level beyond the images. If Parzival, for instance, drives nails into an advertising poster, he does not only destroy the pristine and happy world that it represents but also introduces an atmosphere of obstruction and the chaos of building sites into the tightly structured public message.

However blatant, these small street art messages are meant as an artistic intervention and their challenge is to last longer than three seconds in the mind of the observer. The object here is not a stronger visual impact or a larger format, however impressive that may be: The mere fact that an artistic assault even takes place points out a conflict of a distinctly territorial nature. Many of the contemporary advertising spaces have been put up

Wall sockets
2007
Cologne

Collage of printed matter
2006
Wiesbaden

Shepard Fairey
Obey
2008
London

in the last few decades or even years – and many of them are now in the very place that had earlier been occupied by a piece of graffiti, obviously because this was a very effective location to begin with. How much money the City is spending on the destruction of graffiti is a frequently mentioned fact, says the London street artist Catrain in an interview – how much it earns from pubic advertising, however, much less so.

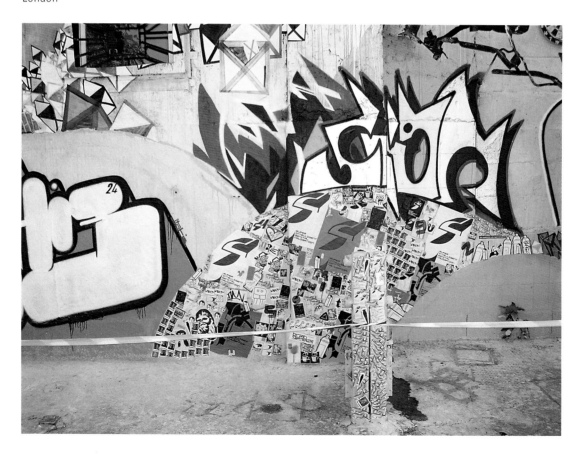

Presence and Representatives

The appearance of graffiti pieces or of street art itself has changed and developed far less than its presence in the media. It is in many respects an astonishing fact that the average bookshop now dedicates about three shelves to books on street art and graffiti. This is not only due to strong demand but also to the fact that the scene takes pride in the creation of well-designed and well-printed books on the subject, which can therefore also be rather pricey. The spectrum ranges from richly illustrated catalogues worthy of a catalog raisonné over erudite commentaries on the concept of public space to personal accounts that evoke the tradition of the picaresque novel. Apart from books and magazines, material on street art is available in a number of other media.

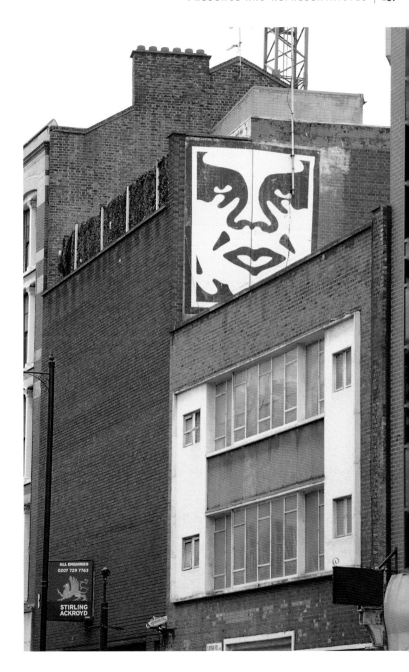

Publication on the Internet is almost a matter of course these days for writers and street artists alike and many happenings are documented on DVD.

Yet, graffiti and illegal street art is still forbidden and in recent years there has been a distinct tightening of the laws in many places. So why this hunger for images? On the one hand, as in the golden days of hip-hop, the street artists appear as the paragons of an intense way of life that seems more colorful and also riskier than the evening program on television. And on the other, street art has attained an equivalent position to the media in the public mind where both sides are simultaneously supporting each other and egging each other on. The street images have become familiar; they frequently appear on book covers and are now recognized as cultural signals in videos or movies. The fact that their presence has become more and more professionalized, aided and abetted by the artists themselves, should not be underestimated. The days of the cognoscenti, as in the golden age of the New York pieces, is long past. Nowadays, there is an entire industry involved in the production of street art.

But not just the street artists have discovered the inherent potential of this situation. In collaboration with Dutch polit-

Campaign

In spite of the oft-cited spontaneity of street art, any successful action is based on thorough planning, not only with regard to the process itself but also the intended effect. Especially in the case of stencils, stickers and cutouts, street actions tend to take on all the characteristics of a campaign. After all, the pieces should not just be seen; they are supposed to elicit a particular reaction. In view of all the talent that is shown in this particular sector of art, it comes as no surprise that politicians and the advertising industry keenly observe the progress and reception of graffiti. There is much to learn from it and young people constitute one of the most important demographic groups.

ical activists, some Palestinian writers offer an unusual service. Against a fee pre-paid via credit card, the artists go to the Gaza strip and spray the graffiti on an empty space on the boundary wall between Israel and Palestine. Since this endeavor is meant to be economically viable, it precludes lewd or politically controversial messages. Digital photographs serve as proof of the successful execution of the work.

The Hamburg-based advertising agency Jung von Matt has also sought collaboration with graffiti writers. The large-scale mural on their property does not just depict the history of graffiti. In a joint venture with mobile phone developers looking for new applications

Run easy
Advertising campaign by a
manufacturer of sports shoes
2006
Berlin

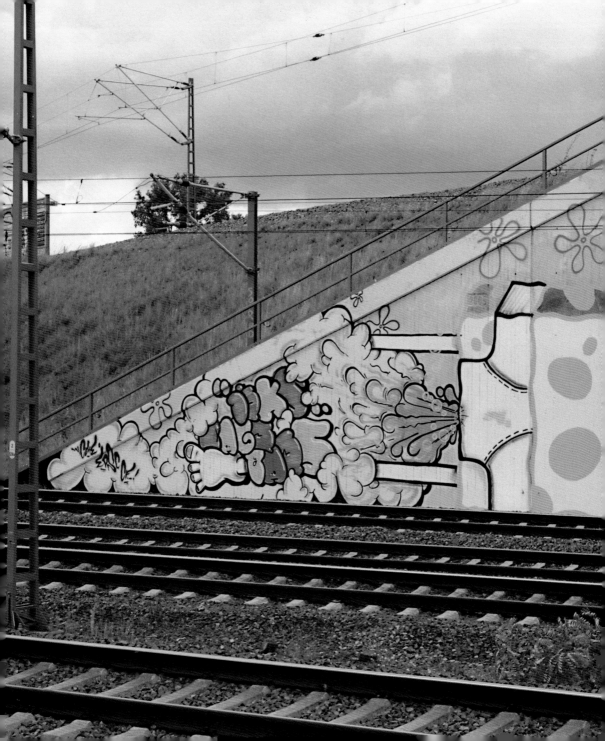

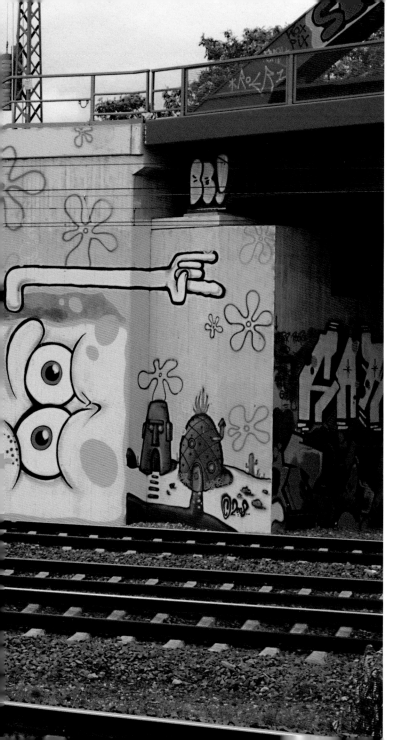

Sponge Bob takes off: Train tracks are still among the preferred locations of graffiti artists. Whilst on the subway it is the pictures themselves that move, in this case the viewer is moving past the image. The graffiti becomes more densely packed and at the same time, more short-lived, the closer one gets to the train stations.

Sponge Bob
2008
Cologne-Buchforst, suburban train station

Fashion

Every fashion changes considerably over a period of 40 years. However colorful the pieces, the protagonists of the graffiti scene prefer to wear dark colors for obvious reasons. They tend to blend better with the dark shades of night, which is the prime period of activity of street artists.

On the other hand, it would be really surprising if the riotous colors of this art form were not reflected at all in the clothing of its makers. At the beginning, however, fashion elements tended to concentrate on certain areas only. The classic hip-hopper wore his cap with the visor pointing backwards, a wide sports jacket and sneakers with the laces open. For the rest, his clothing was unremarkable. All the action took place on the front of the caps and the backs of the jackets: they were often adorned with small drawings or even pieces. Of course, such textile artworks were prized gifts.

Nowadays, individual creations have given way to industrially produced versions. A huge fashion industry has evolved out of the hip-hop movement, taking away much of its original wildness.

T-Shirts
2008
Paris

for cell-phones, they developed the so-called "interactive graffiti." You can dial up specific images on the wall and then enlarge and photograph them. The stored image serves as a code that entitles the user to certain benefits – provided that his cell-phone is sophisticated enough to support the service.

The American Shepard Fairey has drawn entirely different conclusions from the proximity of street art and marketing opportunities. While attending design school, he became well-known through a sticker campaign featuring a star shape with the image of the wrestler André the Giant and the imperative "Obey!" that had impressed him in a movie. The media-critical subtext is almost auto-

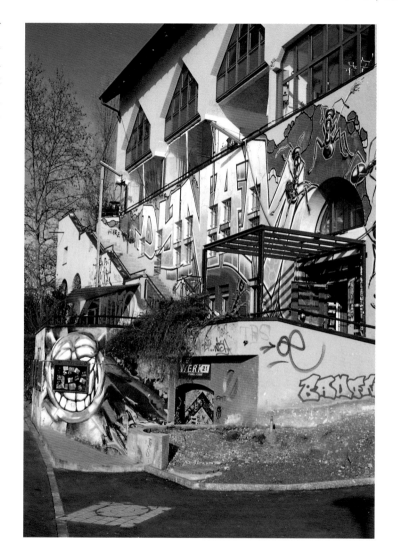

matically associated with George Orwell's "Big Brother". Fairey is keeping his campaign up to this day and the distinctive black-and-white image of the Obey Giant has become famous. The artist uses this calculated effect in order to expose the mechanisms of

Youth Culture Center Dynamo
Photographed in 2008
Design workshop as a
community project
Zurich

public campaigns. This success has led to two new endeavors: Firstly, he launched the website "Power to the People" where he offers to design clothing. Apart from the contribution to the general competition, this is a serious commercial offer, which packs additional punch through his fame. And secondly, Fairey uses his expertise as a consultant for large corporations. He does not want to separate these areas of activity because he considers them as inherent to his personality and as a successful fusion of art and commerce. He is well-respected in the street art scene, although his collaboration with the corporate world is seen rather controversially. His easy efficiency and the way he uses only minimally altered work by other artists do not meet with the approval of all of his colleagues by any means and continue to spark off arguments.

Fairey's idea of an enterprise that works on the basis of a franchise for an already established street art brand, however, has got a famous predecessor. Keith Haring had established a business on the site of Andy Warhol's famous Factory that continued to function long after his death. The merchandise produced here is sold in museum gift shops worldwide. As part as an

Academia

Maybe it is a typical sign of an ageing cultural impulse that its first-generation protagonists, who had been making worldwide waves in their day, have long been established as teachers at institutes of higher learning. Artists like Walter Dahn, Maik and Dirk Löbbert and A. R. Penck are now teaching art at university, whilst others, such as John Fekner, Quik or Christian Hasucha have done stints at teaching while continuing to practice their art. Even though street art is not yet an independent subject, as are for instance media art or installations, it is a regular topic of discussion among the students, showing that this art form has lost none of its vitality.

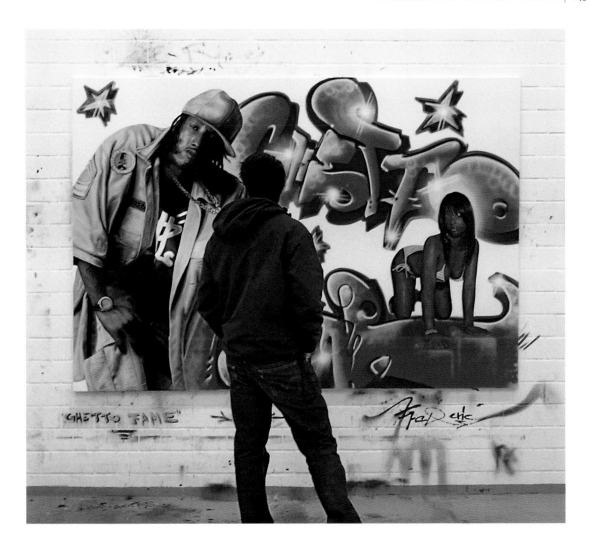

overall artistic concept comprising paintings, graffiti, fashion articles, rip-offs and show effects, the products have developed clear contours that can either be seen as artistic utopia or as a distinctive brand. Haring's graffiti and artwork were a focus of attention for the art world, while his shop in downtown Manhattan

Frederic Spreckelmeyer
Ghetto fame
2005, Spray paint on canvas, installation for the Akademieausstellung Münster 2006

(which for a time even had a Tokyo branch) served as a focus of economic attention. The seamless corporate image comprises shopping bags (with price tag), Internet presence and calling cards. The free badges that have been available in the shop since 1983 deserve special attention: as artistic give-aways they fall into the same category as the graffiti and murals that Haring, by his own account, had spent half of his

time on. After the artist's death from AIDS, the charitable Haring Foundation lives on and donates a certain percentage of its revenues to good causes – a business concept that Haring had followed from the very start. Unlike Warhol, he had thought to protect his work from early in his career so that the copyright sign has since become an integral part of his signature.

Marcus Krips
Untitled
2007
Kripskunst subscription 07,
Digital image

Marcus Krips, a former member of the punk scene who had also participated in the squatting of the Stollwerck chocolate factory in Cologne has worked with graffiti since the early 1980s. His imagery, however, does not really reflect the American graffiti "mainstream", it rather seems to point to a simple, graphical universal language. Like the graffiti of A. R. Penck or Harald Naegeli, his imagery, sometimes combined with textual elements, is at its most effective as a spontaneous expression on the wall. After further studies with Nam June Paik and at

the Academy of Media Arts in Cologne, Krips has changed his artistic medium several times. In a commission for the Nuclear Research Center at Jülich, he created a multimedia CD-ROM installation populated with his signature stick characters. He has done similar interactive work for exhibitions and media festivals. In a recent project, KripsKunstSpam, the artist creates a whole new relationship between the original graffiti impulse and the public.

He offers an e-mail subscription to a daily picture, thus combining the idea of putting a personal mark on the environment with the ideal of direct marketing. In a tongue-in-cheek commentary on his identity as a sprayer, Krips uses the term "spam", which denominates unwanted Internet advertising. At the same time, this artistic solution is as elegant as it is tempting: a daily product against

regular payment. Another parallel to the immediacy of graffiti is the fact that his stream of consciousness is more or less permanently linked to that of his viewers. Through this portal, he is able to drip-feed his criticism of advertising, commercialization and control through the media to the viewers – a criticism that is not necessarily being cancelled out by the commercial character of this service.

"Invader" is the pseudonym of a London artist who has created veritable icons of this controversy in

Marcus Krips
DIGITAL MAL MANUELL
AUTOMATIK MIX
2007
Kripskunst subscription 07,
Digital image

Candy Graffiti
2008
Amsterdam

Space Invader
2008
London

the form of intricate mosaic figures. Although not quite as ubiquitous as the public surveillance cameras in his native city, his "invaders" have nevertheless managed to occupy strategic positions in cities all over the world. The colorful figures made up of small squares evoke the characters of early computer games and have made many friends. They display some text-book campaign qualities: a high recognition factor, positive appeal, high distribution and an element of surprise invest the versatile little figures with all the characteristics of a brand. But they are still invaders, unsent-for intruders of the public space, whose Internet counterparts are called Trojans or viruses. Just

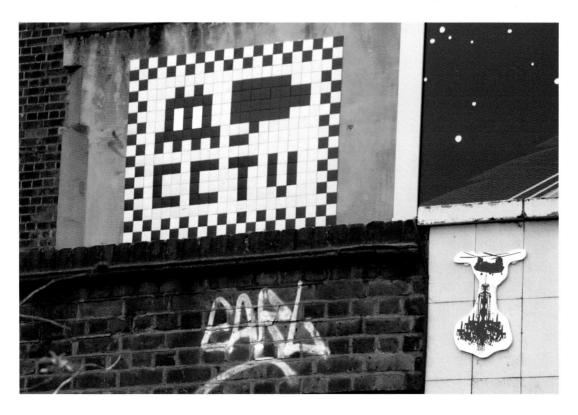

like these, the invaders reiterate a message that keeps knocking at a back door in the viewer's mind: You are being watched. A large-scale work by the artist in his native city makes this explicit: The letters CCTV next to an invader and a camera pictogram say clearly: CCTV is watching you. What at first glance appears like simple, playful imagery slowly reveals its deeper layers: a highly efficient criticism of the presence and the dangers of media control of the urban space.

These days, Big Brother is watching high quality CCTV footage at all times of the day, but by the same token, graffiti no longer disappears from public view by night. Street artists, too, have started illuminating their work, albeit to a lesser extent than advertising, whose brightly lit messages have mushroomed since the 1990s.

Whether self-adhesive modeling clay, LED lights or laser projection, the ingenuity and technical skills of modern artists have managed to keep up with the possibilities of intervention in the public space – closely observed by the authorities as well as the advertising industry. This applies in particular to the Paris artist ZEVS, whose pieces in phosphorescent colors only come into their own when it is dark.

Working Class Hero putting up
posters
2007
Basel

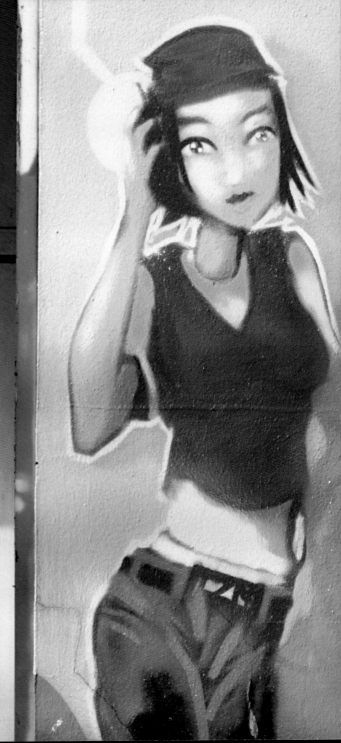

EVENEMENTIEL

CULTURE HIP-HOP

Moving on

Gloria's father got on her nerves. And school as
well, of course. Okay, dad had this advertising
agency and the Rio kids bought the stuff that was
featured in his advertisements. But it was not ok
that he wanted to hang out with her classmates
afterwards. She bet that the guys only liked her
because her dad gave her money to buy clothes
or the new half-pipe. When the kids told him
what was cool and what was absolutely not on,
it helped with his ad campaigns. But when dad
wanted to come along when they were tagging,
Gloria had drawn the line. Writing as a family
enterprise? No way. Gloria had bailed out and
enrolled in a samba class. Her father had always
railed against those dancing schools, their drill
and their old-fashioned values. He said they were
chauvinist and that had made Gloria think again.
But to hell with it. Anything but hanging out
with those trendies.

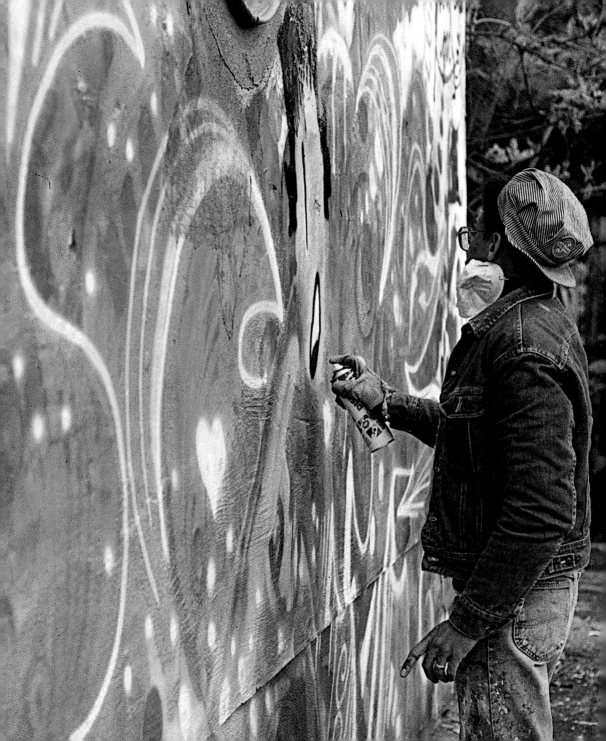

How to: Some Recipes

Technical skills are highly valued in the writing scene. Style and technique are discussed far more intensely than for instance the writers' attitude towards art or their position within contemporary culture. And small wonder, for the art scene, for its part, has never taken graffiti writers overly seriously and this also goes for street art. But the real reason is that it takes a lot of time, energy and organizational skills to plan a good piece. So the discussion revolves around questions like "how did X make this piece, how does the new lighting effect work, how do we deal with the public surveillance systems, who will be the crew members and can we trust them?" Fame and fun, ostensibly the writers' main objective according to many interviews, are at best the topic of small talk after the event. Either you have got both or you are well on the way. The crews freely exchange information on organizational improvements but keep technical and artistic tips and tricks close to their chests – after all, the development of those skills takes too much time and practice to squander on the uninitiated.

There are many recipes for good graffiti and street art, even though neither subject has made it to the status of an independent academic subject. Much depends, as always, on personal taste and intentions.

Pieces

It is a long and arduous process to make it to a respected king of the writers' scene. Apart from the fact that this is predominantly a hierarchical society of

Quik in action
1989
Wiesbaden-Erbenheim

young males, it takes a long time to accumulate the necessary technical skills. You have to gauge the correct distance to the wall, understand your own range of physical mobility and to organize all that you need for your piece well in advance. You need to know the drying time of the different paints and the different sizes of the spray heads and how much pressure you need for your particular purposes. The right kit is important: gloves and mask protect and help keep you presentable for afterwards.

A good piece needs the right foundation. Damp, too absorbent or uneven walls are a problem. The

presence of other pieces has to be taken into account. Apart from the conflicts that overspraying may cause, there are other considerations: how many layers can the wall take and will the design of the old piece interfere with the new one in those places that have not been covered?

Unlike murals, pieces have to be done rapidly. You rarely have the luxury of an overhead projector or scaffolding that provides visual and structural support. The preliminary sketch has to be exact – or binding, as contractors would say. Small wonder that the black book is the first thing the police looks for when they

pp. 256–259:
Koor
Mural
1989
Schweinfurt

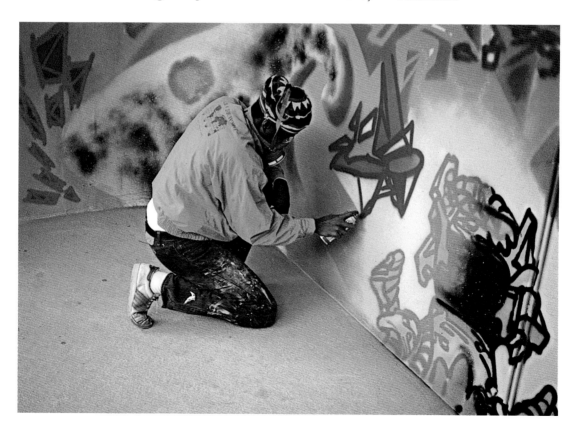

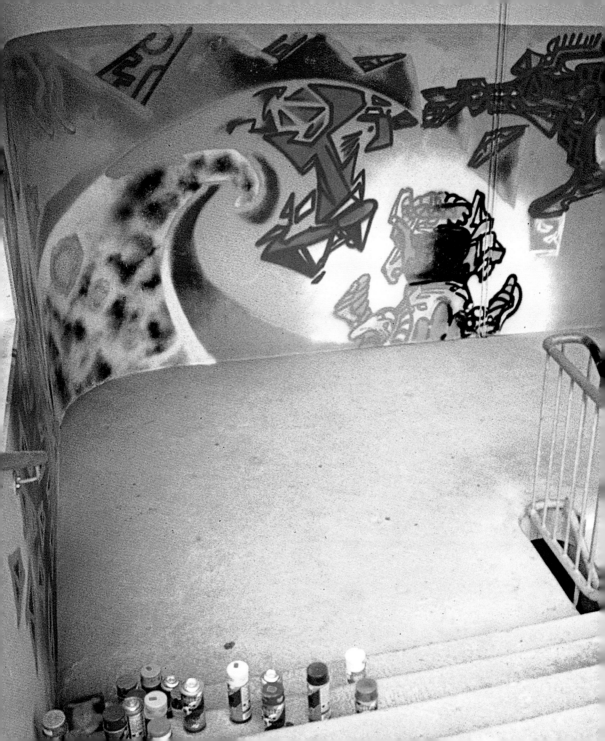

Koor's mural has been built up in several layers. It leads down a staircase in a multi-storey car park under the market. The curving wall displays a science-fiction panorama in riotous colors that offers more than a glimpse into the private cosmology of its creator.

catch you: any tangible evidence can be used against you.

First, the image is sketched out with fine, light-colored lines that later disappear under the final colors; what counts here is not elegance but precision. The right sequence of the elements can also be marked out in different colors. Then the spaces are filled in and the visual effects added by color grading. This is where the cans with higher pressure and the fat caps are used because they allow you to work faster and more efficiently. It takes real skill to create three-dimensional effects through grading the colors by operating several cans simultaneously.

Detail with color changes and gradients
2008
Brussels

Problematic boundary, leftovers
2008
Brussels

Blek le Rat
Tribute to Tom Waits
Stencil
1983

After the foundation has been laid, the finishing touches are added: Outlining the different elements with fine dark lines throws the different element into sharper relief and cross-hatching adds contrast. At the very end, special artistic tidbits are added wherever there is available space. It is a topic of controversy whether to use marker pens or create fine lines with the spray can by blocking off certain areas with a piece of cardboard. But all those artistic details are closely guarded secrets.

In a larger piece, some additional elements are added – the credits, as it were. The crew, date and, if present, sponsors are mentioned, and it is surprising how frequently you can find acknowledgements, dedications or even taunts. After all, the scene is a social organism. The name or alias of the artist is practically never forgotten, because after the fun, there may be fame. Spray actions in front of an audience are often meticulously planned: The decisive detail that throws the whole piece into focus will only be added at the very end in a well-orchestrated denouement, followed, like film credits, by the relevant personal details.

Style?

Style is the keyword for the development of large-scale pieces. After the first beginnings of Grand Design, where large letters were filled in with multi-colored ornaments, came the Bubble Style with its rounded, voluminous shapes. Then the many forms of Wild Style with its complex interlacing calligraphy appeared, where many letters were arrow-tipped. Finally came the block letters, whose simple capitals were rendered three-dimensional by perspective drawing. The on-going development of graffiti styles is an area of close interest for calligraphers and typographers worldwide.

Pochoirs/Stencils
Stencils have developed in a different way. They were less a deliberate

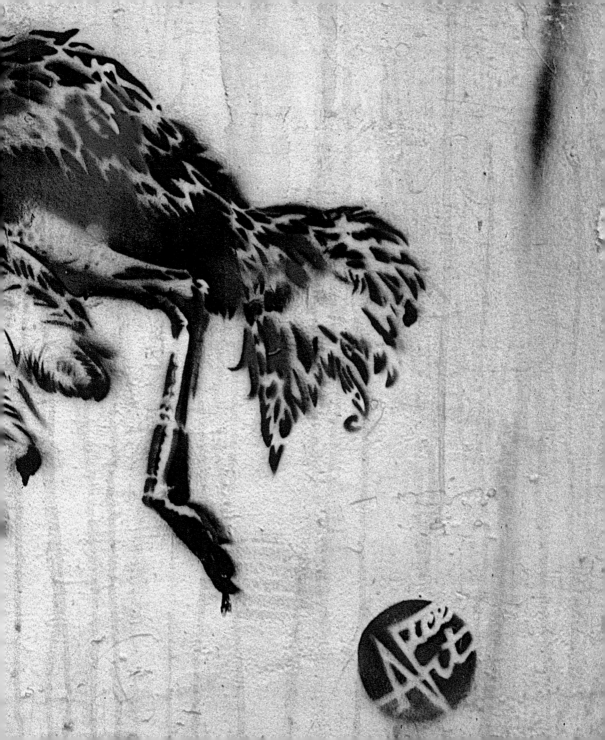

Previous double spread:
Nice Art, Ostrich
1987
Paris

esthetic choice than a means to convey an image to the wall in as little time as possible in order to stay undetected. In the final analysis, these "serigraffiti" are a kind of print, which like all types of printed matter, require extensive preparation before the final and rapid printing process can take place. For graffiti stencils, it helps if the artist has some experience with wood- or linocut. It is not always enough just to sharpen the contrasts digitally or by photocopying until just black and white remain. A good end result requires careful sketching, which is often far more effective than technical manipulation.

Also, the stencil must be suitable for the intended purpose. Walls can have very different textures. Even colors can change the appearance of a stencil dramatically. The colors as well as the stencil itself should be robust because frequent use will take its toll. For large-frame images, more than one stencil may be needed or the

whole process may become too unmanageable. In which case, easily identifiable reference points will be necessary so the different parts of the stencil can be easily assembled. As for color woodcuts or serigraphs, this is especially important for stencil images in more than one color. In this case, using one stencil and folding it may be advisable.

Other considerations are necessary for the correct and most effective placement of a stencil: What will be the distance between the observer and the image – will the image still be readable from certain distances? Depending on their location, complete human shapes like those used by Blek le Rat or Banksy must be seen from certain angles. This may require minute changes to the placement of the stencil or the colors: A hovering person signifies something entirely different from a figure whose feet are firmly placed on the ground. The way a figure is facing is also intricately linked to its particular location.

Street Art – Art on the Street

An entirely different set of rules applies to sculptures in the public space. As sculptures come in an endless variety of shapes, materials and techniques, technical considerations have a lesser significance than for pieces or stencils. Besides the structure of the background, if the sculpture is to be placed on or against a wall, the exact positioning within the available space is most important. Street artists who are especially thorough will take preliminary location shots. This not only affords them a

Positioning a stencil
1989
Wiesbaden

Above
Arrow
2007
Berlin and elsewhere

Graffiti has reached the world of education: This is just one of several walls in a Berlin culture centre for children and young people where a mix of different graffiti styles reflects the wide variety of the center's youthful patrons.

clearer image of their location but also provides them with a benchmark for "before and after" documentation. When at work, artists like ZEVS like to wear inconspicuous workmen's clothes. When the East-German Jörg Herold was working on his legendary sculpture on the Augustusplatz in Leipzig, Germany – a massive plinth in cast concrete – he used to reply to the questions of inquisitive passers-by that he was only doing his job and did not know anything else. In the German Democratic Republic, people did not tend to question such statements; nowadays, many would have picked up their cell-phone and made some inquiries. Cordoning off the work area with official-looking equipment also helps to give a legitimate look to many street art endeavors. Since many of these hap-

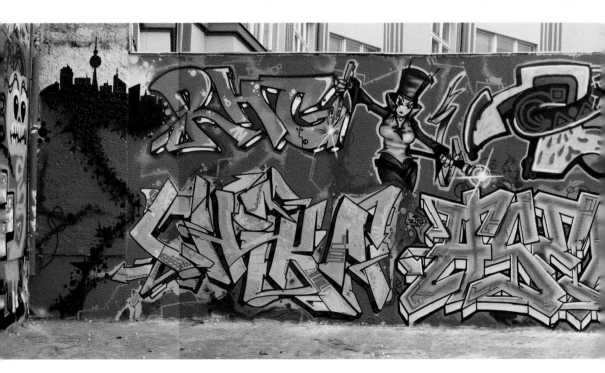

penings are being documented for posterity, a cameraman or photographer will be in on the game. Given that passers-by might well question the necessity of a camera crew for a public works project, additional strategies, such as hiding the camera or making the entire set-up look quite normal to the average passerby, might be called for. Nor is it always a good idea to carry out the work during the early morning hours, either.

For temporary street art actions that are supposed to be repeated, it is essential to know the manufacturing and operating process inside out. This also helps if artwork that has been lost or removed must be replaced. In this context, foldable, lightweight and recyclable street art seems like a really good idea.

Mural in the KIJUKUZ cultural center for children and young people
2008
Berlin-Kreuzberg

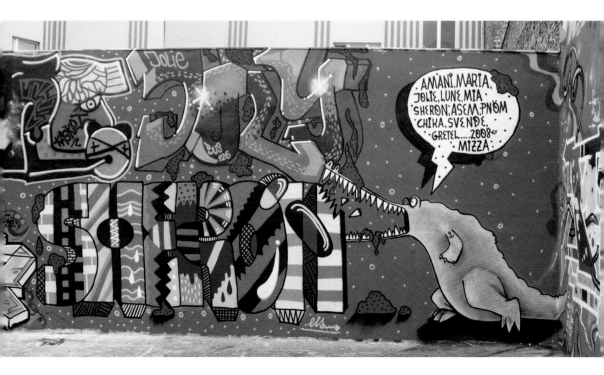

Graffiti as an Educational Objective? Some Questions

Mural, school project
1985
Cologne

"Happy child before sad wall"
1970s
Watercolors, school project
Private collection

their closely-knit crews, which also functions as a sort of training center. The path of apprenticeship starts with obtaining the necessary materials; acting as lookout; the passing of cans; and the filling-in of letters during the creation of the artwork. It ultimately leads up to the status of planner and sketcher who is responsible for the orchestration of the piece. Documentation and processing into films and video clips is another field of activity that can be structured as strictly as the production of the art itself. The fact that the creation of large-format graffiti requires a stringent division of labor has brought the phenomenon into the focus of interest of educational institutions. A graffiti piece created by a group of students will be visible as a proof of their joint efforts for a long time and it also has the added

However strongly theoreticians may emphasize the street artist's spontaneous urge for individual expression – nobody can create stencils, or cover large wall spaces with seemingly effortless throw-ups or large-scale pieces without at least some form of training and practice. The New York City writers have developed a distinct hierarchy within

benefit of showing the school in a younger, cooler light.

There are two main arguments in favor of teaching graffiti at schools. On the one hand, there is a persistent perception that graffiti is the occupation of young people with educational deficits, which is often countered with the integrative effect of graffiti projects. This perception does not generally hold true, as can be seen as early as the first boom of the New York City writers. Even then, a good many of the writers had been well educated, and today, more and more street artists are closely linked to art and design endeavors elsewhere. The most important argument in favor of the integrative factor is therefore the fact that this activity brings the members of very diverse social groups together. On the other hand, street art is seen as a positive way of channeling young people's creativity and aspirations towards self-assertion. This idea is a highly controversial subject for sociologists and also depends on many different factors like location, mobility or education. But it should not be forgotten that most writers, however aggressive

their statements may sound, are opposed to violence and destruction.

The specific approach to a street art project in art class is important. There is a fundamental difference between seeing street art as an all-pervasive visual continuum and using this as a vehicle to sensitize the children to their environment, or an approach that, right from the word go, aims at the development of an independent creativity. The first route belongs to the realm of historiography and will encourage a reflective approach, which can also be used to analyze social phenomena outside of the art world, while the second will lead to a closer look at creative techniques. In the latter case, a stronger focus on the stencil seems appropriate within a limited time frame because it is easier to learn than the creation of a graffiti piece and yields faster results. In this context, a workshop with a master of street art may raise the school in the students' esteem and can also serve to build bridges towards the outside world. This, incidentally, is also true for the more theoretical approach because street art documentaries can serve as a theme for photography exhibitions and as an introduction to media pedagogy. Generally, street art as an educational subject has the potential to replace the image of school as a hostile environment with a more positive concept and to encourage the students to discover their school as an environment that they can put their own creative stamp on. Even though such endeavors often surpass the limited resources of the art department, either with regard to time or materially, they are very popular. The reception of these art projects by the outside world, however, is pivotal for their success because activities that are seen as fundamentally illegal will inevitably lead to controversy. Its is therefore indispensable to consult the parents as well as the relevant political representa-

Quik finishing a piece
1989
Wiesbaden

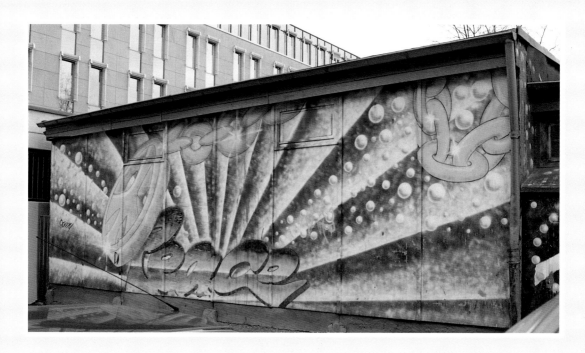

tives before the event in or-
der to give the students
scope for personal develop-
ment and to establish the
school as a positive environ-
ment.

Yet such creations are sub-
ject to a strong pressure to
change, especially where
they conform to the creative
ideas of their young cre-
ators. Therefore, the result
of a street art action in a
school is, by its very nature,
not a long-term installation.
It will have to be repeated

on a regular basis, for exam-
ple by each new generation
of students. The competition
between the different age
groups can be channeled in-
to a fruitful competition and
encourage mutual accept-
ance and respect, which will
facilitate the individual's
progress from the school en-
vironment into society as a
whole.

Mural, school project
2006
Cologne
(Same wall as on p. 270)

Glossary

Badges and stickers

In youth culture, as in any culture based on representation, identity marks are important. They show the wearer as belonging to a certain group, idea or style and, of course, they are a type of adornment. Like fan merchandise, they are sold and passed on and so anyone can wear them or stick them on. Through this, with the help of their fans and supporters, the comparatively small writer's scene manages to spread its message over a large area.

Cutouts

Many artists have taken to the used of cutouts, which are faster to make but also more short-lived than stencils. They are mostly smallish stickers cut out from photocopied paper and stuck on the walls. Sometimes they are covered with a layer of varnish or they are

made from special durable paper to start with.

Leftover

Strictly speaking, all graffiti are uncalled-for public expressions. Nowadays, three-dimensional elements are included more and more frequently in street art. Like relics of their presence, such leftovers enter into a playful dialogue with their surroundings. Since they are relatively easy to remove, most of these predominantly small-scale objects tend to survive only relatively high on walls and facades. Larger arrange-

Sticker
2008, London
Colorful diamonds sparkle on this sticker, called "city tattoo" by its creator Jean Baudrillard.

Cutout (above left)
Judith Supine
2008, London
Collage, photocopy, color and glue: Judith Supine's cutouts are an elaborate conglomeration of techniques.

Stencil (above right)
Doom
Photographed in 2008, London
A detailed and lifelike portrait assembled from syringe shapes.

Whole Car (below right)
Mesh/Age/Reas
1986, New York City
The spraying of a Whole Car is a witness not only to the feat of having covered a very large area with graffiti in a comparatively short time and without getting caught, but also the ability to plan a piece of this scale well in advance.

DANGER

LIVE WIRES

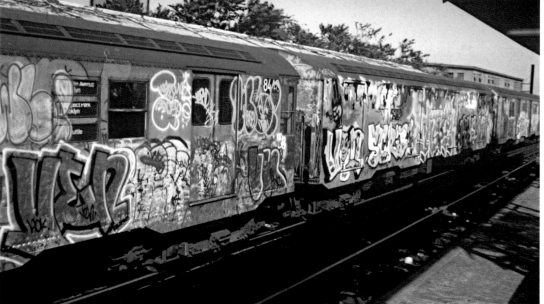

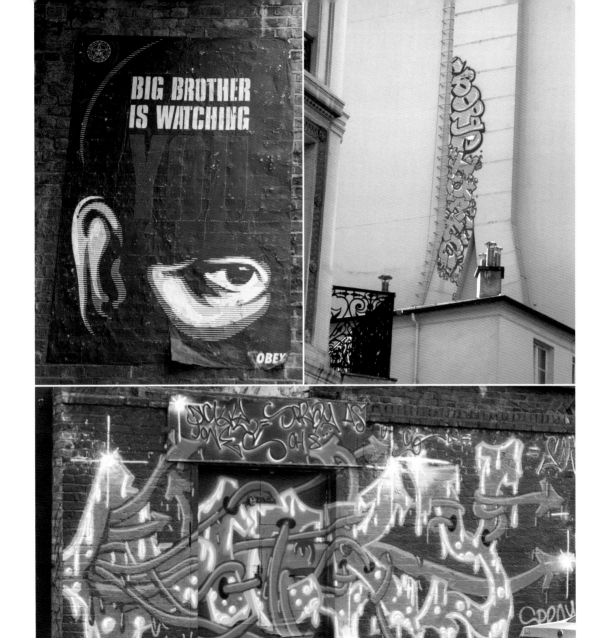

Right
SLO
Photographed in 2008, Cologne
SLO clearly classifies his statement as his own thing: neither as art nor as attack on law and order.

Rooftop (above right)
Photographed in 2008, Paris
As if bringing the surroundings to life, this rooftop grows out of a building in the heart of central Paris.

Poster (top left)
Shepard Fairey
Obey
Photographed in 2008, London
Shepard Fairey's Big Brother poster challenges public propaganda with its own devices.

Piece (bottom left)
Dickie Jones
Photographed in 2008, London
This piece by Dickie Jones is a masterpiece of street art, demonstrating the versatility of typography.

ments often take this process into account; the changes and developments over time are then minutely observed and documented.

Pieces

The piece (short for masterpiece) is the common and most widely accepted form of graffito. The central element is usually the name of the writer in large letters. Over the last few decades, the often intricate shape of these letters have developed into historically distinctive styles that have been a fount of inspiration for typographers and type designers. In and around the central letters, there are often other references in the so-called box and a multitude of shapes and images.

Posters

Parallel to the interplay between graffiti and public inscriptions, there has been a long-standing competition and interaction between public and illegal posters. Whether hand- or machine-printed, they have been a means of artistic expression and a vehicle for political propaganda since the beginning of the twentieth century. Artists like Jakob Kolding have used this medium to mark the demarcation line between free art and public discussion. Some posters aim to bring an atmosphere of poetry into the urban space. Meanwhile, the advertising industry has jumped on the bandwagon, utilizing the posters' decisive gesture for fashion ads or concert announcements. At the same time, many artists use this fact in order to place their own subversive artwork in the public space.

Rights

The legal situation for street art is far from clear but it is fair to say generally, uncalled-for art in the public space violates the law of the land. And in most cases, these artistic expressions are not considered a petty offence or misdemeanor, but are seen as a clear case of willful damage to property: Any change to an object's appearance is liable to prosecution. Due to the tightening of the law in some European countries, the police are often forced to press charges against sprayers. Consequently, many sprayers now have their own legal support system in order to survive economically. Besides the penalty charges, there have been many cases where the sprayers have had to pay high compensation to house owners who pressed charges.

Rooftop

Pieces on end walls that can be seen from the street are a common occurrence these days. These locations are acces-

Mural
Kaos/Maze
Baby don't do it
1986, New York City
Many murals are based on educational traditions, aiming to appeal to a sense of community.

sible from the rooftop of an adjacent building, so the sprayers should nimble on their feet and they have to have a good idea of what exactly can be seen from the different vantage points on the street. Nowadays, this placement is not just a favorite venue for sprayers but also for the advertising industry – occasionally graffiti pieces are being replaced by public advertising.

Stencil/Pochoir

The need to work fast has induced sprayers like Blek le Rat to utilize the ancient technique of stenciling for his art. A stencil can be prepared at home and the actual spraying of the image will take a comparatively short time. The similarity to other art forms like woodcuts with its strong emphasis on contrasts entails a whole different set of artistic rules.

Tags/Throw-ups:

Tags and throw-ups probably range lowest in the scale of public appreciation of graffiti. Tags are applied with a special pen that allows the sprayer to draw fat lines. These cryptic signatures tend to scare people because their messages are often aggressive or plain indecipherable. Tags require a minimum of logistics and technique – the object is simply to be quick and prolific. Throw-ups tend to be large contour letters quickly filled in with a layer of paint.

Murals

Murals – commissioned or non-commissioned wall paintings – have a very long tradition. The Mexican muralists of the 1930s continue to exert their influence on contemporary artists. Often, the wall seems to disappear behind its function as image carrier and is completely replaced by the visual impact of the huge wall painting. Occasionally, the mural opens a different visual perspective and its subject matter constitutes a veritable narrative. For these reasons, wall paintings are a favorite propaganda vehicle for politics, advertising and art.

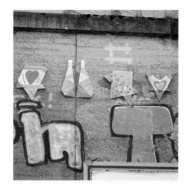

Leftover
2007, Cologne
Side by side with graffiti and equally non-commissioned: these painted elements demonstrate one of the many ways to introduce the third dimension to street art.

Whole Car; Whole Train; Top to Bottom

Here as everywhere, size matters. In subway art, the number of cars covered with graffiti is tantamount. In the heyday of the pieces on the New York subway, besides style and proliferation, the spraying of a whole car or even an entire train was the most important criterion for a sprayer's or a crew's reputation. While is has become virtually impossible to do a whole car in New York City, they do tend to crop up here and there in other parts of the world where surveillance is less strict.

Following double spread:
Throw-ups
Smash 137
2008
Spray paint on kitchen sponges
Urban Feedback Exhibition, Basel
In the context of an exhibition of street art, Smash 137 shows a throw-up sprayed on a background of kitchen sponges: an ironic comment on the public image of these tags.

Further Reading

Abel, Ernest L./Buckley, Barbara E.: The Handwriting on the Wall. Towards a Sociology and Psychology of Graffiti. London 1977.

Banksy: Wall and Piece. London 2005.

Baudrillard, Jean: Kool Killer oder der Aufstand der Zeichen. Berlin 1978.

Bou, Louis: Street Art. New York 2005.

Brassaï (Guyla Halasz): Du mur des cavernes au mur d'usine. Minotaure 3/4, Paris 1933, p. 6–7.

Castleman, Craig: Getting Up. Subway Graffiti in New York. Cambridge, Mass. 1982.

Chalfant, Henry & Cooper, Martha: Subway Art. London 1984.

Chalfant, Henry & Prigoff, James: Spraycan Art. London 1987.

Christl, Markus: Stylefile. From prototype to silver. Mainaschaff 2005.

Cooper, Martha & Sciorra, Joseph: R.I.P. New York Spraycan Memorials. London 1994.

Freeman, Richard: Graffiti. London 1966.

Garrucci, Raphaele: Graffiti de Pompéi. Paris 1856.

Hager, Steven: Hip Hop – the Illustrated History of Break-dancing, Rap Music and Graffiti. New York 1984.

Heinicke, Christian; Krause, Daniela: Street Art. Die Stadt als Spielplatz. Berlin 2006.

Hundertmark, Christian: The Art of Rebellion. Aschaffenburg 2003.

Hurlo-Thrumbo: The Merry Thought: or, the Glass-Window and Bog-House Miscellany. London 1731.

Jacobson, Staffan: Den Spray-målade Bilden. Graffitimåleriet som bildform, konströrelse och läroprocess. Lund 1996 (Diss. Uni Lund).

Jakob, Kai: Street Art in Berlin. Berlin 2008.

KET: Graffiti Planet. London 2007.

Kreuzer, Peter: Das Graffiti-Lexikon. Wandkunst von A bis Z. Munich 1986.

Mailer, Norman/Kurlansky, Mervin/Naar, Jon: The Faith of Graffiti. New York 1974.

Matzinger, Gabriele: Can art : ist art. Vienna 2007.

Nelli, Andrea: Graffiti a New York 1968–1976. Lerici, Cozensa 1978.

Prou, Sybille/King ADZ: Blek le Rat. En traversant les murs. London 2008.

Reid, Leon A. & Downey, Bradley T.: The Adventures of Darius & Downey. London 2008.

Riout, Denis: Le livre du graffiti. Paris 1985.

Schildwächter, Jan P./Eggers, Britt: Street Art Hamburg. Hamburg 2007.

Schwartzmann, Allan: Street Art. New York 1985.

Siegl, Norbert: Kommunikation am Klo. Graffiti von Frauen und Männern. Vienna 1993.

Stahl, Johannes (Hg.): An der Wand. Graffiti zwischen Anarchie und Galerie. Cologne 1989.

Stahl, Johannes: Graffiti: zwischen Alltag und Ästhetik.

Munich 1990 (Diss. Uni Bonn 1989).

Stampa Alternativa/IG Times (Hg.): Style. Writing from the Underground. Viterbo 1996.

Stewart, Jack: Subway graffiti: an aesthetic study of graffiti on the subway system of New York City, 1970– 1978. Ph.D Thesis, New York University, 1989.

Thiel, Axel: Graffiti-Bibliographie. Eigenverlag, Kassel 1986.

van Treeck, Bernhard: Graffiti Lexikon. Street Art – legale und illegale Kunst im öffentlichen Raum. Moers 1993.

van Treeck, Bernhard und Metze-Prou, Sibylle: Pochoir – die Kunst des Schablonengraffiti. Berlin 2000.

van Treeck, Bernhard: Street Art Berlin. Berlin 1999.

Witten, Andrew/White, Michael: Dondi White – Style Master General. New York 2001.

WOSHE: Blackbook. Les Mains dans l'Alphabet. Paris 2005.

Zürcher Sprayer (Harald Naegeli): Mein Revoltieren, Mein Sprayen. Bern 1979.

Exhibition catalogues (listed chronologically)

Martinez, Hugo (Hg.): United Graffiti Artists. Exhib. cat. UGA, New York 1975.

Postgraffiti. Exhib. cat. Sidney Janis Gallery, New York 1983.

Graffiti. Exhib. cat. Museum Boymans van Beuningen, Rotterdam 1983.

Alinovi, Francesca (Hg.): Arte di Frontiera. Exhib. cat. Galleria communale d'art moderna Bologna. Milan 1984.

Christ, Thomas: Subway Graffiti. Exhib. cat. Gewerbemuseum Basel 1984.

New York Graffiti. Exhib. cat. Louisiana, Humlebæk 1984.

Lee Quiñones: New Horizons. Exhib. cat. Riverside Studios, London 1985.

Ramm-Ell-Zee. Exhib. cat. Gemeentemuseum Helmond 1986.

Adrenalin. Exhib. cat. City Gallery, Melbourne 1988.

Crash. Exhib. cat. Sidney Janis Gallery, New York 1988.

Futura 2000. Arcs & Cracs. Exhib. cat. Galeria d'art contemporani, Barcelona 1989.

KOOR. Exhib. cat. Art Boom, Deurne (NL) 1990.

Coming from the Subway – New York Graffiti Art. Exhib. cat.

Groninger Museum, Groningen 1992.

Quik/Blade. Exhib. cat. Art Boom, Deurne (NL) 1993.

Backjumps. The life issue #3. Exhib. cat. Kunstraum Kreuzberg/Bethanien, Berlin 2007.

Thomas Baumgärtel. 1997–2007. Exhib. cat. L.-Hoesch-Museum Düren et al., Heidelberg 2008.

Films

Beat Street. Stan Lathan. Orion Pictures 1984, 106 min.

Stations of the Elevated. Manfred Kirchheimer. New York 1979, 46 min.

Stylewars. Tony Silver/Henry Chalfant. Public Art Films Inc., New York 1984.

Wholetrain. Florian Gaag. Goldkind Film GmbH, Munich 2007, 85 min.

Wildstyle. Charlie Ahearn. Pow Wow Productions, New York 1983, 82 min.

Links

www.graffiti.org
www.graffiti-europe.org
www.stickernation.net
www.woostercollective.org

Index of Names

Captions of illustrations in text boxes:

(p. 76)
Roman Defaming Picture
Drawing
1876

(p. 82)
Sprayed Banana with
Polemic Comment
1988
Düsseldorf

(p. 106)
Dan Perjovschi
(Detail of p. 60)
Free Speech
2007
Basel

(p. 112)
John Fekner/Peter Mönnig
(Detail of p. 116)

Walhalla
Installation
1985
Berlin, facing the Wall

(p. 130)
USA (Detail of p. 160)
Character
1986
New York City, Graffiti
Hall of Fame

(p. 136)
Euro-Man
2007
Brussels

(p. 182)
Don't mess with my pieces
2007
Cologne

(p. 188)
Mural
(Detail of pp. 200/201)
2007
London

(p. 202)
Poster
2008
Berlin

(p. 208)
Gerôme Mesnager
1985
Rome

(p. 234)
Marker pen in Polaroid
format
1983
Cologne

(p. 238)
Toaster
2008
London

(p. 244)
Laser 3.14
Tradition can be a Prison
2007
Oil and spray on canvas
Private collection

(p. 262)
Zephyr
Style
1983
Berlin, Wall

Captions of illustrations at beginning of chapter:

(p. 12)
Grotte de Pech Merle
Southwest France
Rock painting
Stone Age

(p. 26)
Election propaganda
(Graffiti), 50 AD
Via dell'Abbondanza,
Pompeii, Italy

(p. 42)
**Pieter van Laer
(1592–1642)**

Artists' Tavern
Drawing c. 1630
Kupferstichkabinett SMPK
Berlin

(p. 64)
**Auguste Bouquet
(1810–1846)**
Ah! petit drole de prince, je
vous y prends cette fois ...
on est jamais trahi que par
les siens! (Gotcha, funny
little prince ... Nobody
deceives you like your
own!)

Lithography, 1833, in "Le
Charivari" No. 358

(p. 92)
Harald Naegeli
c. 1978
Zurich, Predigerkirche

(p. 124)
Subway-Station Dean
Street
1986
New York

(p. 172)
Wild Style
1983
Berlin, Wall

(p. 214)
C:\>
Pencil on tiles
Paris

(p. 252)
Girl
Photographed in 2008
Paris

Picture Credits

All pictures by Johannes Stahl, except:

Publisher's Information

Thanks to Felicitas Pohl for her assistance in finding illustrations.

For the artists' works:
© VG Bild-Kunst, Bonn 2013 / Giacomo Balla
© VG Bild-Kunst, Bonn 2013 / Thomas Baumgärtel
© VG Bild-Kunst, Bonn 2013 / Jean Dubuffet
© VG Bild-Kunst, Bonn 2013 / Bogomir Ecker
© VG Bild-Kunst, Bonn 2013 / Linwood Felton
© VG Bild-Kunst, Bonn 2013 / Christian Hasucha
© VG Bild-Kunst, Bonn 2013 / Jenny Holzer
© VG Bild-Kunst, Bonn 2013 / Hugo Kaagmann
© VG Bild-Kunst, Bonn 2013 / Xavier Prou
© VG Bild-Kunst, Bonn 2013 / Jean Tinguely

© h.f.ullmann publishing GmbH

Original title: *Street Art*
ISBN 978-3-8331-4943-6
Project management: Lucas Lüdemann, Kristina Scherer
Author: Johannes Stahl
Editor: Julian von Heyl
Graphics editor: Hubert Hepfinger
Layout: e.fritz, berlin06
Cover Design: Simone Sticker
Cover Photo: Blek le Rat, "Tribute to Tom Waits", © Johannes Stahl

© for the English edition: h.f.ullmann publishing GmbH
Special edition

Translated by Frauke Watson
Edited by ce redaktionsbüro für digitales publizieren
Typeset by ce redaktionsbüro für digitales publizieren
Project coordination for the English edition by Kristina Scherer
Overall responsibility for production: h.f.ullmann publishing GmbH, Potsdam, Germany

ISBN 978-3-8480-0393-8

Printed in China, 2013

10 9 8 7 6 5 4 3 2 1
X IX VIII VII VI V IV III II I

www.ullmann-publishing.com
newsletter@ullmann-publishing.com